VIDEO GAME
STORYTELLING

VIDEO GAME

STORYTELLING

What Every Developer Needs to Know about Narrative Techniques

Evan Skolnick

WATSON-GUPTILL PUBLICATIONS
Berkeley

To Lynn, to my sons Jacob and Bennett, and to my Mom and Dad.

Published in the United States by Watson-Guptill Publications, an
imprint of the Crown Publishing Group, a division of Random House
LLC, a Penguin Random House Company, New York.
www.crownpublishing.com
www.watsonguptill.com

WATSON-GUPTILL and the WG and Horse designs are registered
trademarks of Random House LLC.

Library of Congress Cataloging-in-Publication Data is on file with
the publisher.

Trade Paperback ISBN: 978-0-3853-4582-8
eBook ISBN: 978-0-3853-4583-5

Printed in the United States of America

Cover design by Christina Jirachachavalwong and Amy Huang
Interior design by Amy Huang and Betsy Stromberg

10 9 8 7

First Edition

Contents

Introduction

All but the smallest-scale video games are created by groups of people working together. Mission designers collaborating with AI programmers, concept artists working with 3D modelers, audio designers coordinating with tools engineers, environment artists working with lighting experts, and dozens or even hundreds of other potential kinds of interactions. But success will elude them all, unless everyone on the team—whether it's comprised of two members or two hundred—is pulling in the same direction.

There's rarely one person you can point to as the reason a game is of high quality. Conversely, there's hardly ever a single individual you can blame for the opposite. Game development is a team effort, and the team wins or loses together.

This is also true of the game story. *No one person can pull it off alone.*

It is not enough to hire a talented writer and/or narrative designer for your game. Depending on the scope of your project, it will ultimately take designers, artists, animators, programmers, audio experts, and potentially many other specialists to deliver the narrative content in the final product—to bring the story to life.

Thus, the working relationship of the writer with the rest of the team largely determines the game's potential narrative quality. That relationship hinges on the team members' familiarity with storytelling, their attitudes toward story's place in games, and their mastery of a common language with which everyone on the team can discuss the game narrative.

It is the goal of this book to provide that common language, and to help give you, your team, and your game the best chance to deliver entertaining, effective, and well-integrated story content.

I have spent over a decade in the game development industry, working in various roles, on dozens of projects, delivered on every major platform. During that time I have collaborated with hundreds of developers to solve creative, technical, and logistical game development problems. I have found narrative challenges to be among the most subtle and intractable.

1

And I'm not alone. Over the years I've been fortunate enough to become acquainted with many fellow game writers and narrative designers, each with their own "war stories" and frustrations from projects current and past, each of us trying to find ways to make game and story play more nicely together—attempt after attempt to solve this ongoing conundrum.

My own efforts in this area have met with some limited success, on projects ranging from kid-targeted handheld games such as IGN Game of the Year cowinner *Over the Hedge* for the Nintendo DS, to the Academy of Interactive Arts and Sciences story award nominee *Marvel: Ultimate Alliance 2*, to the first mature audience–oriented *Star Wars* title ever attempted: E3 2012 showstopper (and unfortunate victim of corporate upheaval) *Star Wars 1313*.

Beyond toiling behind the scenes on these and other projects, I've also very publicly tried to bridge the gap between gameplay and storytelling by speaking at various conferences and shows, particularly the Game Developers Conference (GDC). On an annual basis since 2006, I have run a day-long tutorial at GDC in San Francisco—by now experienced by over one thousand working and aspiring game developers—focused on the essentials of story development. With a wide mixture of attendees including game producers, designers, artists, programmers, and academics, the workshop provides core principles of storytelling in a compact and intensive primer.

But not everyone can get to San Francisco easily; nor can every producer afford GDC passes for every member of his or her team. Thus this book, which contains similar information to what one would experience in my tutorial, albeit in a noninteractive (but eminently more affordable!) format.

The book is divided into two main parts. Part I provides a basic grounding in well-established principles of Western storytelling: the common language that everyone on the team can use when discussing narrative elements. Part II represents a deeper dive, investigating the specifics of storytelling as they relate to the main areas of game development and describing in greater detail how members of each discipline can contribute to—or potentially sabotage—good storytelling.

As we embark on this journey together, you may notice a few choices I've made. The first is that when it comes to examples from existing stories, many of the ones I've selected are from movies. As this is a book about *video game* storytelling, you might wonder why most or even all of the examples aren't culled from games. The simple answer is that there are a significant number of movies that I feel safe in assuming nearly everyone has seen from beginning to end (for example, the original *Star Wars*). When it comes to games, though, due to their longer length and potential for players to get "stuck," there are few if any examples for which I can safely make the same assumption. Sadly, there just aren't many games that *everyone* in our industry has purchased and played. Even if there were games we had all played, it's unlikely we all would

have finished them. Online player data regularly confirms the low percentage of players who tend to push through any game's story mode to completion—it's almost always less than half.

Another aspect you might notice is a focus on console and PC games vs. games on other platforms, particularly the burgeoning mobile and tablet gaming sector. With regard to narrative, large-scale projects generally offer the "biggest stage" for storytelling, which in turn allows for a deeper discussion of those elements as they relate to game development. Please be assured, the core lessons from this book are applicable to the development of *any* digital game, whether it's on a console, PC, handheld system, tablet, or phone.

Finally, although they are two distinct roles, for simplicity's sake I will use the terms "game writer" and "narrative designer" (along with the more generalized "narrative expert") interchangeably throughout this book.

With those caveats and explanations out of the way, it's time to dig in. Let's take a look behind the curtain at what makes your favorite stories tick, and discover how you can apply these lessons to your own role as a game developer.

PART I
Basic Training

Video game storytelling doesn't begin or end with a writer. The best game stories emerge from a collaborative process between a writer and a cross-disciplinary team of game developers. And so, as a game developer, you are also a storyteller.

That's right, you. It doesn't matter if you're a designer or animator, a 3D modeler or an AI programmer, a producer or a music composer—if you're helping to develop a game that is trying to tell a story, then you are helping to tell that story.

You and the rest of the team, that is.

And the first thing any team needs to have in common is a shared understanding of the "rules of the game."

Does writing have hard and fast rules? Not really. But when it comes to fiction development, there are core principles, proven structures, and best practices that have been identified, vetted, and verified over the past several thousand years. And they're used every day, to incredible effect by professional writers of every stripe.

Basic comprehension of these narrative principles and patterns, as described in the pages that follow, will improve your ability to help tell your game's story.

Now, reading this first section will not make you a professional writer any more than reading a book on karate will make you a black belt. If you want a top-notch story in your game, you'll still need a narrative expert to help guide you. But understanding these core concepts can make your collaboration with such an expert go much more smoothly, netting a better final result for you and for your players.

1

Conflict: The Fuel of Story

Think of your favorite sports car and imagine it sitting in your driveway right now. Maybe it's an American muscle car like a Corvette or a Mustang, or possibly a Japanese screamer with an Acura, Infiniti, or Lexus badge. Then again, perhaps you'd prefer a German performance machine from Porsche or BMW, or a sleek Italian model from Ferrari or Maserati.

Now imagine that vehicle with not a single drop of gas in the tank. (Fully electric cars are excluded from this metaphor.) Whatever car you prefer, no matter how sleek, muscular, powerful, or beautiful to look at it is, what good is it without fuel?

Sure, even on an empty tank you can sit in the car and *imagine* the wind flying through your hair. You can grip the wheel, enjoy the leather seats, and if the battery's charged, you can even play some of your favorite tunes on the stereo for a while.

But you'll never get anywhere. And you'll very quickly lose interest in your new toy. Without fuel, even the most impressive vehicle is useless and boring.

The fuel of fiction is *conflict*.

Conflict powers your story. Conflict is the burning energy that propels it forward. And if your tale runs out of conflict before it reaches its destination, you've got a problem.

But what is conflict? In terms of story, we can use this simple definition: *Someone wants or needs something, but someone or something stands in the way.*

In order for a story to *be* a story, it needs to have at least one main conflict. Longer, more complex narratives may have several major conflicts and will also be peppered with countless smaller-scale ones.

Think of the original *Star Wars*. First there is the now-famous text crawl, which sets the stage by laying out a number of galactic-scale conflicts. Then,

once we're in the actual movie, a compelling series of sub-conflicts inexorably leads to the introduction of the movie's first main conflict.

In order, and each phrased in terms of the definition above:

1. The crew and passengers of a small diplomatic ship *want* to escape, *but* their craft is being pursued, fired upon, and boarded by much more powerful Imperial forces.

2. C-3PO and R2-D2 *want* to remain functioning, *but* are caught up in the battle.

3. The Rebels *want* to defend their ship, *but* it is being boarded by overwhelming invaders.

4. A furious Darth Vader *wants* the princess and the secret plans found, *but* so far there is no sign of either.

5. R2-D2 *wants* to get away in an escape pod, *but* C-3PO thinks it's a crazy plan.

6. Princess Leia *wants* to escape, *but* she's hit with a stun beam and brought to Darth Vader.

7. R2-D2 *wants* to wander into the Tatooine desert in one direction, *but* C-3PO wants to go in another.

8. Darth Vader *wants* Princess Leia to tell him where the secret plans are, *but* she claims to know nothing about them.

9. R2-D2 and C-3PO *want* to reach safe destinations, *but* both are captured by droid-dealing Jawas.

10. The Imperial Stormtroopers *want* to find the droids and so search the Tatooine surface, *but* they are nowhere to be found.

11. The droids *want* to remain together, *but* are about to be split up when Owen Lars chooses a red R5 unit instead of R2-D2.

12. Luke Skywalker *wants* to see the rest of Princess Leia's message on R2-D2, *but* the droid doesn't seem able to comply.

13. Luke *wants* to leave the moisture farm and join the Academy, *but* is made to feel obligated to continue helping his uncle with the farm.

14. Luke *wants* to be seen as responsible, *but* he allows R2-D2 to escape into the deep desert.

15. Luke *wants* to recover R2-D2, *but* he's knocked out by Tusken Raiders.

16. The Tusken Raiders *want* to steal Luke's equipment, *but* they are confronted and scared off by a hooded, wailing Ben Kenobi.

17. A message indicates that Princess Leia *wants* to protect the galaxy from the evils of the Galactic Empire, *but* she's been captured and needs Obi-Wan Kenobi's help.

18. Obi-Wan *wants* Luke to come with him to Alderaan to help rescue the princess, *but* Luke, feeling obligated to stay on Tatooine, refuses.

Point 18 completes the introduction of the story's first main conflict: *there is a princess who needs rescuing*. This major challenge drives us through much of the rest of the story.

But notice how many smaller conflicts we see first! (And this is by no means a complete list.) From its very first shot to the moment the Death Star explodes, *Star Wars* is saturated in conflict. Virtually every scene involves characters with opposing, or at least obstructed, goals. Some are resolved favorably (e.g., R2-D2 and C-3PO *do* escape the Imperial Stormtroopers who are pursuing them) while others are not (the Tusken Raiders lose their prey). Some are physical conflicts, while others are social or emotional.

Watch the movie all the way through and you'll notice a constant stream of new sub-conflicts, all related to the main conflict of a princess needing rescue. Obstacle after obstacle is thrown into the path of the Hero, requiring him to think, fight, run, shoot, swing, climb, escape . . .

Then, once the princess has been rescued, a new main conflict emerges: the plans on R2-D2 must be used to destroy the Death Star before it obliterates the Rebel base. Once this new challenge is overcome—the Death Star is destroyed—notice how quickly the movie wraps things up and ends. With all conflicts resolved, the story is out of "fuel." The journey is over, and everyone knows it. Time to get the hell out before the audience has a chance to get bored.

And that's an important point. Without an unresolved conflict fueling the experience, the audience perceives they are not in an actual story. They will very quickly lose patience and interest, and then *you* will lose *them*.

Conflict is also the fuel of gameplay. A challenge, with goals and obstacles, is placed before the player. The player *wants* to succeed and win, *but* the game adds complications and challenges that must be overcome first. A game with no challenges, goals, or obstacles can hardly be called a game, any more than a story without conflict can be called a story.

At this core level, stories and games are in blissful agreement. The driving force behind both experiences is the core conflict of a character wanting something, but needing to overcome challenges in order to get it. It is compelling to *watch* someone try to resolve conflicts (as in books, TV, movies, etc.), and it is potentially even more compelling to feel like you really *are* that conflict-resolving character (as in games).

Here are the main conflicts of some modern, story-driven games:

- *Tomb Raider* (Crystal Dynamics, 2013): Lara Croft *wants* to help her friends escape from a mysterious island, *but* a bizarre militaristic cult has other plans for them, and supernatural forces prevent anyone from leaving.

- *Far Cry 3* (Ubisoft Montreal, 2012): Jason Brody *wants* to help his friends escape from a mysterious island, *but* they are being held by an army of thugs ruled by a pair of psychopathic warlords.

- *Portal* (Valve, 2007): Chell *wants* to escape the dilapidated Aperture Science facility, *but* a deranged AI is holding her captive and forcing her to solve bizarre, deadly puzzles.

- *Uncharted 2: Among Thieves* (Naughty Dog, 2009): Nathan Drake *wants* to recover the long-lost Cintamani Stone, *but* it's also being tracked by a madman who intends to use it to become superhumanly powerful.

In each case, the goals of the main character and the goals of other characters are at odds with each other; thus the *want/but* pattern (the conflict) we see in everything we call a story, and in everything we call a game.

Buts are what stand behind the many obstacles the player faces. In turn, the levels or missions of the game are the physical expressions of those conflict-generated obstacles.

Without a *want/but*, there is no conflict. Without a conflict, there are no obstacles. Without obstacles, there is neither a story nor a game. Conflict is essential to both.

So fill 'er up!

Scope of Conflict

When determining what the main conflict for a story might be, the question of scope almost immediately comes into play. What is at stake? How big is this conflict going to be?

A common misconception among beginning storytellers is that the bigger the scope of conflict, the more dramatic the story will be. What you end up with can be *overinflated stakes*: the whole country is at risk . . . or maybe the whole world!

Seriously, how many stories have you experienced in which the fate of the world was at stake? Too many, I would expect. And the stakes sometimes get even more super-sized than that! What about the galaxy? The space-time continuum? The universe?

Bigger stakes do not equal more powerful stories. The conflict in your story only needs to *feel* huge. It does not have to literally *be* huge.

What makes a conflict of any scope feel huge? *If it's important to a character we care about.*

For better or worse, we as humans are better able to emotionally relate to a single person than to a thousand or a million. Seeing a single person in pain will evoke a stronger emotional response than watching a planet full of people explode.

A number of video games have gotten great mileage out of relatively small-scale stakes. *Grand Theft Auto III* is about the criminal career of a single, obscure thug. *Sly Cooper* is about the family birthright of a thieving raccoon. *Diner Dash* is about keeping one's job. *The Walking Dead: Season One* is ultimately about keeping one little girl safe. And *Mr. Mosquito* is about keeping a single mosquito fed!

The stakes don't even have to be life or death, necessarily. Just very important to a character we, as the audience, have become emotionally attached to.

So remember—always have conflict. And only make the scope of the conflict as large as it needs to be, no larger.

Final Thoughts on Conflict

Without fuel, a car engine will sputter and grind to a halt. And it's the same with stories. But stories don't come with gauges or warning lights to indicate a fuel problem, so it's up to you, the storyteller, to always be mindful of a story's constant need for conflicts that the characters are challenged to resolve.

Conflict is the very core of story, its beating heart. I really can't emphasize this enough. In fact, if you were to come away with only one lasting lesson from this entire book, I would hope it to be: "story is conflict."

The Three-Act Structure

A car's main components are engineered to convert fuel into forward, controllable motion. Everything is built around this core function.

As covered in the last chapter, the fuel of story is conflict. And as you might expect, the entire structure of story is built around it.

One of the oldest and best-known story models is the *Three-Act Structure.* The word "act" might seem to imply that this paradigm only applies to plays, but don't be fooled. You will find this simple, time-tested foundation in everything from ancient Greek tragedies to bestselling espionage thrillers; from Broadway hits to 30-second children's breakfast cereal commercials; from *Casablanca* to the very latest Hollywood blockbuster.

The realization that virtually every fictional work you've ever experienced shares the same structure may be disconcerting or even dismaying. But does it really need to be? Does it sadden the Ferrari owner to know that the internal combustion engine that powers his dream machine is structurally and functionally similar to the one that powers a rumbling Mack truck? Or a boxy SUV? Or an Army Jeep? Or a bargain-basement Kia?

Under the hood, nearly all stories are built pretty much the same way. And that's okay.

Origin and Basics

The core concept of the Three-Act Structure was first (and best) expressed way back in 335 B.C. by the Greek philosopher Aristotle in his *Poetics*: "A whole is what has a beginning and middle and end."

In other words, all complete stories consist of three distinct phases: beginning, middle, and end. This simple truth should come as no surprise.

After all, we grow up hearing fairy tales that start with "once upon a time," then describe a series of events, and inevitably wrap up with "and they lived happily ever after." Beginning, middle, end.

But is that all there is to the Three-Act Structure? Well, no. The beginning, middle, and end of a story all relate to its *conflict*.

- Beginning: *Setup* (of the conflict)
- Middle: *Confrontation* (of the conflict)
- End: *Resolution* (of the conflict)

Each of these three story phases is associated with one of the acts in the Three-Act Structure, like so:

Beginning	Middle	End
ACT I	ACT II	ACT III
SETUP	CONFRONTATION	RESOLUTION

Act I: Beginning/Setup

Nearly all stories open with an *introduction*—a starting point before the main conflict is presented. This is the "once upon a time" phase of the story, during which we meet our *Hero* (or protagonist, or main character, whichever you prefer) and get a feel for his current life situation and his world, before any of them are affected by the main conflict. Hence, *setup*.

But why bother? What's wrong with just jumping right into the action? Why do we need to take time to introduce all those various elements, or worry about what people, places, or things were like before the main conflict arrived?

There are a number of good reasons. First, we must give our Hero somewhere to start as a character, a place from which he needs to grow. (Character change and growth is covered in more detail in chapter 4, "Characters and Arcs.") In order to understand any change, we need to have a clear picture of the *before*, as well as the *after*. Generations of weight-loss advertisements have proven this beyond any reasonable doubt.

We as the audience also need to understand *why* the Hero would want to confront the conflict at all. The Hero is often charged with improving not only his own lot but also the condition of those around him—sometimes that of his whole community. Why will he care enough to try? It's almost always because the world he's from is a good one and worth fighting for, or it's a bad enough place that it's going to require a struggle to improve it.

A particularly important element of Act I is the *Inciting Incident*. This is the event, occurrence, or action that first introduces the Hero to the main

conflict. Without it, the Hero wouldn't become aware of the conflict and there-fore would never have an opportunity to resolve it (which is the entire point of the story's existence!).

So, despite its introductory nature, Act I is full of important elements that lay the groundwork for the rest of the story. Returning to our automobile analogy: Think of Act I as starting the car, adjusting your mirrors, putting on your seatbelt, checking the gas gauge—all the things you really should do before putting the vehicle in motion.

Act II: Middle/Confrontation

This is the "meat" of the story, kicking off at the point when the Hero finally commits to resolving the conflict. With initial setup complete, it's time to start seeing what kinds of obstacles the protagonist will confront and how he'll man-age to overcome them.

We'll also become acquainted with the source of the main conflict, if we haven't already. This story element often takes the form of a *Villain* (or antagonist, if you prefer), supported by lesser *Henchmen* who will, throughout Act II, harass and/or try to block the Hero from achieving her goals and resolving the conflict.

Act II simultaneously serves two setup/payoff relationships:

- *Payoff* for much of what was set up in Act I

- *Setup* for the resolution of the final conflict in Act III

Act II is usually about twice the length of either of the other acts—it's *big*! So big, in fact, that it sometimes gets hard to handle when it comes to structure, planning, and pacing. A writer can start wandering in Act II and lose momentum quite easily. Because of this, many writing gurus split Act II into two halves, separated by a *Midpoint*—the halfway point not only of the act, but also of the overall story—at which time things will often spin in a new direction.

Act II sees progressively increasing tension, drama, and stakes—what's often referred to as the *rising action*—and culminates with the Hero finally understanding and seeing the path to resolving the conflict.

Act III: End/Resolution

This is the big finale, what the audience has been itching to experience ever since the conflict was first introduced—to find out "what happens?" The Hero makes his ultimate effort to resolve the conflict and either succeeds (happy ending) or fails (sad ending).

Sad or "down" endings in mainstream stories are rare because they break expectations and can leave audience members feeling disappointed, angry, or

even depressed. Of course, it's true that many critically acclaimed and financially successful stories conclude sadly or tragically. But ending one's story on a "down" note is very, very risky business.

Happy or "up" endings tend to evoke a positive reaction, but only if they are cleverly constructed to give the audience what they wanted—success for the Hero and resolution of the conflict—but *not* the way they expected it. (We will delve a bit more into this point later on, when discussing exposition in chapter 5.)

With the conflict resolved, the story is now out of fuel and needs to end before things grind to a complete halt and the audience gets bored. We briefly check in with various characters we met along the way to let us know if everyone got what we think they truly deserve, and it's curtains.

Transitions/Plot Points

The Three-Act Structure, by its very name, seems to imply distinct and obvious breaks that separate its three story phases. However, in modern storytelling we often don't experience any kind of pause or other overt indication that we're transitioning from act to act.

When you go to see a movie, are there two intermissions demarcating these act breaks? Of course not—the experience is designed as a single, flowing unit of entertainment. Even in TV shows with their commercial breaks, novels with their chapters, and video games with their levels, we can't always assume that those divisions align with the narrative breaks implied by the Three-Act Structure.

The act breaks may not be actual breaks, but the transitions are still there. Close examination of any standalone story will almost always reveal three acts and the turning points that separate them. In fact, if you know the Three-Act Structure well enough, you can often sense these transitions happening even while you're experiencing a story for the first time.

The two breaks between three acts are often called the story's *Plot Points*.

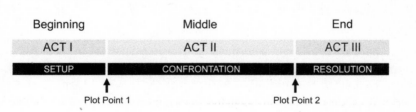

Beginning	Middle	End
ACT I	ACT II	ACT III
SETUP	CONFRONTATION	RESOLUTION

↑ Plot Point 1 ↑ Plot Point 2

The first Plot Point divides Acts I and II and happens at the moment the Hero fully commits to resolving the main conflict. It is at this point in a story that we can feel the gears shifting; we sense that the story has finally gotten going, and we know that the real ride is just beginning.

Plot Point 2 separates Acts II and III, and is sometimes a bit fuzzier. Generally it's the moment in which the Hero, battered by the effort of already overcoming so many challenging obstacles, finally sees the path to victory. She hasn't achieved it yet, and the outcome could still go either way, but the Hero has had some kind of epiphany and at last knows what she needs to do— if she can only pull it off!

Tension Map

The level of tension as felt by the audience is a good metric of conflict and pacing, and can be counted on to predict how engaging the story is likely to be to the audience at any given moment. Below is a look at how tension levels generally look in a standard, three-act story:

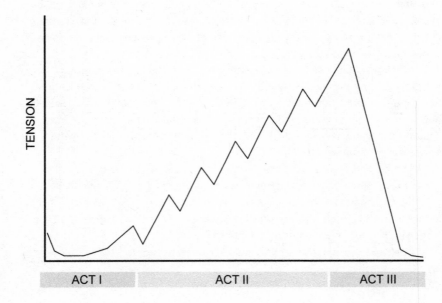

There are a few interesting things you might quickly notice about this *tension map*.

The first attribute that may jump out at you is its overall shape. Low tension in Act I, rising tension in Act II, the highest tension as we cross over into Act III, and a rapid drop-off of all tension by the story's end. Tension is closely associated with conflict, so no huge surprises there, right?

But what about all those "spikes"? What's with the mountains and valleys in Act II?

Each spike in Act II is a *crisis*, and the biggest crisis of all is the *climax* (in Act III).

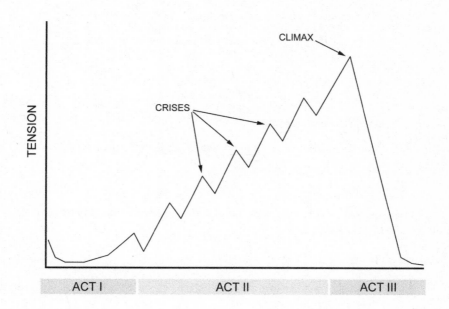

Each *crisis spike* in the graphic above represents the escalating conflict presented by an obstacle. These obstacles progressively increase in scope, danger, and stakes, with each one needing to up the ante over its predecessor to continue the rising action. After each crisis resolution, a lessening of conflict levels follows—a short respite before the next obstacle begins to raise tension again, even higher than last time.

Some versions of this chart depict a straight, steady increase of tension through Act II, but to me that's oversimplified. Except in the briefest of stories, the audience simply can't tolerate an Act II that inexorably and without relief ratchets up the tension every minute. After each resolved crisis, it's important to give the audience a break to let them (and the Hero) catch their breath before pulling them through the next, even bigger crisis. Otherwise, fatigue can set in and the audience may feel oppressed, uncomfortable, and, frankly, less entertained.

The tension hills and valleys of the chart above represent, on a macro scale, what most story developers refer to as *pacing*. And if you look at each of these spikes, you'll note that they are miniature versions of the Three-Act Structure. Each spike starts by setting up a sub-conflict, which causes tension to escalate as the Hero tries to overcome it, and concludes with a tension relaxation once the sub-conflict is resolved.

The Structure Applied

Most stories, to one degree or another, resemble the following structure:

- Act I: We meet our Hero, eking out a livable but humdrum existence.

 - Inciting Incident: Hero becomes aware of the main conflict, or its implied existence.

 - Plot Point 1: Hero commits to resolving the main conflict.

- Act II: Hero overcomes increasingly challenging obstacles in his quest to resolve the conflict.

 - Plot Point 2: Hero has epiphany, sees the path to success.

- Act III: Hero resolves the conflict; rewards and punishments are doled out.

Let's apply this format to a number of very well known, standalone stories and observe the repeating pattern.

Star Wars (1977)

- Act I: Luke Skywalker living out a frustrating existence with his uncle and aunt on Tatooine.

 - Inciting Incident: Luke sees the holo-message on R2-D2 from Princess Leia.

 - Plot Point 1: Luke, seeing his uncle and aunt have been murdered, agrees to go with Obi-Wan Kenobi to help rescue the princess.

- Act II: Rescue of Princess Leia, escape to the Rebel base, attack on the Death Star.

 - Plot Point 2: Luke hears Ben Kenobi's voice and turns off his targeting computer.

- Act III: Destruction of the Death Star, rewards for Luke and all his allies.

The Matrix (1999)

- Act I: Neo sleepwalking through his unfulfilling life as a corporate programmer and part-time hacker.

 - Inciting Incident: Neo is directly contacted by Morpheus, and pursued and arrested at his office by Agents.

- Plot Point 1: Neo commits to knowing the truth, and takes the red pill.
- Act II: Detachment from the Matrix, training, meeting with the Oracle, capture of Morpheus, rescue of Morpheus.
 - Plot Point 2: Neo chooses to fight Agent Smith instead of running; he's beginning to believe he's the One.
- Act III: Neo fulfills his potential as the One, easily obliterating the Agents and taking his place as the primary force in the war against the Machines.

Titanic (1997)

- Act I: Rose DeWitt Bukater, feeling trapped in a high society prison, is soon to marry a cruel, snobbish thug.
 - Inciting Incident: Rose's suicide attempt is thwarted by a charming, happy-go-lucky third-class passenger named Jack Dawson.
 - Plot Point 1: Rose decides to secretly meet with Jack despite concerns over her violently jealous fiancé.
- Act II: Rose and Jack fall in love, *Titanic* hits the iceberg, Jack is framed by fiancé as a thief and chained to a pipe below decks.
 - Plot Point 2: Rose refuses to get on the lifeboat in order to stay (and probably die) with Jack.
- Act III: Jack dies in the ice-cold water, but Rose, drawing upon the lessons she learned from him, summons the strength to save her own life, in more ways than one.

Dune (Novel: 1965, Film: 1984)

- Act I: Paul Atreides is a well-trained but pampered young prince living under the protection of his powerful royal parents.
- Inciting Incident: The Atreides move to Arrakis to take over spice production from the rival Harkonnens.
 - Plot Point 1: The Harkonnens attack House Atreides, smashing their facilities, killing the Duke, and sending Paul and his pregnant mother fleeing for their lives into the desert.
- Act II: Survival in the desert, meeting the Fremen, earning their respect, training with them, organizing them into an army.

- Plot Point 2: Paul takes the Water of Life and realizes that threatening to destroy all spice production on Arrakis is the key to victory.

- Act III: Defeat of the Harkonnens, abdication of the Emperor and Paul's rise to the Emperor's throne.

Application to Games

The Three-Act Structure is demonstrably present in nearly all works of fiction in traditional, linear media, but what about in games?

The more story-driven a game is, the more likely it is to reflect elements of the Three-Act Structure. In particular, Acts II and III are almost always easily distinguishable in video games. The rising action and final resolution of the main conflict tend to map almost perfectly to a game with multiple, increasingly challenging levels, culminating in a final boss battle or other climactic gameplay sequence.

In fact, swap out a few of the labels and we can easily reuse the Three-Act Structure chart from page 16 to accurately map most close-ended video game experiences.

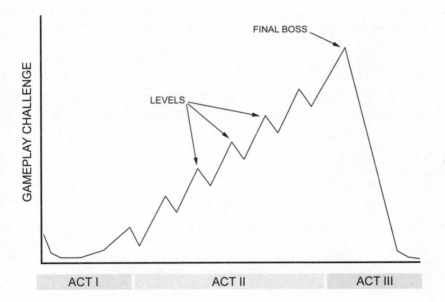

What about Act I?

You'll note that in the chart above that the Act II area is full of increasingly challenging levels, and Act III concerns itself with the final boss (or other climactic

gameplay experience), while the Act I zone is a bit, well, blank. That's not an accident. But it is a problem for many game-story developers.

The audiences of other story-based media—novels, movies, comic books, and plays—come into the experience with a certain degree of patience. They're willing to spend some time up front getting familiar with the world and characters before the main conflict is introduced and the story really gets going. Readers, moviegoers, and TV viewers are there, first and foremost, to experience a story, and they generally understand and accept that setup is part of the structure. Players, on the other hand, have come to play a game.

Of course, in many cases *these are the same people*. But their expectations change radically when they sit on their couch and insert a game disc into their PlayStation versus inserting a Blu-ray movie.

While traditional story audiences regularly tolerate 25 percent or more of the total story time being devoted to initial setup, video game players expect to be actively *playing* within seconds—or at the most, a minute or two—of launching into the experience. And in games, playing generally means overcoming obstacles related to a conflict.

Moreover, those first few minutes of gameplay need to be very compelling indeed, to convince players that they're going to want to stay awhile.

Consequently, game designers and writers often jump straight to the introduction of the main conflict, since they don't see a straightforward path to creating compelling gameplay without the main conflict to provide interest, motivation, and context for players.

The Act I of many games, even those that boast eight or more hours of epic storytelling, often lasts only a few seconds, or is essentially absent. Here are a few examples:

- *BioShock*: The main conflict is introduced within the first minute of the game, as the player character survives a plane crash and fights to stay alive and return to the normalcy initially glimpsed. The entire rest of the story revolves around the protagonist's struggle to survive and return to the ordinary world.

- *Far Cry 3*: Within the first ninety seconds, the player transitions from video footage showing player character Jason Brody and his friends and family members vacationing in Bangkok (Act I) to the revelation that after skydiving onto a nearby island, they were kidnaped by brutal slave-traders. The main conflict for most of the rest of the game story is finding a way to rescue Jason's friends, defeat the slavers, and escape the island.

- *Grand Theft Auto III*: The opening cutscene shows the unnamed player character, a small-time thief, as he's violently betrayed by his partners during a heist. He's arrested, but he and another

prisoner escape from the van taking them to jail. The rest of the game story is centered around the protagonist working his way up the criminal underworld on his path to taking revenge for the betrayal seen in those first few seconds.

There is a natural inclination to introduce conflict into a game experience from the very beginning. And it's the right instinct, because conflict is at the heart of both story and gaming experiences. However, is there always an *immediate* need for conflict or even true gameplay? And does the initial conflict you encounter need to be the story's *main* conflict?

The answer to both questions, of course, is no.

Once in a while you will see a dev team demonstrate more effort in creating a legitimate Act I for their game, investing time and effort to establish a status quo before shattering it with the introduction of an Inciting Incident and Plot Point 1. Here are a few examples of different ways this has been—and can be—successfully applied.

A Day in the *Half-Life*

The opening sequence of Valve's *Half-Life* is an excellent example of handling Act I in an interactive way, but with little to no conflict driving the initial experience. If you have never played this game, a quick Internet search for "Half-Life Walkthrough Part 1" should allow you to view a video playthrough on your computer or other connected device. (I recommend you do so before reading further.)

As *Half-Life* opens, we as the player are scientist Gordon Freeman, riding the train into work at the Black Mesa Research Facility, like we do every day. While this opening sequence is interactive, to use the word "gameplay" for it is probably being overly generous. There is very limited ability to interact with other characters or the environment, no combat, and no way to die or otherwise fail. It is, however, immersive and engaging.

Through this sequence, the beginning of which also serves as a credits roll, we get a sense of who "we" are, where we work, and what people generally think of us. We get off the train, and we see and hear from our workmates as they discuss the upcoming experiment and make small talk. It's the beginning of another humdrum workday, the calm before the storm. This is classic Act I setup material.

Once the experiment fails and all hell breaks loose, the chaos we see from that point on is *amplified* by our firsthand knowledge of how calm and orderly the facility used to be. Hallways that were pristine just minutes ago are now splattered with blood and strewn with dead bodies.

The length of *Half-Life*'s Act I is partially controlled by the player and how much time he chooses to spend exploring the environment vs. taking the specific actions that advance the plot. But even on a rushed playthrough,

the player will spend at least fifteen minutes firmly entrenched in Act I—with no main conflict yet established.

Half-Life 2 follows this structure as well; however, the aim of its Act I sequence is not to evoke a calm day at the office, but rather to establish the existence of a repressive and malevolent dictatorship. In the original *Half-Life*, the player's narrative goal is to re-establish some semblance of the positive world glimpsed in the game's first few minutes; in the sequel, the player's purpose is to shatter the negative world that oppresses and provokes us right off the bat.

Both *Half-Life* games are very successful, highly rated and held up as prime examples of strong, effective writing in games. So, it does seem that gamers are willing and able to handle a low- or even no-conflict beginning to their games.

A Marvel-ously Long Act I

When I was lead writer on *Marvel: Ultimate Alliance 2* (*MUA2*), Game Director Dan Tanguay, Narrative Designer Jonathan Mintz, and I all committed to including a true, substantial Act I in the game's structure. With a storyline based on Marvel Comics' hugely popular "Civil War" crossover event from 2006, it was clear that we had a lot of ground to cover in order to transition from the normal status quo of the Marvel Universe to a point where the super heroes have split into two camps and are fighting a war against each other.

We knew we needed to start with gameplay-contextualizing conflict, but we couldn't just jump into the main conflict. Fortunately, we understood that *the conflict introduced to kick off the game does not need to be the main conflict of the entire story.*

This is an important and potentially liberating concept for a video game storyteller.

In *MUA2*, we were actually able to have three full playable missions firmly ensconced in Act I—establishing the status quo, introducing an Inciting Incident, and ultimately allowing the player to choose from one of two options for Plot Point 1. Our Act I breakdown looked like this:

- Act I: Super heroes embark on a secret mission to Latveria, led by Nick Fury, then spend another mission dealing with a Latverian revenge strike on New York City. We learn that since the original mission wasn't sanctioned by the U.S. government, super heroes are now seen by the public as having overstepped their bounds.

 - Inciting Incident: Congress passes the Superhuman Registration Act, requiring all super-powered beings to register and reveal their identities.

- Plot Point 1: The player is forced to choose a side—pro-registration or anti-registration—and fight in a super-powered civil war.

On a standard playthrough, this would encompass about two to three hours.

Spending this much time in Act I is very rare for most narrative-driven games, but it seemed to serve *MUA2* well, with reviewers describing the story elements as "gripping," "satisfying," and "one of the best stories from any superhero game in memory."

In the Middle of a *Tomb*

The developers at Crystal Dynamics, when creating the story for their popular and well-received 2013 reboot of *Tomb Raider*, attempted to find a way to have their cake and eat it too when it came to Act I.

Tomb Raider's opening cutscene reveals less than thirty seconds of Hero Lara Croft's normal world before introducing the Inciting Incident: the ship Lara's on runs aground and she barely survives the violent crash, ending up alone and afraid on an uncharted tropical island. Before she can react, an unknown attacker knocks her out from behind. She wakes up to find herself hanging her by her feet in a dingy cave, condemned to a slow death. By the time gameplay has begun, Lara's world has literally been turned upside down, and she's in a fight for her life.

As the player, within these first few minutes you've already crossed into Act II, having accepted the challenge of the main conflict: survive, find your shipmates, and escape the island.

However, over the course of *Tomb Raider*'s Act II, bits of the apparently absent Act I begin to emerge, via a series of video clips Lara plays while resting at campfires, thanks to her recovered camcorder. These short vignettes, fed intermittently to the player at lower-tension moments, help fill in the backstory and relationship development that in many tales would have come first. By the time you've completed Act II and its numerous, increasingly challenging missions, you've also been gradually fed a complete Act I.

This technique, called *in media res* ("in the middle of things"), is clever and effective, but hardly new. The fact that it's translated from the Latin indicates its age. Some of the primary examples of *in media res* are *The Iliad* and *The Odyssey*, dating back to the ninth century B.C. Starting a story *in medias res* and subsequently filling in backstory via flashbacks and other methods is a time-tested approach from traditional storytelling media that can also work very well in games.

The advantage of doing so is that you can grab the audience's attention with intense, dramatic action right off the bat and immediately hook them into the main conflict. A caveat, however, is that when you introduce the main conflict so early audience members might not yet care about the characters or understand what's at stake, since they lack full context.

Act I truncation aside, the rest of the Three-Act Structure matches up very well to the narrative structures that can and do work well in many games.

Other Game Formats

I'm often asked if the Three-Act Structure applies to narrative-rich games that don't adhere to the traditional story-based, single-player campaign that is seen in most console games and many PC titles. For example, what about MMOs (Massively Multiplayer Online games) such as *World of Warcraft* or *Star Wars: The Old Republic*?

If you've ever played an MMO for any length of time, you know there are some fundamental differences between that game genre and traditional video games. MMOs feature persistent worlds that don't stop or "pause" when you decide to suspend or end your play session. In an MMO you don't play as the main character; you are one of thousands of players simultaneously interacting with the virtual space. And there is no main conflict that you try to resolve to end the game. The game doesn't even *have* an ending—it theoretically goes on forever (or at least as long as it's profitable or feasible).

In an MMO, you're just another adventurer among many. There might be world-altering "events" that are staged by the game designers from time to time in which you can participate in some small way, but you will never be the central character of that world, nor the individual who resolves that world's singular conflict. So how can you be the Hero?

Looking at the entirety of a traditional, story-based video game, one can almost always see the touchstones of the Three-Act Structure: setup, confrontation, and resolution of a central conflict. But when you look at the enormous, endless sweep of an MMO, you won't readily see the Three-Act Structure, because you need to look more closely.

The Three-Act Structure does exist in MMOs, and as a player you will encounter it again and again, but on a much smaller scale.

Approach any quest-giver in any MMO and you'll find it. The quest-giver describes a conflict that needs addressing, and will ask you if you want to try to resolve it. Act I.

If you accept the quest, you then engage in gameplay that challenges you as you try to resolve the conflict. You might even have to succeed at multiple, "chained" quests of increasing difficulty before your work is done. Act II.

Once you complete all the quest requirements, you return to the quest-giver, who will confirm your success and grant you a reward of some kind (experience points, an item, etc.). Act III.

Not only are MMO quests clearly aligned with the traditional Three-Act Structure, but in these scenarios you are inarguably the Hero. Only *you* can

resolve this conflict! (Even if out of the corner of your eye you see other players busy working away on their personal versions of the same quest.)

Many MMOs also feature "instanced dungeons" (even if they are not truly dungeons), which take you and a limited number of other players into your own private version of a more lengthy adventure. These, too, very clearly feature the hallmarks of the Three-Act Structure.

Other nontraditional formats also feature the Three-Act Structure at a smaller scale. World-building social games such as *FarmVille* and *Clash of Clans* establish conflicts and challenge the player to overcome them to advance the games' admittedly light narratives. Episodic titles such as those developed by Telltale Games—*The Walking Dead* and so forth—are structured more like television dramas, with season-long arcs comprised of episodes each containing their own, smaller-scale conflict setup/confrontation/resolution cycles.

Final Thoughts on the Three-Act Structure

The Three-Act Structure dominates and defines the most popular stories told across the ages, and is sure to do so for the foreseeable future. Games are no exception to this rule. Of course, the scale and length of the Three-Act Structure within story-centric games may vary, but if there is indeed a predetermined story to be told, you'll find that in nearly every instance, the Three-Act Structure is there.

The Monomyth

Having now become familiar with the Three-Act Structure and the (perhaps surprising) reality that nearly all stories contain many of the same elements, you are ready to level up to the *Monomyth*, or "Hero's Journey." This is a more recent and more elaborate analysis of story that covers not only structure but also characters.

A Brief History

While the Three-Act Structure was first documented thousands of years ago, the Monomyth was conceived less than a hundred years ago by legendary American mythologist and writer Joseph Campbell, in his seminal book, *The Hero with a Thousand Faces* (1949).

Influenced mainly by the theories of Swiss psychiatrist Carl Jung, Campbell put forth the idea that many of our myths and modern stories incorporate certain recurring character types—or *archetypes*—that fulfill specific story functions and resonate with us all on a very deep level. Additionally, Campbell identified story beats that appear again and again in ancient as well as modern tales, laying out a more detailed shared story structure than the Three-Act Structure previously described.

These important concepts were positively received at the time, but they largely languished in academic circles for decades. They didn't really penetrate the public consciousness until the late 1970s, when George Lucas announced in interviews that he was heavily influenced by Campbell and *The Hero with a Thousand Faces* when developing *Star Wars* and its immediate sequels.

Screenwriter and film development executive Christopher Vogler later boiled the Monomyth down for fellow filmmakers in a seven-page memo

entitled *A Practical Guide to The Hero with a Thousand Faces by Joseph Campbell*, which ultimately led to the development of Disney's smash hit *The Lion King*. Vogler eventually expanded his memo into a full book, *The Writer's Journey: Mythic Structure for Writers*.

Today, the Monomyth is widely known and used on a daily basis by writers, editors, and other creative professionals working in movies, TV, novels, comic books, plays, and yes, games. If you're working with a game writer, it's very likely she'll be more than a bit familiar with it, and will probably integrate aspects of it into your game story.

The Monomyth is composed of two main elements: *archetypes* and *story structure*.

Archetypes

The core concept of the Monomyth is that of *archetypes*—a small group of highly resonant character types that we see again and again in myths and stories. According to Campbell, each of these archetypes represents one component of a human psychological profile—so that, combined, they represent a complete individual psyche.

The Hero starts the story in an incomplete state (since he is only one part of a complete psychological profile). By meeting and interacting with other aspects of human personality along the way, he learns from them—incorporating select elements into himself, while rejecting others—thus becoming more whole and fully realized as the story progresses.

There are seven archetypes, and most stories feature some or all of them. Archetypes are not always 100 percent matched to specific characters in the story, but rather they are roles, masks, or energies that any character in the tale can potentially take on at any time. Sometimes a character in a story will act like one archetype and then minutes later take on the attributes of a different one. It is not a strict one-to-one relationship—the point is that these character *types* tend to show up in almost all stories.

We'll cover the archetypes in the general order they're often encountered in a typical story. And for each archetype, we'll relate it to the video game context, as well as the most popular embodiment of the Hero's Journey: the original *Star Wars*.

1. Hero

This is our protagonist, and the main character we're either watching or (in a game) playing as. It is the only archetype that absolutely must appear in a story. More than any other archetype, the Hero is usually embodied in a single character consistently throughout the story.

The Hero's primary function is to resolve (or at least attempt to resolve) the main conflict. Other functions and/or aspects often seen in a Hero are audience identification, change and growth, action, risk, and sacrifice, all of which will be covered in more detail in chapter 4.

In *Star Wars*, the Hero is Luke Skywalker.

In the vast majority of video games, the Hero is the player character.

2. Herald

The Herald announces the main conflict, or at least its potential, to the Hero. Don't let the mythic, ancient-sounding title throw you—in modern stories this isn't a feather-capped, tights-wearing trumpeter who walks onstage bearing a scroll full of ill tidings. The means of communicating the Herald's vital, story-kickstarting message can be as modern as a TV news report, a phone call, a Web page, or a text message.

In *Star Wars*, R2-D2 is the Herald, carrying Princess Leia's urgent call for help to our Hero, Luke.

In video games, the Herald role may be filled by an NPC (non-player character) or by the UI (user interface) itself, or it may be absent entirely, especially when the player character is almost immediately and directly swept into the main conflict.

3. Mentor

As the name suggests, the Mentor is a teacher and an adviser. The classic Mentor character is older than the Hero, wiser, and perhaps in an earlier time could have actually been the Hero. Grey hair, beards, and robes are the classic physical attributes of a Mentor, though as with every archetype, modern versions can take many forms.

Mentor functions and roles include:

Teaching: This is the baseline of a Mentor character—offering important advice, knowledge, skills, and training the Hero will need to successfully resolve the main conflict and the many sub-conflicts along the way.

Sometimes a negative Mentor will offer bad advice, give poor information, or otherwise demonstrate to the Hero what she should *not* believe, do, or be. Despite their poor information, these Mentors can also be very helpful to the Hero, in their own way.

Gift Giving: In addition to information, a Mentor often bestows powerful gifts to the Hero to aid her in her quest. Again, this might sound mythical in tone, conjuring up images of magic swords and invisibility helmets—but instead think of modern-day equivalents such as a lightsaber, a combat training download for use in the Matrix, or any high-tech spy gadget Q has ever grudgingly entrusted to James Bond.

Motivation and Conscience: Mentor figures often provide not only the means for the Hero to resolve the main conflict, but the motivation to do so in the first place. As we'll cover later, some Heroes are less than enthusiastic about taking on the story's quest, and need a bit of convincing—up to and including a good kick in the pants! Mentors sometimes serve as a reluctant Hero's conscience, trying to convince her to do the right thing.

There is often a single character in a story who best embodies the Mentor qualities. However, because it's a teaching role and conveying information is a frequent and necessary occurrence in fiction, it's very common to see multiple characters acting as Mentors over the course of a story.

Mentor-like characters don't usually have very long lifespans, and they often perish or are gravely wounded well before the story is complete. This is another means by which the Hero's growth can be forced and demonstrated: at some point the Hero must persevere without relying on a parent-type figure to guide or support her. In other words, she has to grow up.

In *Star Wars*, Obi-Wan Kenobi is the character most closely associated with the Mentor archetype. Han Solo serves as a negative Mentor, offering opinions and advice to Luke that are ultimately rejected by the young Hero.

In video games, the Mentor role is often boiled down to its core essence: telling the player what he needs to do, and how to do it. It can be filled by a classic Mentor NPC, such as a squad leader barking orders in your earpiece, or by the game's UI itself.

4. Threshold Guardian/Henchman

The Threshold Guardian—or in modern parlance, the Henchman—does exactly what his classical name indicates: he blocks the progress of the Hero. Often working under the direct or indirect supervision of the Villain, Henchmen do a lot of the heavy lifting when it comes to providing sub-conflicts for the Hero to overcome on the way to eventually confronting the Villain and the main conflict he represents.

The Hero can't just immediately confront the Villain when the story starts. He must be tested by lesser villains—i.e. Henchmen—and learn from these experiences before he is ready for the final showdown with the main antagonist.

It's important to note that the Hero and/or his allies don't always *defeat* Henchmen. Sometimes Henchmen are worked around by convincing them to allow the Hero to pass, or to even change sides and become full-fledged allies!

In *Star Wars*, the Henchmen include Imperial Stormtroopers, the slimy dianoga lurking in the Death Star trash compactor, TIE Fighter pilots, and Darth Vader. Yes, that's right . . . Darth Vader is not the Villain, he's the main Henchman and enforcer of Grand Moff Tarkin, who commands the Imperial forces, including Darth Vader.

In video games, Henchmen are usually embodied by the seemingly end-less waves of nameless enemies a player confronts during gameplay, occasionally punctuated by a named "boss" or sub-boss.

5. Trickster

Even the most intense of story experiences benefits from the occasional moment of comic relief, and that's what the Trickster archetype brings to the table. Whether snarky, ditzy, clumsy, or flamboyant, a character embodying the Trickster archetype infuses comedy and lightheartedness when the story needs it the most.

Like the Mentor, this role can be taken up by a number of different characters during the adventure, but there is usually a single character who displays it most often.

In *Star Wars*, this role is most frequently embodied by C-3PO and R2-D2, with their metallic take on the classic straight man/funny man comedy team. However, Chewbacca, Han Solo, and Princess Leia also take short turns at playing the Trickster.

In games, the Trickster may be represented by a wisecracking companion character (Daxter from the *Jak and Daxter* games is a prime example) or even by the playable character himself (Nathan Drake from the *Uncharted* series, or Spider-Man in any of the Marvel games in which he's playable). However, in most games this archetype tends to be spread across many different characters at different points in the game.

6. Shapeshifter

Mistrust and misdirection are essential story elements used to keep the audience engaged and guessing what's going to happen next. The Shapeshifter archetype is specifically designed to stoke these fires of doubt and suspicion.

The Shapeshifter is a character about whom the audience isn't sure—someone who might be untrustworthy, who can't be relied on, who might betray the Hero and change sides at a moment's notice. Or vice versa—a Henchman who sees the error of his ways and decides to help the Hero, thus revealing that he's a Shapeshifter.

Shapeshifting characters are great catalysts for crucial story components such as surprises, plot twists, and red herrings. Without at least one Shapeshifter, your story may feel flat and bland.

In *Star Wars*, Han Solo serves as the main Shapeshifter. The audience isn't really sure of his true motivations or what he'll do next until that crucial moment when he saves Luke from Darth Vader and clears the way for the Hero to finally resolve the conflict by destroying the Death Star.

In games, Shapeshifters can appear as allies who later turn out to be enemies, or vice versa. It is difficult to name specific examples without spoiling the

stories, but I will say that players who have experienced the original *BioShock* should have no problem thinking of several Shapeshifter moments.

7. Villain

Colloquially referred to as the Villain, this is the head "bad guy" and the instigator behind the main conflict. Like the Hero, the Villain archetype is almost always embodied in a single character throughout the entire story.

We will cover the Villain character in more detail in chapter 4, but for now, sake of this initial overview, the most important thing to understand about the Villain is that he's the generator/defender of the main conflict, and that he exists to present the final challenge to the Hero. The conflict can't be resolved until the Villain has been dealt with.

In *Star Wars*, the Villain is Grand Moff Tarkin.

The Villain fulfills the same role in games as in other storytelling media: generate the main conflict and sub-conflicts, oversee and direct the actions of Henchmen, and (usually) confront the Hero directly to try to prevent him from resolving the main conflict.

Story Structure

Now that you've become acquainted with the Monomyth's seven archetypes, let's look at its story structure, which is more detailed than—but not incompatible with—the Three-Act Structure.

The Monomyth identifies twelve specific story beats or phases that tend to appear in most stories. Some exceptions aside, this is the order in which they will usually occur. We will once again use *Star Wars* as our movie example, and for games we will refer to the highly popular narrative-driven title *Uncharted 2: Among Thieves* (with apologies for multiple spoilers).

1. The Ordinary World

In this introductory phase, we get acquainted with the Hero in the context of her regular life, her Ordinary World. This is occasionally idyllic; however, more often it's livable but unbalanced. The Hero is familiar with and comfortable in this place, but yearns for something more and thus feels unfulfilled, unchallenged, and possibly even trapped. Again, this setup is common because it leaves room for improvement—both in the Hero and in the world from which she comes.

In *Star Wars*, we meet Luke on Tatooine, frustrated with his dead-end situation and yearning to join the Academy and have some adventures. He clearly feels trapped.

In *Uncharted 2*, this is the sequence following the opening tutorial mission in the snowy mountains—starting with the flashback cutscene on the

beach, through the next mission, and ending with Hero Nathan Drake being arrested after being double-crossed by Chloe and Flynn. Nate's life just isn't so hot right now, and he's literally trapped inside a seedy jail cell.

2. The Call to Adventure

This is identical to the Inciting Incident as described in chapter 1: the moment at which the Herald (if there is one) communicates the existence of the main conflict to the Hero. Even if the message is not overly specific, it's usually enough to get the Hero interested, intrigued, and/or concerned. And for the audience, it's generally clear from this point forward that the Hero will not be able to stay in the comfort of the Ordinary World for much longer. Trouble is brewing.

In *Star Wars*, Luke stumbling upon Princess Leia's recorded plea for help on R2-D2 is the Call to Adventure.

In *Uncharted 2*, Sully and Chloe present Nate with the Call in his jail cell, offering to bail him out in order to help them get the Cintamani Stone before Flynn and warlord Zoran Lazarevic do.

3. Refusal of the Call

Once the full scope of the main conflict is known, the Hero sometimes backs off, essentially refusing to take on the quest. This can happen for a number of reasons, but they tend to fall along the lines of "not my problem" or "can't be done." This is where a Mentor (or even the Herald) may need to press the Hero to convince her to commit to resolving the conflict. Or, circumstances may change in such a way that the Hero changes her mind and takes on the quest.

In *Star Wars*, this step occurs after the Meeting with the Mentor, when Ben Kenobi asks Luke to come with him to Alderaan. Luke, citing his family responsibilities, initially declines.

In *Uncharted 2*, Nate at first refuses to have anything to do with Chloe ever again, due to her previous, apparently traitorous turn, which helped land him in prison for three months.

4. Meeting with the Mentor

Sometimes in this early part of the story, the Hero will meet with a Mentor character, who—in typical Mentor fashion—will encourage the Hero to take on the quest, and may also bestow gifts on the Hero to help him along. These gifts may be physical items, training, teachings, or all of the above. If the Hero refuses the call, the Mentor will often work hard to convince the Hero to change his mind.

In *Star Wars*, Luke meets with Obi-Wan (Ben) Kenobi when the old Jedi rescues him in the Tatooine desert and takes him to his secluded home. There Ben tells Luke about Luke's family legacy, bestows a lightsaber on him, and asks Luke to help him rescue Princess Leia.

In *Uncharted 2*, the scene in the jail cell also constitutes the Meeting with the Mentor, as Sully—after giving Nate the gift of freedom by bribing the local police—helps convince him to join the quest.

5. Crossing the First Threshold

Identical to Plot Point 1 in the Three-Act Structure, this is the point at which the Hero finally commits to taking on the quest, and begins her journey to resolve the main conflict. From this moment forward it's usually made clear there is no going back, and at this point the story finally kicks into gear. At this crucial juncture, the audience has been primed with all the setup material it needs to understand what's at stake and to care about the characters involved . . . it's now "go time."

The Hero is entering unfamiliar territory—leaving the Ordinary World behind and entering what's known as the *Special World*. Here she will remain until she's resolved the conflict.

In *Star Wars*, this is the point at which Luke finds that his foster parents have been killed by Stormtroopers. He agrees to go with Ben Kenobi to Alderaan and help rescue Princess Leia.

In *Uncharted 2*, this step also occurs in the jail cell scene, as Nate finally agrees to join Sully and Chloe in their quest to beat Lazarevic to the Cintamani Stone. They all head to Borneo.

6. Tests, Allies, Enemies

This is the initial rising action described in Act II of the Three-Act Structure. The Hero encounters a series of increasingly challenging tests, while getting oriented to the Special World. Along the way he makes new friends and runs afoul of new enemies.

In *Star Wars*, this phase includes a number of events:

- The landspeeder scene in which Ben Kenobi uses a Jedi mind trick to get past the suspicious Stormtroopers

- The Cantina scene in which Luke is attacked and Ben steps in with his lightsaber, cutting off the attacker's arm

- Meeting Han Solo and Chewbacca and hiring them and their ship for a trip to Alderaan

- Escaping with the droids from Mos Eisley under Stormtrooper fire

- Getting to know each other in the ship's lounge area

- Ben training Luke regarding the lightsaber and the Force

- Emerging from hyperspace in a debris field instead of near Alderaan

In *Uncharted 2*, most of the game's missions from this point on constitute the bulk of this Test, Allies, Enemies phase, leading up to the moment that Nate, Chloe, and Elena are faced with the prospect of entering Shambhala.

7. Approach to the Inmost Cave

At a certain point the Hero (and possibly her allies), either willingly or unwillingly, approach the *Inmost Cave*—which is probably the worst place she/they could possibly go. This is the site of the resolution of a major conflict, perhaps even the main one—a rescue or other risky operation. It is not always a cave, of course, but it is often an imposing, threatening structure that it's clear would be difficult to enter and/or leave.

In *Star Wars*, this is quite literally a high-tech cave, as Luke and everyone else on the *Millennium Falcon* are dragged into the Death Star's hangar bay.

In *Uncharted 2*, this sequence is represented by Lazarevic forcibly leading Nate and his allies into Shambhala to help Lazarevic acquire the sap of the prehistoric Tree of Life and become almost invincible.

8. The Supreme Ordeal

Now in the "belly of the beast," the Hero fights to resolve the main conflict, under the most trying of circumstances. Stakes are high and death is on the line: literal death, the death of the quest, or both. Despite overwhelming odds, the Hero does everything he can to directly resolve the conflict.

In *Star Wars*, this is the entire sequence inside the Death Star, from sneaking off the *Falcon* to the rescue of Princess Leia from her prison cell—including being literally trapped in a high-tech version of the belly of a beast: inside the dank, stomach-like trash compactor.

In *Uncharted 2*, the Supreme Ordeal kicks off when the half-dead Flynn detonates a grenade, killing himself, seriously injuring Elena, and leaving Nate to deal with the super-powered Lazarevic on his own.

9. Reward

Having successfully come through the Supreme Ordeal, the Hero now "seizes the sword"—acquiring what she was after and/or accomplishing what she originally set out to do. The reward for all her training, hard work and risk-taking is now in her grasp.

In *Star Wars*, this is the successful rescue of Princess Leia, culminating with the destruction of the pursuing TIE fighters and the escape into hyperspace.

In *Uncharted 2*, this phase is achieved when the player (as Nate) manages to defeat Lazarevic.

10. The Road Back

Despite the Hero's incredible accomplishment, total victory has not yet been achieved . . . and dark forces are now fully mobilized. The Hero must escape the pursuing enemy/enemies and return to the Normal World with his prize.

In *Star Wars*, the Road Back is represented by the flight of Luke, Leia, and their allies to the Rebel base, and the Rebels' hurried preparations to attack the Death Star, while the Empire advances on their vulnerable position.

In *Uncharted 2*, Nate (and the player) must literally run along the Road Back as the city and its roads collapse under his feet.

11. Resurrection

During this final conflict between the Hero and Villain/Henchmen, there comes a moment when all seems lost; when death—or at least the death of the Hero's quest—seems to have actually happened. We are made to believe, if only briefly, that the Hero has been defeated and has possibly even died. However, through a surprising turn of events, the Hero (and/or her quest) is "resurrected," giving her one final chance to resolve the conflict—which she does, spectacularly.

In *Star Wars*, this is the moment at which Luke seems about to be killed by Darth Vader during Luke's trench run. The Sith Lord even says, "I have you now," and we can see on Vader's scanner he's got Luke dead to rights. But Han Solo and Chewbacca swoop in at the last moment, throwing Vader off course and clearing the way for Luke to fire his torpedoes and destroy the Death Star.

In *Uncharted 2*, the Resurrection occurs in a cutscene, when Nate attempts to make a clearly impossible jump across a crumbling gap, and is surely about to fall to his death—at which point Chloe miraculously manages to catch him by the arm and help haul him to safety.

12. Return with the Elixir

With the main conflict resolved, the Hero's path is now clear to return with his boon to the Ordinary World, which is changed and improved thanks to the Hero's brave actions. Rewards and punishments are doled out to any characters to whom the audience has developed any attachment—generally, "good" characters are rewarded and "bad" characters are punished. At this point, with the conflict resolved, the Hero has grown and everyone has gotten what they deserved—the story ends.

In *Star Wars*, this sequence is represented by the awards ceremony, with Luke and Han Solo being rewarded with medals, C-3PO receiving a polish, and R2-D2 revealed as being fully recovered following his ordeal. Luke and all his allies bask in thunderous applause from the Rebels—who have struck a devastating blow to the Empire—providing a strong sense of closure.

In *Uncharted 2*, this phase takes place in an extended closing cutscene, in which we see that Elena has recovered, her relationship with Nate is being rekindled, and that Sully—dirty old man that he is—might actually have a shot with Chloe. Most important, of course, the world is safe because Lazarevic has been stopped.

Final Thoughts on the Monomyth

The Monomyth is a very well-documented and much-discussed theory of story. A simple Web search for "Monomyth" or "Hero's Journey" will yield potentially overwhelming results for anyone interested in digging deeper. Writers, editors, and story analysts have generated Monomyth evaluations of countless movies and books, endlessly demonstrating the versatility and pervasiveness of these elements in the stories we've all experienced.

From a game developer's point of view, familiarity with the Monomyth can only make one a more complete storyteller. It will not magically turn you into a professional writer or story editor, but your interactions with such experts will probably go a lot more smoothly with this common frame of reference.

For many writers, myself included, the Monomyth is not a template used to create a story from scratch. It's more of a checking tool, to be employed when something doesn't feel quite right about a story in progress. Perhaps upon reflection I'll realize there is no strong Mentor; perhaps there isn't enough difference between the Ordinary and Special Worlds; maybe I skimped on the all-important succession of Tests, Allies, and Enemies.

There are no guarantees in fiction development any more than there are in game development. A few of our most treasured stories eschew much of the Monomyth, and some absolutely horrible tales have clung to it beat for beat. Understanding the reality of the structure is just a small (but important) step along the way to becoming a better storyteller.

Characters and Arcs

Through our exploration of the Three-Act Structure and the Monomyth, we've already touched on the topic of *characters*. In this chapter we'll take a closer look at the two most important characters in any story—the Hero and Villain—and also cover the concept of *character arcs*.

The Hero

There is no character more essential to your narrative than your Hero. In fact, as previously mentioned, the Hero is the only archetype that *must* be present in every story.

Heroes share attributes with other character types, but their core, signature hallmarks include audience identification, change and growth, action, personal stakes, risk, and sacrifice.

Audience Identification

The Hero is the person we follow, the character whose eyes we see through, and in whose shoes we walk. The better we as the audience can relate to him, and the more sympathetic we are to his situation, the stronger the emotions the story can potentially elicit from us. The Hero is, for all intents and purposes, us. And in a properly constructed story, we very strongly *identify* with him.

In games, the player almost always takes on the role of Hero. Because of this, identification with the Hero is even more crucial than in other storytelling media. After all, you aren't just watching or following the Hero; you inhabit the character's body, controlling him not unlike the way you control a car.

In his seminal nonfiction graphic book *Understanding Comics*, Scott McCloud points out that when a person drives a car he considers the vehicle to

be an extension of his own body. If someone bumps his vehicle from behind and you ask him what happened, he won't say, "That jerk's car hit my car!" He'll say, "That jerk hit me!"

This happens in games, too. When you're playing *Tomb Raider* and you see your avatar Lara Croft fall to her death, you don't say, "Dammit, she fell." You say, "Dammit, I fell." You're not just following the Hero—you *are* the Hero.

But it goes even further than that. While a player avatar is a vehicle of sorts, it is much more than a car. It's a character, a person, with opinions, desires, and intentions. And if those character traits put him at odds with the desires and intentions of the player, it can generate *ludonarrative disso-nance*: an uncomfortable contradiction or disconnect between the player, the game design, and/or the narrative elements.

The dissonance may come from the narrative depiction of the main char-acter not being consistent with what that character actually does in gameplay. Or it may result from the player's desires and the player character's desires (or required objectives) being at odds.

A hypothetical case of ludonarrative dissonance would be a standard mili-tary first-person shooter game design paired with a narratively pacifistic player character. The player who picks up a military FPS *wants* to shoot enemies, and plenty of them. That's why he bought the game! If the character controlled by the player does *not* want to shoot anyone, the result will be either a glar-ing contradiction (the player is allowed to shoot despite the character's stated moral code) or frustration (if the player is blocked from shooting due to the character's pacifism).

On the opposite end of the spectrum, an excellent case of player/avatar desire alignment would be a situation in which the enemy has frustrated or angered the player character and the player at the same time, causing them both to want payback. A good example of this is in the opening playable sequence of *Half-Life 2*. In this legendary first-person shooter, prior to being given any ability to shoot or otherwise attack an enemy, the player/avatar is barked at and condescended to by various Combine guards. One of them even knocks a soda can to the ground and then orders the player to pick it up— which the player must successfully accomplish in order to progress, cleverly integrating a simple tutorial on how to pick up items in the game.

By the time the player finally gets a hold of a weapon, he—like the player character Gordon Freeman—almost surely loathes the Combine guards and can't wait to mow them down with extreme prejudice. The narrative and game design conspire at that moment to create a situation where Gordon/the player has every reason and opportunity to do just that. And *voila*, we have payback and some very satisfying ludonarrative harmony.

So again, what the Hero wants and what the audience wants should be as closely matched as possible. Otherwise why would we be rooting for him?

Identification with the main character and alignment of desires is important in all stories, but especially in games.

Change and Growth

The Hero usually starts the story in a state of dissatisfaction, formlessness, and/or incompleteness, and during the course of events is changed and grows to a more satisfied, evolved, and/or complete state.

Luke Skywalker is of course an obvious example that jumps to mind, but there are countless others. Think of your favorite movie heroes and look at their situations and emotional states when we first meet them. The frustrated, desk-bound Mr. Incredible in *The Incredibles*; the aimless, irresponsible Neo in *The Matrix*; the trapped, cowed, and suicidal Rose DeWitt Bukater in *Titanic*; even the bland, lonely Sarah Connor in *The Terminator*.

In fact, pick three of your favorite stories. How many featured Heroes who were fully satisfied, fulfilled, and complete before the onset of the main conflict? It's not unheard of, but more common is the Hero with plenty of room for improvement.

Of course, the Hero isn't the only character who changes over the course of a story. But in general she's the one who experiences the *most significant* growth. In fact, if you're ever unsure of who the Hero of a particular story is, look for the character who *changes* and *grows* the most. That's probably your Hero.

In games, it is common (and something of a no-brainer) to demonstrate main character growth not only through the story but also, at the same time, through game mechanics and systems. After all, what is more obvious an improvement to a character than "leveling up"? Happily, many game genres have character growth built right in! It's important to try to sync the narrative growth of the character with increases in that character's power, abilities, and standing.

Action

In attempting to resolve the main conflict and its resulting sub-conflicts, the Hero must take *action*. A compelling Hero not only reacts to what's happening around him, but he proactively works to resolve the conflict. Taking action is a defining element of an effective Hero, and without this attribute in your Hero you're going to have a limp story and a frustrated audience.

You might think that because in games the player controls the Hero, and that gameplay generally equals action, that this isn't as big a consideration for the medium. But that assumption would be incorrect.

Story provides the *why* of gameplay situations, and if the Hero's response is always to react to outside forces and never to attempt to proactively address the problem, the player will respond the same way any audience does to a passive or purely reactive Hero: with frustration.

Personal, Primal Stakes

What's at stake and why should I care? This is the question the audience is silently asking at all times regarding your story. It's your job as a storyteller to engage the audience and make them care what happens.

It's hard to overstate the importance of this. No one has a gun to your audience's head. They can walk away from your story at any time if they wish. Keeping them involved largely means keeping them caring.

What does this have to do with the Hero? The audience's main "in" is through the Hero. They need to care deeply about either the Hero herself, or whatever it is the Hero's resolution of the conflict will benefit. Or both.

The way it often looks is: Player cares about Hero. Hero cares about X. Player therefore cares about X. Consider it the literary equivalent of the mathematical transitive property of equality (if A=B and B=C, then A=C).

If the audience likes the Hero and roots for her, and she desperately wants or needs something in order to be happy/healthy/satisfied, then the audience very much cares about her getting that thing or accomplishing that goal. They are invested.

So, for the audience to care, the Hero needs to care. And it can't just be an academic, dry, or sterile brand of investment. It needs to be something primal. Life, death, health, family, love, sex—these are the kinds of connections and stakes that resonate most strongly with audiences.

Aliens (1986) is a great example of this principle. The Hero—Ripley—is a character most audience members immediately care about and want to follow. But what does *she* care about? Ripley is initially motivated by a chance to re-qualify to work on a ship again, but this isn't a goal that the audience can really relate to on a core level. Later on, Ripley (and a good-sized group of other characters) are confronted by aliens, and while Ripley does care about all of their welfare, it's very clear that the young orphan Newt is the one about whom Ripley is most concerned.

On a very primal level, Ripley has effectively adopted this child as her daughter (making it a family connection) and will do anything to defend her life (making it a life or death situation). It is no accident that when Ripley has finally saved Newt from the ultimate threat, resolving the conflict, Newt runs into Ripley's arms and cries, "Mommy!" Nearly everyone in the audience can relate to feeling protective of a child who's in mortal danger, even if few of them have ever actually experienced that situation.

This same technique has been used in video games, with a prime example being Telltale Games' excellent *The Walking Dead: Season One*. Playing as ex-college professor and convicted murderer Lee Everett, the player is thrown into a zombie apocalypse and soon happens upon a scared and lonely eight-year-old girl named Clementine. The rest of the game, the player (as Lee) is singularly concerned with getting Clem to safety. It's powerfully effective.

This transitive property also gives the writer the flexibility to feature a Hero who is thoroughly unlikable and largely unrelatable. The audience can still be emotionally engaged as long as they are made to care about what that Hero cares about. Conversely, audience members might have little sympathy for the Hero's cause, but if they care about the happiness and well-being of that Hero, it won't matter.

So, in the case of *Aliens*, maybe you don't really like Ripley that much, but you feel very protective of Newt and want to see her survive. Or, maybe you're a Ripley fan but find Newt annoying and wish she'd just stop screaming. Either works. As long as you care deeply about at least one of these two things—Ripley's happiness or Newt's survival—you will engage with the story and be emotionally invested in its outcome.

As we covered in chapter 1, it's not the size of the stakes that matter when it comes to emotional involvement of the audience. As stakes pertain to the Hero, the bottom line is that the Hero needs to care on a personal level in order for the audience to do the same.

Risk and Sacrifice

Being a Hero involves a willingness to take risks—usually big ones, with stakes that are intensely personal to the Hero—and being willing to face the consequences of failure.

Why is this risk-taking such an important part of being a Hero?

Captain Kirk, at the Plot Point 1 moment in an otherwise mediocre episode of the original *Star Trek* entitled "Return to Tomorrow," makes an impassioned and memorable speech to his command crew as they debate taking a risk:

> They used to say if man [was meant to] fly, he'd have wings. But he did fly. He discovered he had to. Do you wish that the first *Apollo* mission didn't reach the moon? Or that we hadn't gone on to Mars, and then to the nearest star? Risk! Risk is our business. That's what this starship is all about. *That's why we're aboard her.*

He's talking about the *Enterprise*, but in reality, Captain Kirk—a classic Hero figure if ever there was one—is putting into words the fact that risk is what *being a Hero* is all about.

The Hero exists to resolve a conflict, yes, but if he does so at no personal risk to himself or anything he cares about, then nothing is really at stake. The story will lack drama, and the audience is unlikely to be engaged at any level but the most superficial.

Risk-taking can include the Hero making (or clearly being willing to make) huge personal sacrifices in the name of resolving the conflict or helping/protecting those he cares about.

Again, think of Ripley and Newt from *Aliens*. There is a point in the story at which Ripley could safely leave the alien-infested colony on planet LV-426, but she knows that Newt is still somewhere in the complex. Ripley decides to risk her own life to go back in and try to rescue her surrogate daughter. This is classic Hero behavior.

Sometimes a Hero's risk-taking ante is upped by giving the Hero a weakness, fear, or other handicap that makes success that much harder. The classic example is the normally fearless Indiana Jones and his snake phobia. Alfred Hitchcock's *Vertigo* features a Hero who is terrified of heights but must conquer that fear in order to resolve the conflict. And in *Who Framed Roger Rabbit?*, private eye Eddie Valiant, in order to resolve the conflict, must overcome his paralyzing fear of Toontown (where his brother was killed by a homicidal cartoon character).

Inherent to the concept of risk is that of sacrifice. There is a danger of losing something important with every risk a Hero takes, and sometimes things don't go the Hero's way. Even if the conflict is successfully resolved, sometimes the Hero pays a terrible price, occasionally even the ultimate one. Audiences, aware of this, can be made to legitimately worry for the fate of the Hero—a huge part of keeping them engaged and wanting to see how things turn out.

In games, of course, the heroic elements of risk and sacrifice are seen through a different lens: the player's. It is rare that the player has any true fear of forging ahead in a game, because ultimately his own life is not really on the line. This is another example of ludonarrative dissonance, and one that is difficult to completely overcome. It's the reason why in games you rarely see the Refusal of the Call—Heroes can be reluctant, but players rarely are.

There are ways to bridge this ludonarrative gap, however. While a player may not share with his avatar a true fear of being in danger, the game design can be structured in such a way that something the player has worked to build up or find within the game space is put at risk. "Rogue-like" games are built on this foundation of player risk and sacrifice, and while games such as these can be exhilarating, they can also be frustrating and are certainly not for every player. Your design need not be quite so punishing, but putting at least something the player is likely to treasure on the line can help harmonize the player character's sense of risk-taking with that of the player himself.

Final Thoughts on Heroes

There are all kinds of Heroes, but they tend to have certain things in common. Once again, this list includes:

- Having desires and goals the player can *identify* with
- *Changing* and *growing* over the course of the story

- Taking *action* to resolve the conflict

- Taking personal *risks* for *stakes* that are equally personal

- Being willing to *sacrifice* it all

It's possible—and in fact desirable—to leave some of the specifics up to the player while still staying true to the core essence of what it means to be a story's Hero.

The Villain

Villain, Shadow, bad guy, antagonist, adversary—whatever term you prefer, he's present in most stories in one form or another. Every story needs a conflict, and that conflict usually stems from a specific, motivated source—the Villain.

The impressiveness of a story's Villain has a huge bearing on the overall quality of the story and the audience's estimation of the Hero. A two-dimensional, poorly realized antagonist can do enormous damage to an otherwise well-constructed tale. Conversely, a vividly conceived, memorable Villain can catapult your story into the stratosphere. As a storyteller it's important to invest at least as much time conceptualizing and characterizing your "bad guy" as you would your "good guy."

What are the essential elements of a well-designed, effective and modern Villain?

Viable Challenge

The core function of a Villain is to generate the main conflict, either directly or indirectly, as part of a larger goal. Most Villains don't just wander away after they create the conflict, allowing the Hero (or whoever) to undo what they've done. They remain in the picture, either standing by ready to thwart anyone who tries to interfere, or actively continuing to move things down a negative (to the Hero) path.

So, the Villain needs to present a viable challenge to the Hero. We must take her and the threat she represents seriously, and not only for the sake of the plot. The Hero's impressiveness to the audience is based in part on our assessment of what she's up against. During my time working in the Marvel Comics editorial offices, one of the catchphrases I learned was, "Weak villain equals weak hero." It just doesn't say much for the Hero when we don't believe she's in over her head.

For example: I'm a big Boston Red Sox fan, a fact to which my family members will attest based on the enthusiastic cheers and anguished groans they hear while I'm watching a game. That's because I'm rooting for my team (my Heroes, if you will) and I care what happens.

But what if the Red Sox were playing against a Little League team? What if my favorite club scored 30 runs in the first inning while going through every

A Note on Antiheroes

All the attributes mentioned in the previous sections with regard to a Hero apply as much today as they did hundreds if not thousands of years ago. However, Heroes themselves have changed quite a bit in that span of time.

The last century or so, in particular, has given rise to Heroes who are not exactly squeaky-clean, Dudley Do-Right types. With audiences increasingly savvy and perhaps a bit more jaded, many Heroes have changed to match some of those cynical expectations. Called *antiheroes*, they are seriously flawed, often unsociable and unfriendly, and sometimes don't appear very "heroic" at all, demonstrating few of the traditional ideals such as nobility, politeness, patience, humility, and restraint.

In fact, these rough-around-the-edges figures can appear almost indistinguishable from Villains at times. Their goals may be laudable, but the means they're willing to take—while not generally outright evil *per se*—can be questionable and sometimes brutal. Still, they tend to clearly have a "heart of gold" lurking under their less-than-cuddly exteriors. This, combined with positive goals with which the audience is enthusiastically on board, and adversaries who are much, much nastier than they, ensures that we still root for them.

Clint Eastwood's Man With No Name, the X-Men's Wolverine, and Ash from the *Evil Dead* films are all good antihero examples from movies. In games, we can look at Marcus Fenix from *Gears of War*, John Marston from *Red Dead Redemption*, the eponymous player character of the *Duke Nukem* games, any of the playable characters from the various *Grand Theft Auto* games . . . along with many, many others. Antiheroes work particularly well as playable characters in games, given the massive body counts they tend to rack up. Including one helps ludonarrative harmony (brutal antihero character coupled with brutal, deadly gameplay) but has become so commonplace it's pushed the playable antihero to the edge of cliché.

pitcher the kids could put on the mound? I can't say I'd be very interested; in fact, I'd probably start rooting for the Little Leaguers, until finally turning the "game" off in disgust after an inning or two.

Why? Because though my Heroes would be playing to the best of their abilities—just as they always do—they wouldn't be up against a worthy adversary. So, I would lose respect for them, and more important, I'd lose interest in the game.

Furthermore, in this hypothetical situation I would begin rooting for the Little Leaguers, because they were so badly outmatched. Remember, audiences—especially American audiences—love an underdog. So, the ideal Villain isn't just a match for the Hero, she's *more than a match*. This instantly transforms the Hero into an underdog—all the more likely to be rooted for by the audience, and ensuring a final victory that's even more impressive.

This rule holds true for Henchmen too, by the way, though to a somewhat lesser degree. Henchmen should be a strong challenge for the Hero, while the Villain should represent the ultimate opposition, seemingly beyond what the Hero is capable of defeating. Bottom line: the strength of your Hero is largely defined and measured by the threat level of your Villain and his Henchmen.

Speaking of whom . . .

Blocked by Henchmen

You don't generally get to start a video game by jumping straight to the final boss battle. You have to work your way up to it, dealing with multiple lesser enemies and obstacles over the hours of play time, before you've earned the right (and learned the moves!) to challenge the Villain himself.

The Villain is generally outside the reach of the Hero's grasp for most of the story. Henchmen provide interim challenges for the Hero, with perhaps a brief interaction between Hero and Villain early on to demonstrate how much farther the Hero has to go before being ready for a real confrontation. But always keep in mind, the ultimate conflict between Hero and Villain is something the audience looks forward to, so don't miss the opportunity to build their anticipation for it.

Desire and Motivation

One of the traps writers often fall into with a Villain is to not really think the character through beyond a very superficial level—resulting in a two-dimensional, obstacle-generating plot device, instead of living, breathing character with wants, desires, and plans of his own.

It is backwards to decide what obstacles you want the Hero to overcome, then simply have "the bad guy" conveniently throw those particular obstacles into the Hero's path. As with all characters, you must instead start with this question: what does this person (the Villain) want or need?

Desire drives everything a person does, and if you want characters whose actions ring true with how people really behave, they must also be driven solely by their desires. This is why actors stereotypically ask their director, "What's my motivation?" Without that information, there's no way to know how to act.

The audience needs to comprehend what the Villain wants and be able to understand and, on some level at least, appreciate that desire. This doesn't mean the Villain can't want something bad or that the audience has to agree with it. It just needs to make some kind of (possibly twisted) sense. At the heart of every Villain's motives, there is usually a kernel of something that is theoretically good, or at least that the audience can relate to.

In movies:

- *Aliens*: The Alien Queen wants her offspring to thrive and will fight to protect them.

- *The Godfather*: Don Emilio Barzini wants his family to prosper.

- *Watchmen*: Ozymandias wants to save humanity from self-destruction.

- *Monsters, Inc.*: Henry Waternoose wants to save his company from bankruptcy and prevent an energy crisis.

- *Star Trek: First Contact*: The Borg want to integrate other cultures and strive for perfection.

- *Superman* (1978): Lex Luthor wants to be rich and own beachfront property.

And in games:

- *Injustice: Gods Among Us*: Alternate-reality Superman wants to keep everyone safe.

- *Ratchet & Clank Future: A Crack in Time*: General Azimuth wants to retroactively prevent the near-extinction of a sentient race.

- *Infamous 2*: The Beast wants to save superhumanly powered Conduits from a deadly plague.

None of these desires, isolated like this, are inherently evil. What makes a Villain "bad" is what she is *willing to do* on the way to achieving her desires— whom she is willing to hurt or even destroy in order to get what she wants.

Once you've decided *what* your Villain desires, you can then focus on *how* she intends to get it.

Man with a Plan

A well-conceived Villain is no dummy, and should have concrete plans for getting what he wants. These schemes need to hold up under at least a decent amount of scrutiny. The Villain's plan must have an internal logic—it shouldn't be just a random jumble of obstacle-generating actions. That's lazy and incoherent storytelling.

Let's look at Grand Moff Tarkin, the Villain from *Star Wars*. We'll start by identifying his desires. As an arrogant, power-hungry, authoritarian military leader, Tarkin is motivated to continue to increase both his own power and that of the Empire he serves. The Death Star is a means to that end, a dreadful weapon that can be used to bring any rebellious factions into line, or to simply obliterate them. As the Death Star's commander, Tarkin is exceedingly proud of his new baby.

When word gets out that the Rebels have obtained schematics that could threaten the Death Star (and thus his and the Empire's power), he aggressively moves to find and retrieve the plans. After his Henchman Darth Vader brings the suspected Rebel Princess Leia before him, Tarkin is determined to wring the information out of her by any means possible. He threatens to destroy her home world of Alderaan unless she reveals the location of the Rebel base, where he believes the plans to be. And even when she tells him where the base supposedly is, he destroys Alderaan anyway.

Why? Not simply because he's a bad guy. He even explains his thinking: "No star system will dare oppose the Emperor now." Every action Tarkin takes in the story makes sense from his point of view and is a reflection of his character: his desires, his plans, and even his personality traits. He reacts to the evolving situation, and continually updates his moves accordingly.

Even Tarkin's single (but fatal) mistake feels completely in character for him. Given the chance to escape the Death Star during the Rebels' attack on it, he rebuffs the offer due to his pride: "Evacuate? In our moment of triumph? I think you overestimate their chances!"

It can still surprise me when I come upon a story in a Hollywood movie or a bestselling novel in which the writer clearly hasn't thought the Villain through to any real extent. It's not that hard to check your Villain's actions to make sure they hold together. Every time you decide to have the Villain do something, ask yourself:

- What does this Villain want?

- What is his plan for getting it?

- Does this current action jibe with the previous two answers? Does it seem to be part of an evolving plan?

- Does it make sense? Is it believable?

- Does it make him look smart, stupid, or just random?

For every action the Villain takes, the answer to "why did he do that?" cannot be simply, "Because he's evil." It must be, "Because he wants [this]."

Thinks He's Good

There was a time of simpler storytelling when Villains twirled their moustaches, tied damsels to train tracks, and proudly proclaimed their evilness. Ah, the bad old days!

On the cover of *X-Men* #4 back in 1964, Magneto and his allies proudly proclaimed themselves "The Brotherhood of Evil Mutants." And to comic book readers of the 1960s, the name of this new super-villain group raised no red flags. Cackling, hand-wringing, self-identifying evildoers were perfectly believable in that era and to that audience.

The days of self-proclaimed villains are long gone. Modern audiences are savvy enough to understand that in the real world, no one acts that way. And that's because in the real world, *no one thinks they're evil.*

Forty years later in the film *X-Men: The Last Stand*, when it came time to introduce Magneto's assembled villains to movie audiences of 2006, there were a number of changes made—including the group's name.

They simply called themselves "The Brotherhood."

A small change that made a big difference! Removing just three words makes it clear that this organization sees itself in a positive light, as a family. The super-villain team instantly feels many times more believable.

And if the movie writers had retained the original name? Can you even imagine Sir Ian McKellan (as Magneto) uttering, "The Brotherhood of Evil Mutants" with a straight face? It would have felt off-tone, and possibly produced some unintended guffaws.

The self-identifying evil Villain has become so laughably passé, in fact, that it's now a character that tends to be found only in the arenas of comedy and parody. In the *Austin Powers* movies, for example, much of the humor stems from the main Villain, Dr. Evil—a parody amalgam of several James Bond criminal mastermind characters from the 1960s. Dr. Evil laughs maniacally, wants to take over the world, and insists on being called Dr. Evil (rather than Mr. Evil), citing the long years he spent at Evil Medical School. When his long-lost son reveals he's hoping to become a vet someday, Dr. Evil wistfully asks, "An evil vet?"

The word "evil" itself has become a punch line.

So, unless you are purposely going for cliché or comedy, your Villain must not self-identify as a Villain. The one-dimensional antagonist of old has been replaced by a more nuanced, more believable and frankly much more frightening modern incarnation . . . the Villain who thinks he's a Hero.

Villain as Hero

As discussed, modern, three-dimensional Villains don't consider themselves to be evil, or even Villains. They think they're good. They believe they are right.

And this, by the way, doesn't just apply to Villains. *Every single character* in a well-told story feels justified in their beliefs and actions. Everyone does what they have convinced themselves is the "right" thing to do, and they will have reasons to back up their positions. After all, what can be most terrifying about human beings is our ability to rationalize just about any belief or action.

In fact, more than just thinking he's good and right, the Villain is actually the Hero in his version of the story. He faces his own conflict (usually embodied by the Hero and the Hero's allies) and fights to overcome these threats to his own goals, happiness, and/or fulfillment.

During my GDC tutorials, one of the exercises that attendees say they find most interesting is one in which I ask them to take one of their favorite stories, and write up a first-person synopsis of the entire narrative from the Villain's point of view. With well-written Villains, it's amazing how easy it is to see their perspective, and to even start to take their side a bit. Try it yourself sometime!

This isn't just an academic exercise I reserve for when I'm lecturing. It's something I do, at least in my head, when I write. And not just for Villains—for every major character. The story, when seen from any character's point of view, should still hold up.

Growth and Change Optional

Unlike the Hero, who has a defining characteristic of changing and growing over the course of the story, the Villain may or may not go through any such metamorphosis. In fact, what makes a character a Villain instead of a Hero can be something as simple as an inability or outright refusal to change her views or to grow out of a negative emotional state such as hatred, jealousy, or vengefulness.

Occasionally a Villain sees the light and ultimately transforms into a heroic figure, or at least moves a bit more down that path. Most times, though, she remains bad to the finish, often ending up punished, consumed, and even destroyed by her own negative intentions and actions. This can reveal another purpose of the Villain (in addition to generating the conflict and opposing the Hero), serving as a cautionary figure for the audience.

Directly Confronted

While for much of the story the Villain is protected by Henchmen, by the story's climax the Hero must have the opportunity to directly confront the Villain, who very often represents the final obstacle to resolving the main conflict. The audience has been itching for this throughout the story, and if you don't eventually pay it off, it can be quite a letdown.

Every rule has its exceptions, of course. Luke Skywalker and Grand Moff Tarkin don't meet each other in *Star Wars*. And in *Star Trek II: The Wrath of Khan*, Kirk and Khan are never in the same room or even on the same ship— all their verbal interactions occur across a viewscreen. (Though it can and has been argued that their respective ships, battling back and forth, represent physical stand-ins for the Hero and Villain themselves.)

In a game, it's almost non-negotiable that if you've established a solid Villain, the player must eventually be given the chance to directly defeat him, and in as cathartic and satisfying a way as possible.

Final Thoughts on Villains

One last observation regarding the Villain: not every story has a Villain, or at least not necessarily a character who embodies the Villain energy. But there is always some source or cause of the main conflict.

Sometimes it's nature (like in *Twister* or *The Poseidon Adventure*). Occasionally it's an animal or creature motivated only by instinct (*Jaws*, *Cujo*). And sometimes the source of the main conflict is something within the Hero himself—a destructive element of his own personality that blocks him from fulfillment and happiness (*Sideways*, *The 40-Year-Old Virgin*).

But story-driven video games almost always feature a character who embodies the Villain role, since games are generally about physical conflict as opposed to those stories that are purely emotional or psychological.

Character Arcs

Heroes aren't the only characters who confront conflicts over the course of a story; nor are they the only ones who change and grow. The confrontation of a conflict and the potential resulting change in a character and/or his situation is called an *arc*.

The most obvious and dramatic character arc in any story almost always belongs to the Hero. As already covered, the Hero's change and growth—his arc—is a defining characteristic.

The story's *plot* and the Hero's *arc* are rarely the exact same thing, but are almost always inextricably entwined. Going back to the classic example of *Star Wars* and its Hero Luke Skywalker:

Plot

- A repressive galactic empire is kidnaping princesses, destroy-
 ing planets, and seeking to crush the freedom-loving Rebels who
 oppose it.

- A Force-sensitive farm boy and his allies fight to rescue the princess, escape with crucial military plans, and attempt to deal a major blow to the Empire by destroying their fearsome new weapon.

- The Death Star is destroyed and the Rebels live to fight another day.

Hero's Arc

- Young Luke Skywalker, a farm boy who dreams of being a heroic space pilot, feels trapped by circumstances on a dusty planet at the edge of the galaxy.

- Luke is swept up in an adventure that forces him to interact with colorful and dangerous characters, learn about the Force, and take enormous risks to help others.

- Luke destroys the Death Star, and is now clearly no longer a boy but a man.

Note that both plot and arc are structured with a beginning, middle, and end—setup, confrontation and resolution—just like the Three-Act Structure.

Arcs apply to all major characters in a story. The most compelling ones chronicle a deep change in a character's values, in what he stands for, and who he is. These can be called *growth arcs*. This is the kind of arc we expect to see in a Hero, for example.

But even if a major character doesn't change or grow as a person over the course of the tale, it's likely his situation does. We can refer to these as *circumstantial arcs*.

Each arc includes a beginning point (who is this character and what is his situation when we first meet him?), a middle point (what happens along the way?), and an end point (where does this character and/or his situation end up?). Let's look at two more character arcs from *Star Wars*.

Obi-Wan Kenobi's Arc

- Obi-Wan is a powerful Jedi in hiding, considered by the local population to be a crazy old hermit.

- After seeing Leia's call for help, he decides to leave his exile and begin training Luke in the ways of the Force. He ultimately sacrifices his life to allow the others to escape.

- From beyond the grave, Obi-Wan guides Luke and helps him destroy the Death Star.

Han Solo's Arc

- Han Solo is a self-assured, self-centered smuggler who relies on and believes in just one thing: himself.

- Han sees Luke, Obi-Wan, Leia and others taking huge risks and making sacrifices for each other and for the greater good.

- Han chooses to help his new friends rather than see to his own interests, demonstrating that he has grown from a simple scoundrel to a heroic figure in his own right.

As you may have noticed, these two arcs are of different types. Obi-Wan experiences a change of circumstances: he goes from seemingly inconsequential hermit to ghostly facilitator of the Death Star destruction. But his core attitudes have not really changed—just his situation.

Han Solo's journey, on the other hand, represents a true evolution in his character—he's not the same person he was when we first met him. He's grown. He's learned to care about something other than himself.

Obi-Wan's transition is a circumstantial arc, while Han's is an example of the more deep and resonant growth arc. Both, however, are character arcs, and both make *Star Wars* a richer story experience.

Application to Games

Every major character who appears in a story-driven game should have some kind of identifiable arc. If you were to extract each prominent character's individual story out of the overall narrative and examine it, you should find that:

- It has a beginning, middle, and end.

- It is driven by a conflict, which is in turn driven by a "want/but" situation.

- It is resolved (even if that resolution is negative).

But in games, what kind of characters are we talking about?

Partners/Squadmates/Allies

Your closest allies—whether diving into battle alongside you in gameplay or helping to support and inform you from the sidelines or during interstitial story moments—need to feel like living, breathing people. Give them something extra they care about or want besides your shared goals . . . then pay it off.

A great, interactive example of this approach can be found in BioWare's *Mass Effect*. The hulking krogan bounty hunter Wrex, who fights at the player's

side for a good deal of the game, comes from a warrior race ravaged by a bio-weapon that causes stillbirth in all but .1 percent of its infants. When he learns that the story's Villain, Saren, is trying to cure this genophage in order to create an army of krogan soldiers, Wrex draws his weapon, defiantly telling player character Shepherd that they must not destroy Saren's facility, lest the cure be destroyed as well.

Depending on player choice, Wrex's arc—indeed, his very life—may end right here, as the player or another supporting character kills Wrex on the spot. Or, if the player finds a way to avoid the gruff krogan's death, Wrex may go on to become an important figure on his homeworld in *Mass Effect 2* and, eventually, the *de facto* leader of his entire race in *Mass Effect 3*. This represents an interactive character arc with plenty of punch to it!

Mentors

Although a stereotypical Mentor character might not have good odds of surviving all the way through your story, giving her a strong arc can make her more impactful and memorable. Often, a Mentor's goal is to indirectly resolve the conflict by encouraging, advising, training, and/or equipping the Hero.

Conrad Roth in the 2013 remake of *Tomb Raider* is a prime example of a Mentor character with goals such as these. (Spoiler Alert: if you haven't played this game but intend to, you might want to skip to the next section, "Named Enemies.")

Beyond the goal of helping the shipwrecked group escape from the island—an objective he shares with playable Lara Croft—Roth, as Lara's surrogate father, has his own personal goal—encouraging and preparing her for the trials that he knows await her.

In his final scene, Roth uses CPR to resuscitate Lara and defends her against incoming enemies with his pistol, eventually shielding her from an axe with his own body. But even this isn't enough for Roth, unwavering in his determination to protect and mentor Lara. In his dying moments, with his very last breath, he continues to encourage and empower his protégé:

"You can do this, Lara. You're a Croft."

While his life ends at this point, it could be argued that his arc continues, as throughout the rest of the game Lara strives to live up to Roth's belief in her.

Named Enemies

As discussed earlier in this chapter, a two-dimensional bad guy who only seems to exist to throw obstacles in the path of the Hero makes for a flat Villain and a less than compelling story experience. This axiom also holds true for other enemies (or Henchmen).

Now, this doesn't mean that every single one of the countless hordes of cannon fodder the player might encounter over the course of a twelve-plus

hour game must have his own detailed back story and character arc! However, the more prominent ones—such as mini-bosses, bosses, and probably any enemy with a name—most certainly should.

The character histories don't all need to be elaborate, and you can compress them to a fairly compact timeframe if necessary. The original *BioShock* does this in a very effective and streamlined way. As you approach the area in which you'll eventually confront a mini-boss, you begin to find audio recordings that paint a picture of the character—history, personality, desires, goals, etc. The environment often offers more clues—writings, photos, illustrations, graffiti, horrific crime scenes—perhaps contrasting the present state vs. the past recordings you're listening to. Finally, by the time you directly encounter the mini-boss, you have a good notion of who he is, what he wants, and why you're about to try to kill each other.

Quest-Givers

Any NPC who asks the player to complete a task can be considered a quest-giver. By definition, these characters will have some sort of arc because a) they want or need something, b) they require the player's help to get that something, and c) the player will either resolve their conflict or not.

Whether it's an herb-seeking alchemist in *World of Warcraft*, a tribal warrior goddess in *Far Cry 3*, a repeatedly kidnaped journalist in *Red Dead Redemption*, or an old, violin-playing woman in *Fallout 3*, quest-givers can inject colorful doses of character and drama to gameplay objectives that would otherwise boil down to, "Go here, kill this being and/or get this object, return."

Completing each quest-giver's arc is key to providing some satisfaction to the player, since she's the one who performed the actions necessary to resolve the NPC's conflict.

Final Thoughts on Character Arcs

When it comes to your main and secondary characters—again, this generally means anyone you've cared enough about to actually name—ask yourself, do they all have character arcs? And do they all resolve and pay off?

If not, you've got some work to do . . . and I don't mean getting rid of their names!

Exposition

The term *exposition*, when referring to storytelling, can sometimes evoke derisive reactions, summoning bad memories of endless explanatory speeches and mind-numbingly boring lectures. But exposition is nothing more than this: *information the audience needs in order to understand and appreciate the story.*

Why should this be such a terrible thing? Well, it isn't. In fact, exposition exists in every single story, because it is absolutely necessary.

But handling exposition artfully is a challenge that trips up many storytellers, especially untrained ones. There are few experiences more frustrating for an audience than to feel trapped in a seemingly endless quagmire of unentertaining expository information. And that's probably why "exposition" has become a bit of a dirty word.

Understanding common pitfalls when conveying critical narrative information to the player will help you avoid them, and make you a better storyteller.

Note: Potentially the stickiest form of exposition is *plot exposition*—the information that helps the story elements make sense. We'll cover other forms of exposition in chapter 7, but for the purposes of the rest of this chapter, "exposition" will refer to *plot exposition*.

Show, Don't Tell

A natural inclination when it comes to conveying exposition is to *tell*. After all, the most efficient way we humans have of conveying complex ideas is with language. So the novice writer, acting on instinct, blasts the audience with a barrage of compacted, highly efficient story points. Her usual weapon of choice: dialogue.

What happens next? Characters explain things to each other in great depth, ask leading questions for other characters to answer, engage in long speeches

full of critical story details—or even worse, a narrator explains everything. The writer bombards the audience with dialogue to get important background information "out of the way" so she can get to "the good stuff." Unfortunately, this completely understandable instinct is wrong—very, very wrong.

Audiences don't want to be *told*. In fact, the less you tell them, the better—they would much rather be *shown*. And that brings us to the venerable Hollywood writer's maxim: "show, don't tell." Games, like movies, TV shows, comic books, and plays, are a visual storytelling medium. This gives the writer an amazingly diverse set of tools beyond dialogue that can be used to convey story information.

"Talk is cheap." "Actions speak louder than words." "His bark is worse than his bite." There are many clichéd quotes that make it clear that people don't take words as seriously as they take deeds.

Therefore, never establish something with dialogue that you can make equally clear—and more impactful—through action. For example, when Darth Vader first appeared on the big screen in 1977 in *Star Wars*, his look, demeanor, and entrance music all helped to convey he wasn't exactly a nice guy. But how did George Lucas decide to quickly *show* just how evil Vader was? By having him choke a hapless Rebel soldier to death with his bare hand, within Vader's first minute of screen time. We don't need to be *told* he's evil—he's just *shown* us.

So, if you want to establish that a Hero is brave? *Show* her being brave. You want the audience to understand how dangerous a weapon is? *Show* it being used. (Or at least show the aftermath of when it was previously used.) A character is forgetful? *Show* it. Whenever you find yourself using dialogue to convey exposition, stop and ask yourself: could I be showing this instead?

In games, the old Hollywood axiom can be amended to, "do, don't show." If you can convey story information with active gameplay, that's better than communicating it in a more passive mode, like a cutscene or a dialogue line.

So, first try to find a way to let the player *do* it; your second choice is to *show* it. And finally, your last resort is to *tell* it.

A laudable attempt to combine all three of these methods of expository communication into a single, interactive experience can be found in the interrogation system of Rockstar's *L.A. Noire*. Taking on the role of a hard-nosed late 1940s police detective, the player interrogates suspects in order to solve crimes and progress the narrative. Advanced facial capture technology allows the player to be presented with highly convincing and subtle actor performances—which he needs to pay close attention to in order to decide whether the suspect is telling the truth. The interrogations careen back and forth as the player reacts to what he is hearing, seeing, and sensing.

This is a very effective combination of *tell* (hearing the content of the dialogue coming from the suspect), *show* (observing the body language and

facial expressions), and *do* (making a decision and taking action based on the previous, which can spin the situation into a new direction).

So, the form of exposition is an important choice. But just as critical is choosing where to place it.

Seeding

Most exposition should be treated the same way you'd try to grow a lawn . . . by a process I call *seeding*. That is, spreading tiny bits of exposition (like seeds) in a fairly uniform manner over a large area—not dumping a giant pile in one spot.

Exposition is information, so you need to keep the information-processing speed of your target platform in mind. No, I'm not talking about the CPU of the latest PlayStation or iPad . . . I'm talking about the target processor of your story content: the player's brain.

Human minds can only take in, comprehend, and store information at a certain pace. Our brains are incredible processors of data, but they have their limits, especially when it comes to story details.

If you have ever used a lawnmower, you know that the taller the grass, the more slowly you need to push the mower. Or it will choke.

If you have ever used a snowblower, you know that the higher the snow level, the more slowly you need to push the blower. Or it will choke.

If you've ever fed baby food to an infant, you know that you can only place food into the child's mouth at a certain pace. Or he will choke.

What all three of these examples have in common is a processing device of some kind; something that chews or mashes through incoming material. Similarly, the human brain processes—chews and mashes through—incoming exposition, and if it's force-fed at too high a pace, the brain "chokes." It either misses many of your story points or gets frustrated and gives up on your story entirely.

So spreading out your exposition, like seeding a lawn, is vital to avoiding overwhelming the audience with information at any given point. And the most important place to avoid exposition overload is in the place your story can least afford to test an audience's patience: at the very beginning.

Yet the opening of a story is where the novice writer most often tends to make this potentially story-killing mistake: a massive exposition dump on the audience.

Of course, it's not hard to understand why. The writer has so much he thinks the audience needs to know before the story can get going: characters, relationships, a world, a conflict—it's a lot to cover! The writer is convinced that the story will be confusing and unclear unless all this information is presented up front. "Just bear with me for a while, and once we get past this tangle of people, places, things, and situations, trust me, it will get good—"

But the audience is already gone. Either physically, or just checked out of the story and focused on other elements.

A Snake in the Grass Seed

A notorious and painful example of front-loading reams of exposition can be found in the classic stealth action shooter *Metal Gear Solid 2: Sons of Liberty*. If you haven't played the game, you should be able to easily find a walkthrough video online. I recommend watching at least the first ten minutes.

The game starts with a short, punchy voiceover from playable Hero Solid Snake over a black background:

> ### *SNAKE*
>
> The Hudson River, two years ago. We had classified intelligence that a new type of Metal Gear was scheduled for transport. The whole thing stank, but our noses had been out in the cold too long.

This is followed by a promising, dialogue-free introductory cutscene in which a mysterious figure in a trenchcoat runs through the rain on the George Washington Bridge at night. As a nondescript oil tanker passes under the bridge, the mysterious running man turns almost invisible, then jumps off the bridge and, suspended by a bungie of some kind, lands on the tanker's deck! His stealth cloak sparking, he throws it aside it to reveal he's Solid Snake. The game's title comes up dramatically.

So far, so good. The opening cutscene is a bit long at just over four minutes, but it's entertaining, and beautifully rendered and animated. And with almost no dialogue! Our show-to-tell ratio is great up to this point.

But then we enter into a two-headshot radio conversation UI between Snake and his techie partner, Otacon. At this point, things rapidly deteriorate, as the two characters engage in a seemingly endless and often baffling conversation ranging from mundane references to the previous game to absolutely critical gameplay information.

During my GDC tutorial, I generally subject the group to the entirety of this noninteractive opening sequence. I've received feedback from a few attendees that while they understood why I did it, they thought it was a waste of their time to sit through the entire thing. Which, of course, is the point.

It is a full *eleven minutes and thirty-five seconds* before the player is finally handed over control of Solid Snake and allowed to play. But prior to this the player has been barraged with a baffling expository hailstorm; a confounding concoction of very important core story and gameplay information, seemingly randomly mixed with obscure references and extraneous story points that could have been more gradually fed to the player during gameplay (or not at all).

Mixing essential information with reams of less-pertinent exposition compounds the problem, as the player can't confidently skip the non-interactive sequences for fear of missing something she will absolutely need to know in order to succeed in gameplay. She's almost forced to endure the entire sequence, while trying to parse the many, many facts and attempting to figure out which are the ones she needs to remember.

For every unit of exposition, a storyteller must determine when the right moment is to present it to the audience. In turn, each bit of information should be weighed with regard to its importance, so that the least-urgent facts can be deprioritized, tucked away, or even eliminated in favor of more important ones.

"Need to know" is a good metric you can apply when deciding what exposition to convey and when. For each expository item you're about to include, ask yourself this simple yes/no question: does the audience *need to know* this right now in order to be entertained? Not to understand, mind you—to be entertained.

Because when it comes to stories, audiences do appreciate a bit of mystery. They enjoy guessing. They relish being surprised. And they don't like being able to easily predict what's about to happen next. Withholding important exposition can provide alignment with all these audience preferences, increasing tension and drama.

I generally organize expository facts into three categories:

- *Need to Know*: As you'd expect, this is a fact that the audience needs to know right now, before they can be satisfyingly entertained by what they are about to experience.

- *Could Wait:* A fact that, while potentially very important, is not necessary for the audience to understand at the current time. It can (and in many cases should) wait, until it becomes a Need to Know.

- *Incidental*: A fact that is relatively unimportant and will remain so throughout the story. While it may add color or characterization, its removal would have little to no harmful effect on the audience's enjoyment of the experience. Therefore it's a candidate for being cut if necessary.

Here is a chart laying out units of expository information communicated before the player is allowed to play *Metal Gear Solid 2*, which I've classified into the three categories. Gameplay-related information and hints are displayed in *italic*.

Need to Know

- The player is Solid Snake, an intelligence operative/super-spy.
- Snake has sneaked onto a tanker.
- *Snake's mission is to obtain evidence the tanker is carrying a dangerous weapon.*

- *Snake's first objective is to go to the ship's bridge, to see where the tanker is headed.*
- Stealthy, deadly invaders have taken over the ship.

Could Wait

- Snake has a techie/hacker partner named Otacon.
- The stealth camouflage is broken.
- Snake and Otacon now work in the private sector.
- The technical specs of Metal Gear were sold on the black market after Shadow Moses.
- This was someone named Ocelot's doing.
- Every state, group, and dotcom now has its own version of Metal Gear.
- This new Metal Gear is designed to wipe the floor with the others.
- The new Metal Gear is described as an amphibious, anti-Metal Gear vehicle.
- This new Metal Gear is under Marine Corps jurisdiction.
- The reason Otacon wants to know where the tanker is headed is that the destination might provide clues as to the Metal Gear's capabilities.
- *Snake should avoid confrontations.*
- Snake and Otacon are not terrorists.

- Snake and Otacon work for PHILANTHROPY now, an anti-Metal Gear organization officially recognized by the U.N.
- *Snake's weapon is a tranquilizer gun.*
- *[Gun controls]*
- *Snake's tranq gun needs to be reloaded after each shot.*
- *The gun's stun effect takes effect in seconds and lasts hours.*
- *Snake's gun has a laser sighting.*
- *The effect of the tranq gun varies depending on what part of the victim's body is hit—limbs, chest, or head.*
- Snake has a digital camera.
- The camera works almost the same way as Snake's old one.
- *[Digital camera controls]*
- The Marines are disguised as civilians because they clearly don't want to draw undue attention to the tanker.

Incidental

- *Otacon believes the target is in the ship's cargo holds, below deck.*
- Invaders silently storm the ship, taking out the Marines on deck.
- The invaders may be Russians.
- Snake uploads a photo of the invaders' leader to Otacon for identification.
- The ship is run by a computer.
- *Otacon believes it would take about eighteen people to take over and run the tanker.*
- Once Snake gets the photographic evidence, they will post it online and blow the whole thing wide open.
- Otacon will be waiting just past the Verrazano Bridge.
- *Snake needs to complete his mission by the time the tanker reaches the Verrazano Bridge.*
- Snake is not in the military anymore.
- Snake didn't plan on relying on the stealth camo anyway.
- Snake is happy as long as no one gives him any more unwanted gifts.
- Snake and Otacon have history with someone named Naomi.
- Snake doesn't miss the chattering nanny.
- Otacon doesn't think Mei Ling is so bad.
- Otacon needs to get in touch with Mei Ling again about some new Natik flashware.

- Otacon and Mei Ling divert toys from the SSCEN.
- SSCEN stands for U.S. Army Soldier Systems Center.
- Snake is concerned that Otacon and Mei Ling will get in trouble with the SSCEN.
- Snake's tranq gun is converted from a Beretta M92F.
- Otacon doesn't approve of Snake smoking cigarettes.
- Snake's smoking is a lucky charm.
- Snake wonders if Otacon's intelligence on the mission is accurate.
- Otacon says he hacked the intel out of the Pentagon's classified files and claims he was too good to be traced.
- Because there is a price on their heads, Snake worries the whole thing might be a trap.
- Otacon doesn't think it's a trap.
- Snake observes the water line and, citing the ship's navigational plans, says it's too high because the ship should have discharged its cargo upriver.
- Otacon believes this confirms the presence of the anti-Metal Gear.
- The military trains you to watch for threats from astern on a boat. It's also standard operating procedure for counter terror ops, too.

| *Continued*

- Snake believes the ship's security should be tighter.
- Otacon thinks Snake worries too much.
- A Kamov chopper is flying above the ship.
- Otacon and Snake aren't sure if the invaders are Russian military or civilians.

- This op isn't like a previous one called Shadow Moses.
- *The frequency to reach Otacon is 141.12.*
- *The frequency to save Snake's progress is 140.96.*

As seen in the chart starting on page 61, this is a massive amount of information to communicate in such a compact time period, and mostly via dialogue (i.e. telling vs. showing). Expecting the player to retain all or even most of it is clearly unreasonable.

As you can see, I've placed very little information in the Need to Know category. If you know that you are Solid Snake, you grasp the very basics of where you are and why, what you're supposed to be doing and who your enemies are, in my opinion, from a narrative point of view you're ready to start playing.

Of course, it may not be long before the developer needs to feed the player additional bits of information, such as how the gun works. As play continues, some of the facts in the Could Wait category will graduate to Need to Know status. But the point is, there is no reason for all the information in that chart to be dumped on the player *before* she actually gets to *play*!

In addition to the sin of a massive, front-loaded exposition dump, the writers of *MGS2* also include a number of clumsy, backstory-feeding lines of dialogue as mentioned in the first section of this chapter. A couple of choice examples:

OTACON

You know how the technical specs of Metal Gear were sold on the black market after Shadow Moses?

OTACON

Don't you forget, you're part of PHILANTHROPY now, an anti-Metal Gear organization and officially recognized by the U.N.

Some of these lines are downright painful. People just don't talk to each other like that, especially about things they both already know. And when a character spouts poorly disguised expository dialogue, it doesn't take a narrative expert to notice . . . or to cringe.

Let's be clear, though; *Metal Gear Solid 2* is an excellent game, and it's not as if the story itself is particularly bad. But the game's opening—and other extended noninteractive sequences along the way—could definitely be reworked to be more effective at drawing the player into gameplay as well as the narrative. Never forget that players come to *play*.

While some inexperienced writers might assume that an audience can't enjoy a story if they don't fully understand what's happening, especially at the beginning, it just isn't true. A skilled storyteller knows that withholding information isn't always a problem, and may be done on purpose to increase the audience's enjoyment of the experience.

The opening of *Uncharted 2*, in contrast to *MGS2*, provides almost no up-front information before the player is thrust into gameplay. Within just a few seconds of this game's *in media res* opening, the player finds herself controlling a man who hasn't been introduced, but who is hanging from a wrecked train, which is in turn hanging over a snowy cliff.

Here's what the exposition chart looks like before the player is handed control in *Uncharted 2*.

Need to Know

- The player character is a young man in a wrecked train.
- The train is precariously hanging off a snowy, mountainous cliff.

- *The player character must climb to safety.*

Could Wait

Incidental

- The player character is bleeding and doesn't seem to remember why.

The player instantly understands the desperate situation, even if she doesn't yet know who she is or how this scenario came to be. *It doesn't matter who you are or how it came to be; right now you need to get the hell off of that train!* It's a perfect example of master video game storytellers understanding what *need to know* really means, and stripping away everything that doesn't apply.

Terminated

Now let's look at a classic Hollywood example of seeding exposition, in a movie I think it's safe to assume every reader of this book has seen: timeless sci-fi action flick *The Terminator*. If you haven't, I recommend you do so before reading further. In fact, you might want to watch it regardless, to refresh your memory of the movie's details.

The Terminator (1984) has a complex, time-travel-related plot that could easily have confused its mainstream audience if not handled carefully. It can be summarized as follows:

> An unstoppable murderous cyborg has traveled back in time to 1984 to kill Sarah Connor, the mother of the man who will lead human-kind's resistance against the machines that rule the world in 2029.

Quite a bit going on there! And remember, the film was released in 1984, a time when movie audiences had had limited exposure to concepts such as cyborgs and time travel. So how did writers James Cameron and Gale Ann Hurd convey this complicated premise? How far into the story did they go before they gave the audience all the exposition needed to fully understand the complex plot?

The Terminator runs a tight 1 hour and 47 minutes (1:47:00), which means the halfway point occurs at around the 53-minute mark (notched on the time scale for reference). Referring to the art below let's look at each point in time that the writers add a piece of the expository puzzle.

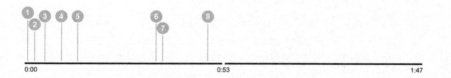

0:00 0:53 1:47

1. Right off the bat, within the first minute, the writers *tell* us (versus *show* us) a number of story points via a block of introductory onscreen text:

 ▪ Following a nuclear war, *machines rule the world in 2029*.

 ▪ A crucial battle will be fought "tonight" (i.e. the present).

2. At 00:03:05, another caption *tells* us that our story takes place in *1984*.

3. We then *see* what seems to be a naked (and muscular) man who arrives via some sort of electrical disturbance, and watch him walk around nighttime Los Angeles. It isn't until the 00:05:26

mark, when he brutally kills the punks at the telescope, that we *see* he's *murderous*.

4. Almost 11 minutes in now, and we still have very little information about what's going on. However, we do learn—from observing him hunt through a phone book—that the murderous muscular guy with the Austrian accent seems very interested in someone named *Sarah Connor*. We have no idea why.

5. About five minutes later, we realize that the guy isn't just interested in Sarah Connor—he intends *to kill* her. We know this because he asks a woman named Sarah Connor her name, and then shoots her.

So, just over 15 minutes into this movie, all we know for sure about the plot is:

- In 1984, a murderous muscular guy is out to kill women in LA named Sarah Connor.

- Machines rule the world in 2029.

Moving on...

6. It is not until a startling twenty minutes later (0:35:00) —a third of the way through the film!—that we finally get another piece of the puzzle. After being repeatedly blasted with a shotgun in a dive bar, the muscular assassin rises, apparently unharmed. He appears to be *unstoppable*.

7. Ninety seconds later, via a first-person POV shot, we see that the muscular killer isn't a mere human. Readouts and heads-up displays from his perspective as he's chasing Sarah and her mysterious rescuer confirm that the killer is either fully or partially mechanical/electronic—at the very least some kind of *cyborg*.

Almost unbelievably, we are 36 minutes into this movie, and when it comes to the plot all we as the audience know for sure is:

- In 1984, a murderous, unstoppable cyborg is out to kill women in LA named Sarah Connor.

- Machines rule the world in 2029.

8. It isn't until 0:46:50—nearly the halfway point of the entire movie—that time-traveling freedom fighter Kyle Reese fills in the gaps, by telling Sarah (and us) all the remaining details. It's now, and only now, that we know:

- An unstoppable murderous cyborg has traveled back in time to 1984 to kill Sarah Connor, the mother of the man who will lead humankind's resistance against the machines that rule the world in 2029.

The Terminator is a landmark film that launched the stellar career of James Cameron. How could a movie so successfully entertain a mass audience while withholding so much plot exposition for so long?

Common sense would tell you that keeping an audience in the dark for almost the first half of your story is a recipe for disaster. And poorly handled, it very well can be. But the fact is, the withholding of information is part of what makes the first half of *The Terminator* so riveting and entertaining. It is a prime example of world-class exposition seeding.

Pay It Off

As long you keep them entertained and intrigued, audiences can be quite forgiving when it comes to waiting for all to become clear. But their patience does have its limits, and they do expect that at some point in the story, you will fill in the expository gaps, or provide enough clues for them to do so on their own.

There are several dangers in waiting too long to make your plot fully comprehensible. The first is that the audience gets tired of waiting, becomes unsure that you will ever clear things up, and gives up on your story. The second is that your plot details, after being teased, withheld, and built up for so long, ultimately disappoint once they're revealed. The payoff ends up not matching the extended setup.

This is something *The Terminator* gets very right. When Reese puts the very last piece of the puzzle in place for Sarah and the audience, it isn't just another fact—it's a very personal and mind-blowing one:

> . . . there was one man . . . who taught us to fight. To storm the wire of the camps. To smash those metal motherfuckers into junk. He turned it around . . . he brought us back from the brink.

> His name is Connor, John Connor. Your son, Sarah. Your unborn son.

Wow. A blockbuster revelation *and* an emotional punch to the gut to top off a mystery that's been nagging at the audience since the first few minutes: *Why is this thing trying to kill her?*

From this point on the story is startlingly "clean" by comparison. There are no more open questions, except the main one: How can Sarah possibly survive this ordeal?

Contrast the first fifteen minutes of these three entertainment experiences: *Metal Gear Solid 2*, *Uncharted 2*, and *The Terminator*. The first blasts you with too much information right off the bat, while the other two drip feed you, making you hungry for more.

Planting

Extending our landscaping metaphor—but, I hope, not over-farming it!—let's move from seeding to *planting*.

If seeding exposition is like spreading it evenly across a broad surface such as a new lawn, then planting is choosing a specific spot for a unit of exposition, and very deliberately placing it there.

Think of it like planting a sapling. You need to decide exactly where you want it, knowing that over time it will grow into a tree and eventually provide you with the intended benefit (e.g. shelter, shade, privacy). It is something you plant not for now, but for later.

In stories, planting is simply *establishing something specific that will become important later on*.

You might introduce a machine or gadget and demonstrate how it works, or an object and its properties. Perhaps you demonstrate that a character has a certain knowledge or expertise—possibly even a gift or special ability.

Whatever expository sapling it is you plant, it is usually something that seems trivial to the audience at the time but becomes hugely important later on. The storyteller's challenge is to plant this expository item in as innocuous a way as possible. You want the information to penetrate the audience's consciousness, but at the same time it's important to quickly move on. You don't want to telegraph that (or how) this plant will be used later. Ideally, the audience will have half forgotten about it by the time it comes up again, so that it still surprises them and yet doesn't feel like it's come entirely out of left field.

One of my favorite examples of effective planting in a movie is in *Aliens*. (There's James Cameron again!) Several vital points related to a particular piece of equipment are planted just as Act II kicks off, but are not seen or mentioned again until the climax. I am talking, of course, about the Power Loader.

As with *The Terminator*, I assume you've seen this modern classic—and if you haven't, I recommend you do so before reading further, because this example is going to include at least one massive spoiler.

Shortly after Ripley agrees to accompany Burke and the space marines to investigate what happened to the colonists on LV-426, we see the marines making preparations for their drop onto the planet. As the soldiers hustle and bustle through the *Sulaco*'s hangar bay, with the Sarge barking out commands left and right, we notice one of the marines operating a Power Loader—a humanoid-shaped forklift he's using to hoist missiles and load them onto the drop ship. The

camera lingers on this operation just a bit longer than you'd expect (twenty five seconds, in fact), introducing the mechanical power suit and its basic capabilities.

Moments later, Ripley shows up and asks the Sarge if there's anything she can do to help. Skeptical, he in turn asks if there's anything useful she can do. She replies, "Well, I can drive that loader."

"Be my guest," the mildly surprised Sarge answers.

We now enter into an extended sequence showing Ripley climbing into the Loader, buckling herself in, powering it up, testing the hydraulic arms, clamps, and legs. An inordinately long period of time is spent on this sequence (forty three seconds), which has little if anything to do with what's happening in the story at the moment. We want to see the good guys fight the aliens—who cares about carrying cargo around the hangar deck?

Ripley finally walks the giant metal suit over to a large, heavy-looking container and effortlessly lifts it off the ground, then with a smirk asks the Sarge, "Where do you want it?"

The Sarge and Hicks share a laugh at Ripley's surprising spunkiness.

These two Power Loader sequences account for a combined one minute and eight seconds of screen time. Think about that: over a *full minute* of watching nothing but these high-tech forklifts walking around, lifting and carrying large objects, and placing them where they belong. It might not sound like a lot of time, but stare at the clock on the wall for sixty eight seconds, remembering how precious each second of film is in the editing booth.

Anyone who's ever seen the "extras" on a DVD or Blu-ray knows that scenes far more engaging than this one are often left on the cutting room floor, ruled to be extraneous. But this one stayed in.

Why? Because the investment of time and storytelling in this scene is intentional. In it, several highly important and interrelated story points are *planted*:

- Power Loaders exist.

- They're present on the hangar bay of the *Sulaco*.

- They make a human capable of great feats of strength.

- Ripley knows how to use one.

These points, mildly interesting at the time, seem to be increasingly irrelevant as the story proceeds, and through the rest of Act II—amidst harrowing, intense action and drama as Ripley and the marines find themselves under siege by hordes of deadly aliens—the audience almost forgets about Power Loaders.

Notice the phrasing: *almost forgets*. The planted information is still there, in the back of each audience member's mind—exactly where the writers want it.

Almost a full hour of riveting action passes before we finally see another Power Loader—at the climax, when Ripley emerges from the airlock suited up in one, ready to fight the Alien Queen to the death.

That moment—when the door lifts and we see Ripley step forward in the Loader—is a perfect payoff for the seed planted way back near the beginning of Act II.

But why not just introduce the Power Loader for the first time here, at the climax? Why bother planting it an hour earlier?

There are two main reasons.

Pacing: Ripley's emergence from the airlock in the Power Loader occurs near the very climax of the entire film. Tension is incredibly high at this point; everything Ripley has fought so hard for up until now is in desperate danger. To slow things down enough to introduce the Power Loader, show its capabilities and establish that Ripley knows how to use it would hobble the momentum that's been rapidly building ever since it was revealed the Alien Queen is in the hangar. Slackening the pace during the movie's climactic scene would have been a tragic mistake—one that James Cameron clearly had no intention of making.

Believability: Without planting, situations like this (called *deus ex machina*, which we'll cover in greater depth in chapter 6), can feel too coincidental and hard for the audience to swallow. If we had never seen a Power Loader before the big reveal near the end, it surely would have raised questions and bounced the audience out of the experience at the worst possible moment. "What is that thing?" "Where'd it come from?" "How'd she know how it works?" Ripley's commandeering of the Loader might have felt forced, exceedingly "convenient," and hard to believe. But by planting it in Act II, it suddenly becomes an *aha!* moment for the audience, and—with no lingering or distracting questions in their minds—they are instantly on board with it.

This is purely my own conjecture, but I believe the writers of *Aliens* probably worked backward from the climactic situation they wanted, and created a scene earlier in the movie to set it up. Writers do this all the time, and most planting works this way—you start with your end goal, and work backward in time to retroactively set it up.

One final observation regarding this "plant the Power Loader" sequence: the time and place the writers chose for it to occur was no accident. Exposition is always easier to convey when tension is low. Establishing what things are or how they work is best done not during an intense, fast-moving sequence, but during a relatively calm and slow-moving one. Nearly all planting is done during these "down times."

Some other notable examples of planting in movies include:

- James Bond receives his special agent gear and gadgets from Q in nearly every 007 movie:

 - At least one always comes in handy at a critical moment later on.

- RoboCop's interface spike in *RoboCop*:
 - When first seen, it's used to connect to computers, but ultimately, it's used to kill henchman Clarence Boddicker.
- Woody's matchstick in *Toy Story*:
 - Planted in his holster by the villain Sid, it's used later in an attempt to light a rocket strapped to Buzz's back.
- Milton Waddams' repeated, mumbled warnings that he'll set the Initech building on fire in *Office Space*:
 - He later makes good on his threat, which in turn saves the skins of Peter Gibbons and his co-conspirators.

The keys to successful planting are to a) introduce the plant in a way that seems innocuous and doesn't call unnecessary attention to itself at the time, and b) allow enough time between setup and payoff for the audience to almost forget about the original plant.

The biggest danger when planting is telegraphing, which can potentially allow the more clever members of your audience to immediately recognize the plant for what it is, and correctly guess how it plays into the story later on. It's a very fine line.

Foreshadowing

The technique of planting relies on the fact that the storyteller, during the construction of a tale, can move forward and backward through time as she sees fit, in order to create a satisfying cycle of setup and payoff. *Foreshadowing* is similar to planting in that it lays the groundwork for future revelations, but it does so with more subtlety and a softer focus.

Foreshadowing is *hinting at something that will either happen or will become clearer and potentially important later in the story.*

Foreshadowing is usually an enhancement to a story, not a core element. A narrative containing foreshadowing could usually survive without it, but is nevertheless enriched by its inclusion. People are genetically predisposed to try to see meaning in everything, and we love to "connect the dots." Foreshadowing presents an unsolvable mystery that ends up providing a sense of satisfaction when all is made clear.

Foreshadowing can take many shapes, but the most common forms include warnings, theories, vague predictions, dreams, images, and feelings. The information rarely makes sense or even seems relevant at the time, and—like planting—is usually kept subtle so that it doesn't telegraph something the writer wants to hold back until the right moment.

Some memorable foreshadowing examples from the movies:

- RoboCop's secret, classified fourth directive in *RoboCop*:

 - The existence of this mysterious directive is initially only known by RoboCop and the audience, though neither is aware of its contents. Much later on, it's revealed to be a back door command that prevents RoboCop from arresting Dick Jones, and nearly leads to the cyborg's destruction.

- Doc Brown's repeated warnings to Marty McFly about his actions in the past potentially impacting the present, in *Back to the Future*:

 - Marty and the audience can't understand the true nature of these warnings, but later on they become clear.

- The entire opening sequence, set in the 1950s and featuring Incredi-Boy, in *The Incredibles*:

 - This sequence is not even recognizable as foreshadowing—it's cleverly disguised as pure setup for Mr. Incredible's eventual, depressing status quo. It's only much later when Villain Syndrome reveals his true identity—the grown man that Incredi-Boy became—that the audience realizes that the opening sequence contained important foreshadowing.

Planting and foreshadowing are similar enough that they can sometimes be confused with each other. The hallmark of foreshadowing is that it initially presents information that is cloudy, vague, and less-than-helpful at the time, but becomes clear later on and thus enhances the storytelling.

Final Thoughts on Exposition

Exposition in stories is often considered a necessary evil, mainly because it's so easy to mishandle. But exposition, while necessary, need not be evil—or boring, or confusing, or annoying. As a video game storyteller, you can play an important role in helping convey exposition in ways that not only inform but also entertain.

Believability

A storyteller and an audience enter into an unspoken pact at the beginning of each story experience. The audience agrees to put aside their disbelief: to temporarily pretend to not know they are experiencing something fabricated, something false. They allow themselves to travel into the storyteller's artificial world, to imagine that what they're observing is real, and to emotionally connect with it as such.

The storyteller, for her part, commits to doing everything possible to make this *suspension of disbelief* as easy for the audience as possible—in fact, to almost force the issue. To draw the audience in, to *make* them forget they're sitting on their couch or in a movie theater, the storyteller agrees to avoid pushing or "bouncing" the audience out of that artificial, constructed world at any point during the story.

To suspend one's disbelief is, by definition, to *believe*. That's a huge part of what an audience wants: *Make me believe it.* If they believe it, they can engage with it emotionally—really *feel* in reaction to what they're reading, seeing, hearing, and/or playing. The core goal of every storyteller is to intentionally evoke specific emotional reactions in her audience. And it's why maintaining believability in your story is so important—because if they don't *believe* it, they won't *feel* it.

The Believability Challenge

A storyteller's success or failure with believability hinges on his ability to present:

- An artificial, incomplete world . . .

- featuring custom-designed characters . . .

- who experience carefully crafted events, actions, and reactions . . .

but that nevertheless *appears to the audience* to be:

- a real, complete world . . .

- featuring genuine people . . .

- who experience spontaneously unfolding events, actions, and reactions.

As you no doubt noticed, the storyteller is essentially trying to convince an audience of the exact opposite of the truth. Balancing the needs of story structure, pacing, characterization, and so forth with the requirement for the story to always feel like "what would really happen" is one of the primary challenges of creating successful story experiences.

There are a number of missteps that can impact believability during storytelling, and they nearly all stem from the writer either failing to properly set up a *surprise* (which we will cover in the next chapter), or forcing a specific action or scene to happen—often in the service of *spectacle*—despite other factors, such as *consistency* or *coincidence*.

These four elements—*consistency*, *coincidence*, *spectacle*, and *surprise*— are the primary factors that can affect believability in a fictional work.

Consistency

Ralph Waldo Emerson may have declared "foolish consistency" to be the "hobgoblin of little minds," but when it comes to storytelling it's the careless disregard of consistency that can be foolish.

Audiences expect and deserve a certain amount of internal logic and uniformity within any story. This generally breaks down into two main areas: consistency of *world* and *character*.

World Consistency

Everyone who experiences your story exists in the real world, and they're all experts on many things about it, such as the world's physics. They aren't physicists, mind you—well, a few might be—but each and every audience member inherently knows just by observation and from personal experience whether something looks or feels *right* when it's, say, falling off a cliff. Or when a person is jumping across a dojo with a flying kick.

So if you present a story that's supposed to take place in the real world and something happens in it that seems physically impossible to the audience— with no explanation provided—the audience will likely lose their suspension of disbelief, at least momentarily.

Defy it regularly, and they will eventually make an unconscious determination that this story—despite your efforts to convince them of the contrary—does *not* take place in the real world. Or, that the storytellers don't know the real world very well. Or, worst of all, that the storytellers think that the *audience* doesn't know the real world very well.

From that point on, the audience's suspension of disbelief may or may not hold together enough for them to emotionally engage to the extent you were hoping—because your world is not consistent.

A good example of world consistency gone wrong in the service of cheap spectacle can be found in the 1996 sci-fi action movie *Independence Day*. Apart from the conceit of hostile aliens in flying saucers attacking Earth, everything else in the film is presented as if it takes place in our world—the real world. In fact the entire point of the movie, I would say, is to dramatize what would happen if aggressive aliens attacked the world that you and I know.

Just shy of the movie's halfway point, during the aliens' initial, devastating attacks, young mother and part-time stripper Jasmine Dubrow (played by Vivica A. Fox) finds herself running through an arched automobile tunnel, a fireball filling it behind her. She and many other terrified motorists run for their lives, away from the engulfing fireball. Then she spots a maintenance door in the side of the tunnel and makes a dash for it, kicking in the door and pulling her young son through it.

Very important: *she doesn't close the door.*

Jasmine's dog jumps into the alcove to join her and her son, just as the fireball approaches. The three of them crouch in safety while the flames—which we've seen expanding to fill the entire tunnel—conveniently defy physics and roar past them.

It's been over fifteen years since I saw this in the theater, and I still remember rolling my eyes at this sequence, realizing I might be in for a long and potentially painful moviegoing experience. I'm no physicist, but it was instantly obvious to me that a fireball *filling a tunnel* would not selectively avoid expanding into an open alcove along the tunnel's side.

Since I knew that this story was definitely taking place in the real world, I concluded that the moviemakers thought that their audience either wouldn't notice this tweaking of the laws of physics, or wouldn't care. In my case at least, they were mistaken. I lost my suspension of disbelief, and the filmmakers were on their way to losing me as an engaged audience member.

This is not to say that every story world needs to be the real world. But all story worlds are *based* on the one we know—sometimes almost exactly, sometimes quite loosely—and all differences between our world and the fictional one need to be clearly established. Set the rules of that world with the audience, then abide by them. Consistently.

Character Consistency

As part of their unspoken contract to suspend their disbelief, audience members agree to convince themselves that the characters in the story are not constructs but real people. The storyteller's half of this bargain is to create believable, engaging, and memorable characters that the audience can connect with, root for, root against, love, hate . . . the entire range of human emotions.

A big part of making a believable character is making a consistent character. By consistent I don't mean a character who always does the same thing. I mean a character who, at all times, does what *seems to make the most sense for that character to do*—not what is most convenient for the writer or the story structure.

As noted video game writer, script doctor, and horror novelist Richard Dansky said in a 2013 online interview:

> I'll try to get to know [my characters] well enough that when the plot throws me a twist, or when I've written myself into a corner, I can write myself out by saying, "OK, what would this person do?" Not, "What do I need to have happen next," but, "This person is in this situation. Where is he or she going to go with it? What does that mean for where I'm trying to get with the story?"[1]

As mentioned in chapter 4, in order to be realistic, every character in your story must always do what she thinks is the best thing to do, at all times. Because that's what people do in reality. We're constantly drawing upon our own morals, experiences, and personalities to decide—moment-to-moment, day-to-day, year-to-year—what the preferable course of action is.

Audiences expect to see the same behavior from characters in fiction. And while we can't accurately predict how a real person will behave at any given moment or how she'll react to any specific situation, if we know the person fairly well, we'll have a pretty good idea of the likely range of her behavior.

So what a character wants—and the kinds of actions she takes in order to get it—should be *consistent throughout a story*. Every time we see a character behave in a consistent way, she not only becomes more believable to us, she becomes more familiar as well. With each congruous action she takes, we feel like we know her better—as long as, viewed as a whole, these actions collectively form a believable combination.

The only time this consistency should vary over the course of the story is when the character is growing and changing as part of an arc. Think about *Star Wars*' Han Solo again. His cockiness and mercenary nature is established within a minute of our first meeting him. He boasts of his ship's speed, he

1 http://www.polygon.com/features/2013/10/20/4753718/richard-dansky-tom-clancy

demands a high fee, and makes it very clear that he's strongly motivated by money. Over the course of much of the story, we see actions on his part that reinforce these core traits, and introduce some other minor ones:

- He is wily and dangerous (shoots and kills Greedo).

- He is good in a pinch (shoots Stormtroopers with turret gun on underside of *Millennium Falcon*, successfully blasts out of spaceport and eludes Imperial forces).

- He believes in and trusts only himself (conversation with Luke regarding the Force).

- He can be foolhardy (threatening to fight the Death Star while his ship is being pulled into it).

- He is wily and dangerous (hiding himself and others in secret cargo hold; tricking Stormtroopers, knocking them out and stealing their armor to go undercover).

- He believes in and cares only for himself (initial disinterest in rescuing Princess Leia).

- He is motivated by money (agreeing to help rescue Leia once a very large reward is mentioned).

- He can be foolhardy (singlehandedly chasing an entire squad of Stormtroopers through the corridors of the Death Star).

And so on. Through the first half of *Star Wars*, Han Solo is a very consistent character, and we, the viewers, feel like we know him. It breaks down like this:

- *Motivations*: Self, money

- *Traits*: Wily, dangerous, foolhardy

With these core motivations and traits understood by the audience, the aptly named Han Solo is a consistent and increasingly believable character—as long as he continues to display behaviors that are aligned with those attributes.

But as Han spends more time with Luke, fighting alongside the enthusiastic if naïve farm boy, we see there is a bit more to Han than we might have first thought. He begins to actually care about what happens to Luke. This is first evident in the trash compactor scene on the Death Star, when Luke gets pulled underwater by the dianoga lurking in the sludge. Han's behavior isn't just that of a smuggler trying to make sure his client stays alive so he can get paid—it's clear Han is genuinely concerned for Luke's life.

It's a minor shift, and certainly doesn't feel inconsistent at the time. But it *is* a shift. In fact it's the first hint of character growth in Han, who

has the second-largest character arc in *Star Wars* (behind, of course, that of the Hero—Luke).

Once we've seen the first inkling that Han actually has a heart and is capable of caring about more than just himself, future actions that reinforce this newly revealed trait will be believable and feel right. As Han continues to grow and change, we see emerging evidence of his transformation:

- He is emotionally engaged with his new allies (celebrating after destroying the TIE fighters; teasing Luke regarding Luke's obvious attraction to Leia).

- He likes Luke and genuinely cares what happens to him (asking Luke if he wants to join Han's crew; wishing the Force to be with Luke before the Death Star attack).

- He is somewhat torn between his own interests and those of Luke and the Rebels (unconvincingly telling Chewbacca "I know what I'm doing").

- He's learned to care about others (saving Luke from Darth Vader and clearing the way for Luke to blow up the Death Star).

Every one of these behaviors is only a slight adjustment from the previous iteration, which allows each to remain consistent and believable.

One of the most celebrated character arcs in recent years was the long, fascinating transformation of *Breaking Bad*'s main character, Walter White, over the course of five intense and groundbreaking television seasons. For the sake of those who have yet to experience this critically acclaimed and immensely popular body of work, I will try to avoid spoilers while making this important point.

Breaking Bad creator Vince Gilligan has said many times in interviews that the point of the show is to watch White slowly transform from Mr. Chips to Scarface—in other words, from a stern but likeable schoolteacher to a jaded, dangerous drug cartel kingpin. Anyone who's watched the entire series from beginning to end knows that some of the actions Walter White takes in the final two seasons would have felt completely out of character if he had taken them in the first few episodes.

It is the *gradual transformation of a character through experiences we have seen her go through* that allows the storyteller to introduce new attitudes, behaviors, and traits that are increasingly divergent from those observed when we first meet that character, and yet allow them to remain believable.

Coincidence

Coincidence is another natural enemy of believability. Each contrived event in your story has the potential to have a negative impact on the audience, raising

questions in their minds and damaging (or even destroying) the fragile illusion that the tale is unfolding naturally vs. being constructed by the invisible hand of a writer. So, getting all the coincidences out of one's story is a laudable goal.

It's also almost impossible.

Coincidences, despite everything bad about them—and there is plenty— also have the potential to propel stories in new and unexpected directions, generating surprises and opening new possibilities as to where things might lead. And virtually every story has them, to one degree or another.

Ironically, they often crop up due to the writer trying to solve other problems. For example, in chapter 4 we covered how important it is for the stakes of the conflict be intensely personal to the Hero. So in action stories, it's very common for someone in the Hero's family—or someone else to whom he's emotionally attached—to be put in danger by the Villain. Sometimes setting up this kind of situation, however, can be a bit of a stretch, and cause an ugly coincidence.

Consider the *Spider-Man* films. At the time of this writing, five theatrical releases have hit the theaters—a trilogy from director Sam Raimi and a two-movie reboot series with a different creative team. In *all five films*, Peter Parker's main love interest ends up being directly threatened by the movie's super-villain. And each successive time audiences see this they probably have a harder and harder time "buying" it. Not only does the scenario become increasingly predictable, it can also be painful to watch the plot contort itself in order to set it up.

Think about the Monomyth (chapter 3) again, and its common inclusion of a Resurrection near the story's end—a surprising twist at the lowest point of the story, when all seems lost. Because the Hero (or his goal) needs to come back to life at the last second, sometimes a writer makes the mistake of bringing in something out of left field to facilitate this turnaround—surprising, yes, but also massively coincidental and thus less than believable.

Of course, not all coincidences are created equal. With so many of them in almost every story, it stands to reason that some coincidences have little to no ill effect on believability or audience engagement, while others can be catastrophic. It's important to know the difference.

The Benign Coincidence

So what are the coincidences a storyteller can generally afford to leave in?

The first was recently revealed as being one of animation giant Pixar's in-house rules of storytelling: coincidences which get your characters *into* trouble are fine, but coincidences which get them *out of* trouble are a form of cheating. Audiences are much more likely to "buy" something randomly making life more difficult—but when the opposite happens, it can feel forced; the invisible hand of the writer may be felt manipulating the odds.

The second type of coincidence that storytellers can safely leave intact is a bit fuzzier to define. It essentially boils down to: *Does the audience even notice it at the time, or shortly thereafter?* Just because the writer is aware of a contrivance in the story doesn't necessarily mean that the audience will notice it. A clever storyteller can often get away with turns of fate which seem small and insignificant at that moment, but end up having a huge, important impact on how the story ultimately plays out.

Let's go back to *Star Wars* for an example. In the middle of Act I, when a dejected Luke Skywalker and his uncle Owen are shopping for new droids from the Jawas, C-3PO and R2-D2—the two characters the audience has been following up to this point in the movie—are among the available choices. Owen quickly chooses C-3PO for his communication abilities, but instead of also picking his companion R2-D2, Owen opts for a red R5 unit.

C-3PO seems disheartened and R2 is clearly upset—these two have obviously been through a lot together. And as audience members we, too, were set up to hope they would not be separated.

So when the red R5 unit obligingly explodes while rolling its way toward Luke, just about everyone—C-3PO, R2-D2, the audience—is relieved. Seizing the opportunity, C-3PO quickly steps in and recommends R2-D2 as a replacement. Luke suggests it, Owen concurs, the Jawas agree, and our story may now continue. Whew! Audience relief probably clouds the perception of a very fortunate coincidence here.

After all, have you ever given much thought to what would have happened in the story if that R5 unit *hadn't* blown up? Think about it . . .

C-3PO and R5-D4 accompany Owen and Luke back to their moisture farm. Poor, rejected R2-D2 is loaded back onto the Jawa sandcrawler, and he's either sold to someone else down the line, or possibly even disassembled for parts. His urgent message from Princess Leia never reaches Luke, and thus is never seen by Obi-Wan Kenobi. Princess Leia is never rescued from the Death Star; she's tortured, possibly to death, or maybe to the point that she reveals the location of the Rebel base. Without the plans contained on R2, the Rebels have no way to defeat the Death Star, and they are either destroyed by it or forced to retreat. In other words, the entire story falls apart, unless this little R5 unit happens to break down while rolling across the Tatooine desert!

But even all these years later, with so many millions of people having watched this movie multiple times, very few have noticed this little coincidence that makes such a big difference in the story. So, it's a "way-homer,"[2] the kind of coincidence that an audience only thinks about on the way home from the theater (if even then). It's the kind a storyteller gets away with.

2 With apologies to Joel and Ethan Coen, I've co-opted this term from their brilliant *Raising Arizona*.

Ironically, if Owen had initially chosen C-3PO and R2-D2, that would *also* have been a coincidence, and probably a more noticeable one!

So yes, there are coincidences that do little to no harm. Now we'll cover the ones that can damage or even utterly destroy an otherwise well-constructed story.

The Bad Coincidence

A "bad" coincidence in a story tends to have many or all of the following traits:

- Benefits the Hero and/or his allies.

- Is the result of the Hero's dumb luck vs. effective planning or action.

- Is unlikely, based on what the audience knows at the time.

- Comes with little or no warning; is not properly set up.

- Seems noticeably coincidental to the audience at the time it happens, or very shortly thereafter.

- Is doubted, questioned, second-guessed, or even mocked by the audience.

We've all had the experience. Something unlikely happens in a story—something with at least two of the attributes listed above—and we just don't "buy" it. We roll our eyes. We mutter to ourselves, "Oh, come on." Or, "Gee, *that* was lucky." We are "bounced out" of the experience, and we may never fully get back into it. We feel our intelligence is being insulted. We lose respect for the story and the storyteller.

If your story contains a coincidence with most or all of the traits listed above, you very likely have a problem.

The Fatal Coincidence

The king of all story-damaging coincidences is called a *deus ex machina*. Translated from the original Latin, it means "god from the machine." And it comes from a time when audiences had very different expectations of their Heroes and stories.

In Greek tragedies of over 2,000 years ago, it was commonplace for characters to get themselves into such a mess that only an Olympian god from on high, magically appearing in Act III, could sort things out. "God from the machine" refers to the physical mechanism used at the time of these plays: a crane-like device that would allow an actor (playing a god) to be lowered onto the stage as if from the heavens.

Audiences at the time were much more predisposed to accepting supernatural interference in the outcome of a story. But even back then, Greek

intellectuals studying the craft of storytelling warned against use of the technique, advocating that Heroes should figure out their own solutions to conflicts.

As Horace advised in his *Ars Poetica*: "That a god not intervene, unless a knot show up that be worthy of such an untangler." To which Aristotle added in his *Poetics*: "It is obvious that the solutions of plots should come about as a result of the plot itself, and not from a contrivance."

These days, we almost never see gods—literal gods—dropping into a story near the end to right all wrongs. But there are modern equivalents that still qualify as examples of *deus ex machina*, and they can be every bit as damaging.

Let's look at the movie version of *Jurassic Park*. I will again assume you've seen this modern classic, and if not I advise you to watch it before proceeding due to spoilers.

It's Act III, and we're careening toward the moment of highest tension, the climax. We can feel it. Our Hero, Dr. Alan Grant, is doing his best to protect his surrogate nuclear family—Dr. Ellie Sattler and children Lex and Tim Murphy—as they all try to escape from an island full of hungry prehistoric predators. Grant empties his shotgun at some vicious Velociraptors, and then leads his charges through the halls and ducts of the island's main building, relentlessly pursued by more of the ravenous predators.

But he leads them into a dead end, and they find themselves unarmed and surrounded by three of the aggressive meat-eaters. Realizing the situation is hopeless, Grant shields the others with his body and cringes, as one of the Velociraptors lunges forward—

—and is chomped on by a giant Tyrannasaurus rex!

The camera pulls back to reveal the suddenly present T. rex, as the giant beast shakes the much smaller Velociraptor in his massive mouth. Almost as convenient, the other raptors lose interest in their human prey and make suicidal attacks on the T. rex, allowing Grant and the others a chance to slip away.

The T. rex isn't a god *per se*, but it's not hard to see that in this situation he serves a similar role—a superhuman force of nature, conveniently dropped into the situation at the climax to resolve the conflict for an otherwise hapless Hero.

Let's check it against the Bad Coincidence list.

- *Benefits the Hero and/or her allies.*

Definitely, since it saves all their lives.

- *Is the result of the Hero's dumb luck vs. effective planning or action.*

Check.

- *Is unlikely based on what the audience knows at the time.*

The T. rex's presence in the visitor center may or may not be unlikely in and of itself. But no one—not the humans, not the raptors—notices the five-ton creature until that last second, when he must have been literally *standing right next to them?* Earlier in the movie, much drama is made of the fact that the ground literally trembles with every step the T. rex takes. That he's now suddenly invisible and silent to everyone around him is questionable to say the least.

- *Comes with little or no warning; is not properly set up.*

Check. We haven't seen or heard from the T. rex since he was chasing the Jeep over thirty five minutes earlier on the other side of the island, and there's no prior indication he's anywhere in the area.

- *Is noticeable to the audience at the time it happens, or very shortly thereafter.*

This is subjective, of course, but from personal experience I recall rolling my eyes when I first saw this in the theater. (I am admittedly a tough audience.)

- *Is doubted, questioned, second-guessed, or even mocked by the audience.*

An online search for "Jurassic Park deus ex machina" will demonstrate that I'm not the first or only audience member to notice this concern with *Jurassic Park*.

However, the movie was also hugely successful, spawning a series of sequels and generating untold millions in ticket and licensing revenue. So, no harm, no foul?

Perhaps. But for every *Jurassic Park* that gets away with reliance on spectacle over story logic, there are a hundred stories that fail to overcome their own weaknesses and thus don't connect with audiences. In other words, just because Spielberg managed to get away with it, don't assume you will too.

Writers don't intentionally insert these disasters into their stories; as mentioned before, they're usually a side effect of the writer trying to do something else. But being aware of coincidences and figuring out which are acceptable and which are damaging is a core skill for a successful storyteller.

The first step is to admit you have a problem. That can be harder than it sounds, because as already covered, there are some coincidences that audiences barely notice and others that stick out like a sore thumb. And as the person closest to the story, the writer may be the worst to judge which is which.

So, a smart writer makes sure to get other eyes on the story. She'll ask test readers their honest opinions. She'll find out which coincidences are noticed and which others she might be getting away with. Then, after a potential Bad Coincidence in the story is identified, the storyteller needs to know what she can do about it.

Handling Coincidences

There are three main ways to deal with a coincidence that's attracting negative attention in a story. Change the plot, retrofit, or downplay it.

1. Change the Plot

This is simple, if not necessarily easy. Change what actually happens. In the *Jurassic Park* example, this could mean removing the T. rex from the equation and forcing Grant to deal with the Velociraptors with his own wits. Ideally, he would succeed based on his special knowledge of dinosaurs and their traits, or even better, something he learned over the course of the film up to this point. In other words, something that springs directly from *who he is* or *who he has become*.

To be fair to Steven Spielberg, let's look at an example in which he and his writers fixed a *deus ex machina* in the source material for his movie version, by changing the plot. I'm talking about *Jaws*.

Peter Benchley's original, bestselling novel differs from the film in a number of important ways. In the book, police chief Martin Brody is the only survivor of the fishing expedition. The boat, having been shredded by the shark, completely sinks, leaving Brody alone and exposed in the water. The great white approaches him, and Brody closes his eyes, thinking it's all over. And then, at that exact moment, the shark inexplicably stops and slowly sinks beneath the surface, apparently dead, leaving Brody befuddled but alive. Coincidence. And arguably, a *deus ex machina*.

When it came time for the film adaptation, Spielberg's writing team of Peter Benchley and Carl Gottlieb made some big changes to this ending, possibly at Spielberg's behest. Some might say it was a more "Hollywood" finale, but regardless, it solved the coincidence problem.

Hooper's scuba tanks and Quint's rifle are repeatedly planted throughout the movie's second act; Hooper even warns Brody to be careful with the tanks because of their explosive nature. When Brody faces off against the shark, much care is taken to replant the air tanks in the scene, before Brody eventually stuffs one of them into the shark's mouth. As Brody lines up his final shot with the rifle, he is even heard to whisper to himself (and to the audience), "Show me the tank. Show me the tank." In other words, *every effort is made* to properly set up that very satisfying moment when he finally shoots the tank and it explodes in the shark's mouth, blowing the carnivore to bloody bits.

Spectacle? Of course. "Hollywood?" Oh, yes. But also much more narratively correct and satisfying than the novel's ending, as this new finale involves no coincidence, feels completely believable, and allows the Hero to actively resolve the conflict through his own wits and actions.

2. Retrofit

What if you really don't want to change what happens? Then maybe you can find a way to retroactively make it feel less coincidental.

Let's go back to *Jurassic Park*. How do we hang onto the amazing spectacle of the T. rex killing the Velociraptors at the climax, while fixing the problem of it being a massive coincidence and resolving the Hero's conflict for him?

By manipulating time and space, we could wind back the clock a bit and plant the idea that the T. rex has entered the building. Maybe during an earlier scene, we (and perhaps Grant) could see this on a security monitor in the background of another shot.

Then, while Grant leads the others away from the raptors, he could see the T. rex's shadow or some other clue that the thunder lizard is nearby. (Again, planting.) Grant could then purposely lead his surrogate family *toward* the T. rex in such a way that he knows the raptors will become its target. He might even do something to purposely draw the T. rex's attention. A fix like this makes the Hero an active participant in setting up the situation, as opposed to relegating him to the role of lucky bystander.

When I ask attendees at my video game storytelling tutorials how they might improve the *Jurassic Park* ending by removing the *deus ex machina*, within seconds they are generally able to come up with something similar to the above solution. If storytelling students at a game conference can accomplish this within moments, it seems surprising to me that professional Hollywood writers weren't able—or chose not—to do the same, over the course of months!

Here's another example from Hollywood, from a much less beloved film: *Spider-Man 3*. In this third installment of the Sam Raimi–directed movie series, after a slime-covered meteor crashes into Central Park, a bizarre symbiotic creature slithers off of it in search of a "host." And Peter Parker—of the millions of New Yorkers in the city that night—is the one it ends up attaching itself to. This conceit sets up the rest of the story, in which Spider-Man initially revels in the additional power the symbiote grants him, but ultimately realizes he needs to free himself of its negative influence.

Now, the coincidence here is that Peter Parker becomes the symbiote's target, for no other reason than he just happened to be nearby. It had nothing to do with who Peter Parker is; it was pure coincidence.

In this example, the coincidence may not have saved the Hero or his allies from an immediate threat, but it was the catalyst for the Hero's main arc and conflict for the entire rest of the film. For it to be kicked off in such a contrived manner hurt the film's credibility early on.

Again, how hard would it have been to fix this? Not at all. Instead of Peter Parker already standing around in Central Park when the meteor hits right near him, how about if he (as Spider-Man) is out on patrol in Manhattan, and he

sees the meteor crash into the park? Being Spider-Man, he's concerned that someone might have been hurt, so he swings over there to investigate. He's the first one on the scene, and thus he's the one who gets slimed.

This solution uses the traits of our Hero to justify the resulting events. Instead of employing a coincidence to get the slimy alien onto Peter, we use what makes Peter unique—his sense of responsibility, and his ability to get to a location faster than almost anyone else. In this version, the symbiote doesn't attach to Peter because of where he happens to be. It ends up attaching to him *because of who he is*.

3. Downplay

The third option when confronting a coincidence in one's story is to mask or *downplay* it. This only works for relatively minor, nagging coincidences. Trying to use this technique on a major case of *deus ex machina* would be akin to putting a Band-Aid on an amputation wound.

Like a dextrous magician performing a card trick, a talented writer can manipulate her audience and distract their attention away from something on which she doesn't want them to focus—in this case, a less-than-likely contrivance.

Let's look again at *Star Wars* for a prime example of downplaying a significant coincidence. The scene is at the juncture of Act II and III, just after Luke, Han, Leia, Chewbacca, and the droids have escaped the Death Star on the *Millennium Falcon* and destroyed the pursuing TIE fighters.

After cheering and celebrating their victory, our protagonists settle down and begin assessing damage and discussing next steps. In the cockpit, Han boasts to Leia about his rescuing prowess, but she bursts his bubble by insisting the Imperials must have allowed them to escape. She believes the *Falcon* is being tracked. When Han protests, she changes the subject and says she's glad R2-D2 is still intact and hopes the secret plans the droid is carrying will reveal a weakness in the Death Star's defenses.

Han makes it clear he has no interest in the Rebels' situation and only wants to be paid for his trouble. Leia, disappointed, assures Han that if money is all he cares about, that's what he'll receive. As she departs the cockpit and Luke enters, she expresses her low opinion of Han and his mercenary ways.

Now alone in the cockpit, Luke and Han talk a bit about Leia, with Luke testing Han's feelings toward the princess. Han, realizing Luke is attracted to Leia, toys with the youth a bit by pretending to have an interest in Leia after all. Luke's defensive reaction makes Han chuckle.

At this point we see the *Falcon* arrive at the gas giant Yavin, then approach and land on a forest-covered moon, in a well-hidden hangar bay, which is quickly revealed to be part of the Rebels' secret base.

Did you spot the coincidence? If not, don't worry—you're by no means alone. But let's take a closer look.

In the first few seconds of this scene on the *Millennium Falcon*, Leia reveals two important facts. One, that R2-D2 is carrying the plans for the Death Star; schematics which the Rebels desperately need to study to try to find a weakness. And two, that she is convinced that the Imperials purposely let them escape and are tracking the *Falcon* with some kind of homing device.

So naturally, where do our heroes travel next? Straight to the Rebel base—the very last place they should want to go if Leia believes the Empire is tracking them!

If you really stop to think about it, you realize that her behavior here makes no sense. Up to this point in the film, Princess Leia has been established to be a smart and capable figure—someone who would certainly be far too intelligent to knowingly lead the Death Star right to her allies' doorstep.

But what happens to the story if she were to act in character? Let's imagine . . .

Our heroes have just escaped from the Death Star and jumped into hyperspace. Realizing the *Falcon* is being tracked, Leia makes contact with the Rebels and they arrange to transfer her and R2 to another ship for transport to the Rebel base. Han and Chewbacca, after being paid their reward by the Rebels, take off at high speed in another direction, leading the Death Star away from the Rebel base and buying some time to find and destroy the tracking device on the *Falcon*. With the plans safely in their hands and the Death Star now wandering the galaxy on a wild goose chase, the Rebels have plenty of time to study the schematics and devise a strategy for taking down the giant space station. Eventually they find the weakness, and they plot to attack the Death Star at some future time and place.

In this scenario the story doesn't exactly fall apart, but the movie is lengthened and its pacing is seriously damaged. The momentum carried forward from the dramatic rescue of Leia should lead us almost directly toward the climax—the battle against the Death Star. But with these additional steps, tension takes a huge hit. The time pressure on the Rebels is almost eliminated, and their situation seems much less desperate. The story rhythm driving us toward the final confrontation is interrupted, slowed, and weakened.

So Leia conveniently "forgets" that going directly to the Rebel base is a terrible idea, and she is never called out on it. Not by anyone in the story, nor by legions of moviegoers and fans who have had over three decades to think about it!

When we look closely at how the distraction was handled in this example, there are two items of note:

One, it's *never outright stated* that the *Falcon*'s next stop is the secret Rebel base. We don't realize it until later on, and we only piece it together gradually, as the ship first approaches Yavin, then its moon, and then finally lands, allowing Leia to greet Commander Willard. So the time between Leia saying they're being tracked and our realization that they've flown straight

to the Rebel base is significant. In fact, by the time we realize what they're doing, they've already done it, and at that point the story is briskly moving on. They don't give us time to stop and think about it.

Two, the interval between the two events (Leia saying she's convinced they're being tracked and the *Falcon*'s arrival at the Rebel base) is *not spent dwelling on the matter*. Instead, a character scene—involving Luke's and Han's potential rivalry over Leia's affections—is inserted in between the two, causing an interesting and off-topic distraction.

Whether it was intentional or not, the insertion of these two elements very effectively downplays the coincidence (as well as a significant case of character inconsistency). The audience, distracted and manipulated, doesn't notice how inadvisable Leia's action is. And the story doesn't miss a beat as we quickly move toward the much-anticipated climax.

Will a tactic like this be enough to help you as a storyteller downplay a known coincidence in your story? It depends on many factors, and can only be judged by getting feedback from trusted, objective readers.

In the examples cited earlier from *Jurassic Park* and *Spider-Man 3*, the storytellers wanted to include a certain scene or sequence in their story. But rather than doing the additional work of making these sequences fully believable and free of jarring coincidence, they forced events to happen the way they wanted. And when things feel forced, audiences may sense it and detach from the experience.

The bottom line is, if there's an event in your story that contains a noticeable coincidence, you have tools at your disposal that can allow you to remove the coincidence or make it barely detectable. It just takes that extra effort.

The Element of Surprise

Given what we just covered regarding coincidences, you might be under the impression that I believe everything in a story should be predictable, and that unexpected events in a story are to be avoided. Of course, that's not the case at all.

No one wants to experience a story in which it's always possible to guess what's going to happen next. The real world in which we all live—and which all fiction attempts to emulate, to one degree or another—is not usually very predictable. Our stories, even artificially constructed as they may be, are generally designed to feel at least as surprising as the real world does. After all, a predictable story is a boring story.

Good stories regularly surprise the audience, and good games regularly surprise the player. The element of surprise is a vital component of good storytelling and solid game design. But it's also very easy to mishandle, because every revelation has the potential to hurt believability. The successful

storyteller walks a tightrope, attempting to strike a perfect balance between these two vital and often contradictory story elements.

Master storytellers of ancient times were well aware of the importance and the risk of incorporating a major shock, especially at a story's end. In *Poetics*, Aristotle, mindful of the need for a significant surprise at the climax but concerned about believability, warned, "The ending must be both inevitable and unexpected."

A more modern take on that thought comes from Academy Award–winning screenwriter and novelist William Goldman—author of *Butch Cassidy and the Sundance Kid*, *All the President's Men*, and *The Princess Bride*—who advises, "The key to all story endings is to give the audience what it wants, but not in the way it expects."

Their lifetimes and experiences separated by thousands of years, these two writers are nevertheless giving us the same advice with regard to the delicate issue of handling surprise.

Crafting a Good Surprise

Think about a trope you've seen a hundred times in the movies: two or more characters in a story start discussing a plan, but the audience isn't let in on it. The camera cuts away just before the details are revealed. Why? To preserve the element of surprise. And on that rare occasion when the audience is actually allowed to hear what the plan is, I promise you: things are *not* going to go according to plan.

That's how important surprise is. Even when the audience is let in on what's going to happen, they're really not! So how to go about making sure the surprises in your story are well constructed and effective, and don't break the audience's suspension of disbelief? The perfect story surprise has four attributes:

1. *It genuinely surprises the audience.* This probably goes without saying, but if the audience is able to see it coming, it's not a very good surprise! Test readers/audiences are invaluable to help evaluate whether your revelation is working.

2. *It is not extremely unlikely or purely coincidental.* We covered this topic earlier in this chapter, but just to reiterate: coincidence and luck should not be the only factors in play when it comes to a story surprise, especially if it benefits the Hero or his quest. This is not as strict a rule if it's a surprise that complicates matters or makes resolving the conflict even more difficult.

3. *It is set up beforehand.* Using the techniques mentioned in chapter 5 such as planting or foreshadowing, the storyteller must do his prep work in setting up the surprise for later on. This is where we can accomplish the seeming contradiction of Aristotle's

"inevitable yet unexpected" criteria. Without this critical step, an unexpected turn of events can morph into a painful *deus ex machina*. A surprise without the setup is like a punch line without the joke. It doesn't usually work very well.

4. *It makes perfect sense—afterward.* With the benefit of hindsight, the surprise should make perfect sense. This is what both Aristotle and William Goldman are trying to tell us. The audience reaction should be "a ha!" not "huh?" Achieving this heavily depends on how effective the setup was. Explaining *after the fact* why the surprise makes sense is cheap, and usually feels that way. Ideally, the surprise should almost immediately make sense and feel right to the audience without anyone having to explain anything. If exposition is needed, it must be delivered well before the actual revelation.

If you check every major surprise in your story against this list, you should be on the right track to striking a good balance between keeping your audience guessing and making them "buy" every last thing that happens in your story.

Spectacle

Many AAA video games, like many blockbuster movies, rely heavily on *spectacle* to wow their audiences. During game development, ideas for mind-blowing events and spectacular set pieces fly freely in energetic brainstorming sessions, sometimes constrained by little more than scope or scheduling limitations. "Wouldn't it be cool if" is the kick-off phrase to any number of ideas for high-octane twists and turns (replacing the word "cool" with "awesome," "epic," or whatever superlative the speaker prefers). This innocent phrase, full of enthusiasm and promise, can nevertheless chill a game writer's blood.

Because there's a problem with "wouldn't it be cool" aside from scope, which often gets overlooked—especially when the game is in its Production phase or later, by which time the story elements should probably be pretty well defined. Often—not always, but often—the "cool thing" is an idea that doesn't really fit the existing story. The forced insertion of spectacle can create a tone problem, violate what's been established for a character and her motivations, contradict the established physics of the world, or pose any number of other narrative concerns.

- *Wouldn't it be cool* if the player got to blow up the ship at this point?

 - Yes, but that ship is important later in the story.

- *Wouldn't it be cool* if Character X changed sides here so the player has to fight her in a climactic death struggle?

- Yes, but she wouldn't do that, and modifying her prior actions to set this up would break other story beats earlier in the game.

- *Wouldn't it be cool* if Character Y went nuts here and trashed the whole area?

 - Yes, but we've established that she lives here and wants to *defend* it from being trashed.

The contortions the writer may have to put the story through in order to accommodate that moment of spectacle can impact any number of other plot or character elements, which may in turn damage believability on many fronts. A well-constructed story eventually resembles a house of cards, and so the further into development you get, the more protective your narrative expert might seem to be. She knows that tugging on the wrong card can spell structural disaster, inconsistent characterization, a weaker narrative, and a lot of new work for herself and other team members, at a time in the dev cycle when you might not be able to afford it.

Thus, the narrative expert on a game team is often forced into the role of wet blanket when a "wouldn't it be cool" idea is floated—or even worse, when some intrepid designer, artist, or animator just goes ahead and implements their new idea into the game without checking first. Once life has been breathed into the concept, it can have an unfair advantage in the marketplace of ideas. If something looks "cool" (or "awesome," or "epic," etc.), it often seems to have the power to trump almost any other considerations.

If you or someone else on your team has had a "cool" idea and your narrative champion raises concerns regarding believability, I hope you'll remember what you read in this chapter, and give his concerns very serious consideration, instead of allowing the unstoppable freight train of spectacle to run right over him and his protests. Because that way lies . . . Michael Bay.

Final Thoughts on Believability

It's no coincidence (ahem!) that this is the longest chapter in this book. Maintaining the audience's suspension of disbelief through every moment of a story is an important and very challenging task. There are so many potential pitfalls—from convenient coincidences and cheap surprises to inconsistent characterization and mindless spectacle—and with a large group of storytellers, the risk of falling into one of these traps is compounded. It's vital that all members of the team understand the believability implications of every creative decision they make.

Believe it!

Dialogue

Dialogue is, sadly, what many laypeople mistake for the entirety of what a narrative expert brings to the table. This erroneous perception may stem from the fact that dialogue of an amateurish nature is the most easy shortcoming to spot—by anyone—when it comes to subpar writing.

This chapter is not intended to teach you or anyone else how to write professional-level dialogue, any more than this book is intended to magically transform anyone into a professional writer.

What this chapter is intended to do is provide a broad overview of dialogue's purpose and how it fits in with the storytelling concepts previously covered.

The Function of Dialogue

Dialogue has one main function: to convey exposition.

However, as extensively covered in chapter 5, dialogue should not be not the first resort when it comes to exposition: it is the last. But the fact remains that dialogue's main job is to convey exposition, which is probably why it's often mistaken for being exposition's primary vehicle. "If all dialogue is exposition, then all exposition must be dialogue." No, no, a thousand times no.

In traditional storytelling media, dialogue conveys three types of exposition: *plot*, *character*, and *emotion*. In game stories, it is also employed to convey *gameplay* exposition.

Plot Exposition

This is what most people think of when they think of exposition: a character explaining what's going on in the story. And much of the time that is a big part of what dialogue does.

There are times in many if not most stories when the plot details are complicated enough that the concepts would be difficult or impossible to convey without resorting to some verbal explanation. Other times the decision to employ dialogue to explain plot elements to the audience is based on efficiency and scope. It can be much faster (not to mention cheaper!) to verbally refer to something than to depict it. This is especially true when it comes to background information or prior events.

Consider this exposition-laden speech from *Back to the Future*, in which Doc Brown first explains his time machine and its workings to Marty (and the audience):

> [Einstein the dog] is fine, and he's completely unaware that anything happened. As far as he's concerned the trip was instantaneous. That's why Einstein's watch is exactly one minute behind mine. He "skipped over" that minute to instantly arrive at this moment in time. Come here, I'll show you how it works. First, you turn the time circuits on. This readout tells you where you're going, this one tells you where you are, and this one tells you where you were. You input the destination time on this keypad.

This is a lot of information—all of it important for both Marty and the audience to comprehend, given what follows shortly—and it's complicated enough to require a detailed verbal explanation.

In the movie's sequel, the time-travel complications become so challenging to convey to the audience that the creators not only have Doc Brown verbally explain them to Marty (and the audience), but also resort to branching timeline diagrams sketched on a chalkboard!

The case could be made that Doc Brown's chalkboard diagram is a clever use of "show" to support the "tell," but to my mind that's a somewhat shaky argument. When story concepts are so complex that words alone can't convey them and you must resort to charts or diagrams, you may be in danger of losing some of your audience along the way. That said, always do whatever you need to do to make sure the audience always has just enough information to be entertained!

Another popular method of "show and tell" is to combine voiceover narration with supporting scenes or imagery. This approach can allow for massive amounts of exposition to be conveyed quickly and visually, spanning multiple characters, locations, and timeframes in a very efficient manner. However, narration is a tricky beast to handle well, so it should be approached with caution and used sparingly. Peter Jackson's film adaptation of *The Lord of the Rings: The Fellowship of the Ring* opens with a good example of handling this delicate process in a way that is compelling, informative, and stage setting. Of note: narration-delivered exposition only occurs once in the entire film.

Used as a last resort and not a first, dialogue to support plot exposition should be artfully written, cleverly woven into natural-sounding dialogue, and should entertain as it informs. Ideally, it should not come across as exposition at all.

Character Exposition

Every time a character in a story speaks, we learn more—if only a bit—about who that character is and what he's about. It's partially *what* he chooses to say, but mostly *how* he chooses to say it.

Every character should have a unique "voice," a specific, recognizable, and consistent way he verbally expresses himself. It should separate that character from every other one in your story. If there is a line of dialogue that could be said by *any* of your main characters, exactly as written, you may have a problem: your characters may be far too similar to each other. When a good writer or script doctor notices similar characters in a story, he usually changes one of them to be more distinctive, or combines them into a single character. Characters in a story should provide good contrasts with each other, and dialogue is an important part of this differentiation process.

The danger that most dialogue writers face in this area is to do what comes naturally: simply writing all dialogue in their own voice. The result is that most if not all characters in the story sound the same (i.e. like the writer), instead of unique, genuine people with different backgrounds, experiences, and attitudes.

In order to establish a character's voice and consistently write dialogue in that voice, the character needs to be very well developed. The writer must know many things about that character in order to write him well. Some of the things that can affect the way a character acts and speaks include:

- Childhood/history
- Intelligence
- Vocabulary
- Ethnicity/accent
- Economic background
- General attitude toward life

This is where a *Character Description Document* (see Appendix I, page 190) comes into play. Early in the story development process, most writers will generate such descriptions for all prominent characters in their story including all of the above information, along with other potentially relevant notes. The better a character is defined, the easier it is for the writer to know what each character would do or say in any given situation. Without this established

background information, character dialogue is more likely to be written in a foggy and seemingly random way, which will often damage the story's consistency and thus believability.

In addition to core background information on each major character, the dialogue writer also must take into consideration the speaker's specific attitudes regarding the person or people he's currently addressing. Within a single scene a character might express the same thought in very different ways to two different listeners. And the character's attitude toward a listener can vary during the course of the story, depending on factors such as:

- The current situation

- The speaker's current emotional state (see below)

- The listener's current emotional state

- Current goals

- A change in the speaker's attitude toward the listener due to character growth or new information

As with people in the real world, the way characters verbally express themselves in stories reveals much about who they really are.

Emotional Exposition

As mentioned in the bulleted list above, the way characters speak provides vital clues not just about who they are, but how they are currently feeling—critical information for a storyteller to convey at all times.

People act based how they feel at least as much as on what they think. So understanding a character's current emotional state helps the audience understand (and believe) his actions. As with other forms of exposition, it is preferable to show than to tell. Someone putting a fist through a wall is generally a cleaner and better way to demonstrate that character's anger and frustration than having him describe it via dialogue. But in a case when showing isn't possible or feasible, dialogue-conveyed emotional exposition is not something that should be stated outright, but inferred by the audience based on *how* the character is speaking.

Bad emotion-conveying dialogue sounds like this: "Dad, I'm scared."

Better emotion-conveying dialogue sounds like this: "Dad, please don't leave me here alone."

Gameplay Exposition

Unique to the game narrative experience is gameplay exposition—using storytelling to communicate gameplay goals, instructions, and hints. Voiced dialogue is a powerful tool here, as the player is fed important direction while he continues

to play the game. However, it is a double-edged sword, as gameplay exposition that the player may have missed—perhaps because he was too engrossed in the gameplay, perhaps because he skipped a cutscene—can result in the player becoming confused as to what to do next.

If you're watching a movie and you miss an important tidbit of expository dialogue, the movie doesn't grind to a halt, freeze in place, and prevent you from continuing the experience. The movie continues to flow, and while you might be a bit confused for a while, you are free to move forward. But in a game, if you miss an important tidbit of expository dialogue, you may not know how to jump a gap that must be crossed in order for you to progress. You might be unable to finish the game!

Because of this risk, gameplay exposition is often hammered at the player, making it sometimes feel ham-fisted and clumsy compared to the way exposition is delivered in other media such as movies. It may be a bit unfair, but it's part of the reality of storytelling in games.

Remember the *Metal Gear Solid 2* opening sequence as discussed in chapter 5 (see page 59)? In addition to a few choice examples of decidedly wooden-sounding expository dialogue, one of the biggest concerns with this opening is the mixing of trivial story exposition with need-to-know gameplay information. Burying important objectives and gameplay instructions in a seemingly endless mire of noninteractive dialogue is an almost surefire way to make the player feel lost when he eventually gets handed avatar control.

Game dialogue writers and the team members with whom they collaborate need to work extra hard to make sure important gameplay information reaches the player's consciousness without hiding it in reams of extraneous dialogue or causing it to sound as clunky as a tin can rolling down the road.

Final Thoughts on Dialogue

When it comes to dialogue, the age-old maxim "less is more" definitely applies. The more lines one is able to cut from a story—either because they're unnecessary, or a way is found to communicate the same information via other means—the better. Any line of dialogue that survives the editing process should convey at least one of the previously listed forms of exposition—ideally, two or more—*while at the same time* flowing smoothly and being interesting, entertaining, and natural-sounding.

It's a very tall order, which is the reason that the art and craft of writing dialogue is best left to a professional writer.

PART II
In the Trenches

At this stage you have some core storytelling learning under your belt. And, as a result, you realize that no matter what your role is on the development team, if the game involves a story, you are a part of bringing it to life. Now you're ready to start thinking more deeply about how you can actually help do just that.

This section is organized into a chapter for each of the primary areas of game development. While it might be tempting to only read the chapters that apply to your specific discipline and/or role, I recommend you read everything. My hope is that this section provides some global insights into how members of each discipline and every sub-group can reach across the team room aisles to work together in the service of creating a compelling, well-integrated game story.

Team Leadership

This chapter is most relevant to those who provide leadership on a game project. Titles might include *executive producer*, *producer*, *creative director*, *game director*, and *leads* of various stripes.

With the exception of game writers themselves, there is probably no one on a game development team with more potential to affect the quality of the final product's story than members of the team leadership. Good storytelling in a game often hinges upon decisions made throughout the development cycle with regard to narrative-related investment, planning, and integration.

The bad news is that the results are often mediocre or downright awful. The good news is that there are specific, known, avoidable traps you as a leader can steer yourself and your team around, giving you all a much better chance for a positive outcome.

First we'll investigate what most often goes wrong with game narrative from a leadership perspective. Then we'll explore some specific strategies to overcome these barriers to high-quality game storytelling.

Why Game Writing Usually Sucks

Reviewers of video games, jaded and blunt, make no bones about their low expectations for narrative quality in the products they critique for a living. Clunky story structure, uneven pacing, cliché-ridden characters, and painful dialogue are expected norms, almost unworthy of comment. In fact, it's only

when a game manages to miraculously rise above this low quality bar and present plot, character, and dialogue on par with, say, a direct-to-disc movie that reviewers and players might sit up and take notice.

And on the very rare occasion that a game story truly rivals the best of any other medium—stirring the player's emotions and leaving an impression that lasts for weeks, months, or even years—the question hangs pregnant in the air: *Why can't more games be like this?*

Why, indeed? Well, there are a multitude of missteps awaiting a game's producers, directors, and leads that can ultimately evoke eye-rollingly poor narrative. These traps, ranging from the painfully obvious to the insidiously subtle, are often not recognized until too late, if at all.

No Writer Hired

It may seem surprising and maybe even silly, but some game development leaders expect a good narrative result in their games without the presence of professional narrative experts on their teams.

Now, to be clear, not every single game needs a professional writer or narrative designer. For example, puzzle games and simple strategy games generally have very light or even nonexistent narrative elements. And rightly so! Would you really want or expect a two-minute long, knock-your-socks-off cutscene to be what you first encounter when starting up a game of *Tetris* or *Bejeweled*? However, since you are reading this book, I will assume the game(s) you are working on would benefit from having a significant amount of high-quality storytelling content.

So how did we get to a point where the writer role for video game development is so often overlooked? To understand, we need to go back into the early history of digital game development, when dev teams were very small. Back then, it was not unheard of for a single person to handle the entire job: story, design, art, animation, audio, programming, QA—soup to nuts. Over time, however, advances in hardware specs made increasingly ambitious titles feasible. Projects increased in scope, teams got bigger, and specializations slowly began to emerge.

First Art broke off from Programming, then Animation from Art, Design from Programming, and so forth. The specialization process continues to this day, with Audio just recently being widely acknowledged as a separate discipline, rather than a subset of Design.

Narrative is in the early stages of trying to make its own clean break from Design, but at most studios these waters remain quite murky, and it's still common to expect game designers to also serve as writers, regardless of their experience or qualifications in that area. In many places, writing is seen as just one more item on the long list of responsibilities a designer is expected to cover.

So what? Everyone can write. This is the unspoken but widely accepted misconception that opens the door to poor leadership decisions related to game narrative. It speaks to a lack of respect for writers and their craft.

Game project leaders would never consider bringing in, say, a novelist to hop on one of their computers and start designing actual game levels. However, many of these same managers seem to have no compunction about doing the reverse—asking a level designer to also write professional-quality fictional content.

In such a situation, the narrative content that slowly wends its way into the developing game is likely to be clunky, inconsistent, and amateurish. At some point, probably too late, it's realized and acknowledged that the game's story is just not going to be good, and that the game will join the hundreds before it with subpar storytelling. If anyone even bothers to ask why, the answer should be obvious.

Amateur writers generally produce amateur writing.

Writer Hired, but Not a Game Writer

There is a common, lazy, and un-researched assumption often heard (usually from reviewers) when trying to explain why the writing in video games is so often poor: If only *real* writers—the professional writers who work in TV and movies—if only *those* talented writers were hired for the games, players would see more examples of top-tier storytelling in this relatively young medium.

On the surface, this claim does seem to make sense. Hire the best writers from the world's foremost storytelling media—motion pictures and television—and you should get the best results, right? Except, when we look at the writers who were behind the most powerful, memorable, and impactful narrative experiences that video games have had to offer, it's almost impossible to find the guiding hand of Hollywood scribes.

Deus Ex. BioShock. Half-Life 2. Portal. Uncharted 2. Red Dead Redemption. Grand Theft Auto IV. Mass Effect. The Walking Dead: Season One. All of these games feature stories crafted not by writers from outside our medium, but by writers within it. Thus, the belief that top-notch writing skills are not to be found among the working professionals in the video game industry is exposed as a myth.

Also without merit is the perception that hiring a gifted writer from another medium will automatically confer an outstanding narrative result to your game. As experienced game writer, narrative designer, and screenwriter Tom Abernathy (*Halo: Reach*, *Destroy All Humans!*) put it in a 2013 online article:

Many game developers have had the bright idea of "bringing in Holly-wood talent," only to be disappointed when the talent in question handed in pages and pages of linear screenplay that were unusable outside the context of cinematics. In crucial ways, game writing is a totally different endeavor from any other kind of writing any story-teller has ever done before the first time s/he attempts it.[3]

This is not to say that a writer from another medium can't eventually *become* a great game writer. Quite the opposite! Many if not most working game writers got their start in other storytelling media.

But writing for games is a unique challenge, and requires the writer to have a firm grasp of what elements make games strikingly different from other media. Game writers have often spent years in the trenches of game development. It can be a long and arduous educational experience, involving the unlearning of lessons gleaned from years of working in traditional, linear storytelling.

Writing is not something "anyone can do," and game writing isn't some-thing "any writer can do."

Sometimes it's a political necessity to involve writers from other media, especially for licensed games. But expecting a good working relationship to magically develop between such a writer and the development team is a mistake.

Some studios, recognizing this potential issue, will hire an on-staff narra-tive designer to be the go-between, charged with carrying the "name" writer's vision forward, and keeping it intact through every update and iteration. This is generally an excellent way to head off most problems.

Bottom line: If you want a good narrative result for your game, you need someone on your team who has strong knowledge of narrative *and* game development. Without at least one team member who can bridge that critical gap—and who is specifically tasked with doing so—your results will very likely be disappointing.

Game Writer Hired, but Late in Cycle

Whether by initial planning or as a late-stage panic move, it is very common for writers to be brought onto the development of a game only toward the end of the process, often at the point when dialogue needs to be written or rewritten. That's what writers do anyway, right?

To the uninitiated, a professional writer's main output may indeed appear to be dialogue. As we covered in chapter 7, it's what a lot of laypeople seem to

3 http://www.gamasutra.com/blogs/TomAbernathy/20130707/195732/Finishing_Each_
 Others_Sandwiches_Arrested_Development_Discovers_NonLinear_Storytelling.php

mean when they say "writing." But dialogue is just one step, late in the writing process, taken only after a huge amount of groundwork has been planned, laid, reevaluated, restructured, examined again, and carefully assembled.

Dialogue is the final surface element that's most clearly discernible to the audience, but it's layered upon a structure that is hugely challenging and deceptively difficult to assemble. To mistake a writer for a mere dialogue-generator (because dialogue is what's most visible on the page) is like assuming a master wedding cake baker to only be an icing expert, because in the final product icing is all you can initially see.

Being brought on board too late in the process is the concern I hear most often from other game writers. Rhianna Pratchett, writer on games like *Mirror's Edge*, *Overlord*, and the 2013 revamp of *Tomb Raider*, has come up with an apt metaphor for this all-too-common scenario. She says the game writer coming late onto a project serves as a sort of "narrative paramedic," trying to resuscitate a game story that is in very bad shape. There's no question of a full recovery; the goal is to just stabilize the patient.

By the time these late-stage writers are hired, deep-rooted damage to the narrative has often already been done—and there is no time or money to undo most of it. By "damage," I mean incorrect structure, clichéd characters, redundant scenes, missing scenes, massive coincidences, uneven pacing—things that are so baked into the near-complete levels and their designs that there is probably little anyone can do about them while maintaining schedule and budget.

I've heard several tales in which many of a game's levels had already been brought to a near-final state, with full environmental art, and only then was the writer hired—to invent a conceit for why the player character would visit all these different places to "tie it all together." This is not how great or even good stories are crafted.

So the writer does his best, slapping a coat of "dialogue paint" onto the shaky, crumbling story structure (or even inventing a last-minute structure!), hoping it helps a bit, but knowing the problems are much more fundamental. The game ships, its narrative components are perceived as weak and amateurish (but at least there's some decent dialogue), and it too is piled upon the heaps of previous games reinforcing the notion that game developers—including game writers!—just don't know how to "do" story. Cue the executive producer vowing to force his team to hire a Hollywood writer next time . . .

Game Writer Hired Early, but Let Go Early

A game development leadership team that recognizes the benefits of hiring a game writer very early in a project's cycle is already doing something very right—like a sprinter getting off to a great start. Which makes it all the more sad to see a stumble just short of the finish line.

When a game's primary (and probably only) writer leaves a project before it's finalized, the situation presents problems almost the exact opposite of hiring a writer too late in the cycle. The game may have solid underlying story structure, characterization, and world-building thanks to the early involvement of a writer. However, during the project's frenetic final stages—a time in which major swaths of the game can still be (and often are) hurriedly updated based on user testing, executive or licensor reactions, ESRB considerations, and so forth—*someone* has to step in and generate updated narrative content to match. And if that someone isn't a writer, it will show.

Imagine again our metaphorical wedding cake, expertly baked to moist perfection, stunningly iced and decorated, and now delivered to the reception venue several hours prior to guests arriving. The proud cake maker leaves, but shortly thereafter the wedding planner realizes that a large number of guests who didn't RSVP have shown up for the wedding, and now there won't be enough cake! Rather than call the baker back, though, the wedding planner decides to run out to the local supermarket, buy a few premade sponge cakes and some canned icing, and attempt to graft an addition onto the wedding cake herself.

Do you think no one looking at that cake would notice?

If you avoid the mistake of hiring a game writer too late, don't fall into the trap of letting him go too soon. A writer should stay with the team until there is no more chance of any updates to the levels, dialogue, or in-game text. Only then can you be confident that your players will not find themselves enjoying a rich, moist mouthful of narrative cake one minute and a stale Twinkie the next.

Game Writer Isolated and/or Unempowered

Even if team leadership appears to be doing everything right on the narrative front—hiring an experienced game writer early in the process and keeping him on through the duration of the project's development—there are several other, more insidious missteps that can undo much of these good intentions and actions. All involve the writer's working relationship with the rest of the development team.

Imagine a symphony conductor stepping onto the stage before an orchestra with whom she's never before worked—or even practiced. Further, imagine that a number of the orchestra members have made it clear that they don't really believe that conductors or composers are important or even necessary, and so can be expected to ignore both the conductor and the sheet music she's placed before them. On top of all this, of the musicians who are willing to try to work with the conductor, many of them are positioned so their views of her podium are partially or even fully obstructed!

Sounds like a recipe for horrible cacophony, doesn't it? If you were the managing director of this symphony orchestra, would you believe this to be the way it should be run?

And yet this conductor's unenviable situation is akin to that which a lone game writer might very often find himself when working on a large-scale game project. Poorly integrated; resented and rebuffed by a significant percentage of the team; unsupported by those who hired him.

So, there are three additional obstacles to narrative success:

- *Isolation*: Writer is not fully integrated with the team.

- *Lack of Collaboration*: Team is at least partially uncooperative and uninterested in helping to tell the game story.

- *Unempowered*: Management knowingly or unknowingly undercuts or overrides the narrative intentions and instincts of the writer.

Let's look more closely at each of these sometimes subtle challenges.

Isolation

If the game story is seen as a completely separate component from the rest of the game's elements—such as its design, levels, game mechanics, etc.—the writer is encouraged to work in isolation, having limited contact with the rest of the team. He makes narrative choices that may directly clash with the game mechanics and levels, and the reverse is also almost sure to happen.

At some point someone will notice these issues, but it may occur far enough into the development cycle that addressing them will be cost-prohibitive, almost as if the writer were hired too late (see pages 104–105). Most likely the narrative elements will be forced to bend to the direction charted by the other team members, since their programming, art, and animation is generally more expensive and risky to rework than the story elements are. Or, the clashes will simply be allowed to stand, making for a discordant game experience at best.

Lack of Collaboration

Some game developers, like some game players, just aren't interested in game story. They don't think it has value. As players, they skip cutscenes and other story elements at every opportunity. As developers, they may resent any time they're asked to spend on tasks related to narrative, when they believe they could be focusing their attention on "more important" matters.

Referring to the highly successful, narrative-driven *Assassin's Creed* games, Ubisoft Screenwriting Director Corey May said in a 2013 interview:

> I like to think as time goes on, you can prove [narrative] is a valuable component, or a defining element of a franchise, that people under-stand the need for it. But I would say those arguments still continue; even though there have been five [*Assassin's Creed* games], there's still a push-pull. There are still people out there, even on the team,

who would love to see something entirely systemic and that has no narrative at all. And I totally understand that, but at the same time you know what you're getting into when you sign up to make one of these games, so I'm sometimes confused when those arguments continue to happen. I'd like to think after a certain amount of time the defining elements of a franchise have been defined.[4]

Like the conductor who asks the orchestra to take the time to practice a new symphony, the game writer requests that the development team work in service of the game story. Make no mistake: video game narrative experts make extra work for other team members, some of whom may not see the point. And the writer is just one person; he absolutely needs the support of the team in order to tell the game story. Resentful, skeptical, uncooperative team members are not likely to do this to the best of their ability.

If the team's management has not clearly communicated the importance they're placing on the quality of the game's narrative, and "back up" the writer when necessary, this kind of attitude will go unchecked, and it can lead to uncollaborative behavior almost sure to cripple the quality of the final result.

Unempowered

When one looks at the writers behind some of the most revered video game stories—those of *Psychonauts*, *Grand Theft Auto IV*, *BioShock*, *Red Dead Redemption*, *Uncharted 2*, *Heavy Rain*—a pattern starts to emerge.

The writers on these games possessed a great deal of on-team power and creative control.

In four of these cases, the writer was also the creative director. In two others, the writer was one of the game's producers. This doesn't mean that every game with stellar narrative quality must have a writer who is also the creative director or producer. (Counterexamples include *Deus Ex*, *Portal*, *Star Wars: Knights of the Old Republic*, and *The Walking Dead: Season One*.) It also doesn't mean that putting the game's director or producer in charge of storytelling will automatically yield good results—especially if they have no particular training or expertise in this area.

But it does indicate that in order for narrative experts to be effective on a game development team, they need to be taken seriously and have the political capital to push back against the inevitable resistance that presses on the story elements from almost every direction during the game's development.

So when a concept artist (for example) produces something that directly contradicts the writer's intent, but which the game director nevertheless

4 http://www.polygon.com/features/2013/2/7/3960084/
 alice-ubisoft-storytelling-video-games-corey-may-assassins-creed-far-cry

thinks is "cool," what happens? Who gets trumped? Which side takes on the burden of reworking and revising content? If the answer in these situations is consistently the writer, then he's probably unempowered and will have a very hard time delivering a strong narrative outcome for the game, despite all good intentions going in.

Likewise, when the creative director, lead designer, or similarly senior person on your team doesn't agree with the writer on a narrative issue—not something that clashes with gameplay or the overall vision of the game, but just a purely narrative beat—and the writer gets overruled even in these situations, you've definitely de-powered your writer and marginalized his effectiveness.

The "anyone can write" myth runs more subtly in some people than others, and many don't recognize when they're acting on it. But when push comes to shove, it becomes clear that everyone's got strong opinions on story.

It's fine to have an opinion, and it's healthy to express it. Just recognize that having seen many movies and TV shows doesn't mean your opinion on game story is an informed one. And you overrule a professional game writer— someone who has likely dedicated years if not decades studying and practicing the art of storytelling—at the peril of your game's narrative quality.

. . . And What You Can Do about It

With so many potential obstacles standing in the way of fantastic storytelling in video games, it's no shock that the results almost always fall somewhere on the "Spectrum of Suckage." In fact, the surprising part is that a great game story ever manages to make it to market, period.

So, how do you as a game developer get it right?

Avoid the Traps

Based on all the pitfalls listed in the previous sections, you should now understand that achieving narrative excellence in your game involves:

- Recognizing that professional-level game writing is a specialized skill.

- Hiring a qualified game writer very early in the game development cycle.

- Integrating the game writer fully into the development team and its processes.

- Empowering the writer with decision-making authority over game narrative and strong influence over anything closely related to it.

- Supporting the writer when cross-discipline conflicts inevitably arise.

- Keeping the writer on-team until the very last changes to the game are complete.

Beyond these points, identifying and hiring the right candidate(s) should maximize your chances for success. We will cover recruiting and hiring tips later in this chapter. With regard to the points listed above, here are a few additional notes.

Integration

Proper integration starts, in all likelihood, with physical co-location of the writer with the team. The writer should be on-site with the team for at least the majority of her work time, if not full time. When she is on-site she shouldn't be isolated, especially if the rest of your team works in an open plan. (That said, you might want to give the writer a secondary, quiet location where she can work when she needs to buckle down and *write*.)

Team leads should convey the importance of fully integrating the writer into the development process, and recognize that narrative touches almost every other aspect of the game's design, mechanics, and features. Thus, the writer should be invited to any meeting and involved in any process that involves brainstorming or deciding:

- What will or can the player potentially *see* or *hear* (concept art, art, animation, audio)?

- What will or can characters potentially *do* (game design, mission design, AI design, AI engineering, animation)?

- *Where* will the action take place (concept art, mission design, art)?

- *How* will narrative elements be *presented* (UI design, animation, audio, engineering)?

Yes, that's a lot of meetings. Can anyone attend so many and still be productive? When in doubt as to whether a specific meeting is narrative-related, the best approach is to create a clear agenda for your meeting, then invite your narrative expert as an optional attendee and let *her* decide whether it makes sense to participate.

Empowerment

It is vital to trust the instincts of the writer you've hired, even when you might not quite understand or agree with them. Susan O'Connor, founder of the Game Writers Conference and a writer on *BioShock*, *Gears of War*, *Far Cry 2*, and other top-tier titles, says that when it comes to story and character, professional writers can "see around corners." In other words, an experienced writer

can imagine story scenarios and evaluate their potential very quickly, proactively avoiding paths that lead to narrative dead ends while simultaneously identifying scenarios that might work well.

These instinctive reactions, born from a career of solving story problems both large and small, allow an experienced writer to determine whether something will likely work long before a lot of time and energy has been expended on exploring the idea further. Think of it as a writer's "spider sense."

So, if the writer feels strongly that a narrative beat "has legs" but there are many doubts from the team, it could be an example of the writer using this special vision. Similarly, if the writer is warning that a story beat probably can't be made to work, it's not just an opinion to be thrown onto the pile with everyone else's. It should carry much more weight. Ignoring your writer's instincts or allowing her to be repeatedly overruled on narrative matters undercuts the very point of hiring her in the first place.

At the Game Narrative Summit at GDC Online 2011, I asked Mary DeMarle, lead writer and lead narrative designer on the highly rated *Deus Ex: Human Revolution*, whether she ran into any story-related conflicts with the rest of the team on that project, and how those conflicts were handled. She replied:

I remember in one of the early meetings, we were debating about the Zeke Sandoval character, how he might come back if you don't kill him. The writers in the room knew we had created a character that makes total sense—he's a man of honor, and if you let him go he's not going to like it but he's going to help you at some point. And everyone else in the room was arguing with this, saying, "I don't buy it. I just don't buy that he would do that, it just doesn't work."

And they're arguing and arguing for like fifteen minutes, and I'm arguing with them, and finally I got so frustrated I just said, "Guys, if you would trust me to do my job the way I trust you to do yours, we would have no problem here."

And when I said it, there was a moment of silence. And then the game designer looked at me and said, "Okay, you think you can make it work?"

I said, "I know we can."

He said, "Okay. Let's move on."

And we did.

And when the game came out, no one ever doubted it, no one ever doubted that that character would do that, because the narrative team knows what it's doing.

So yes, you have to spend a lot of time arguing, and explaining, and sometimes we [writers] can't really explain the feelings that we have, but you have to really spend a lot of time educating as you're going through.

Which leads nicely into my next point

Education

Educating your team on the foundations of good storytelling is important, and should start early in the development process.

Even if the majority of the team buys into the idea of working together to tell a great story, and even if they respect the idea of having a narrative expert help guide them there, if their core understanding of storytelling is weak and they remain uneducated throughout the process, they will constantly inject narrative missteps into the game, probably faster than a narrative designer can help them course-correct. Not only can't the writer tell the story alone, but the writer also can't be everywhere at once. And on a large-scale game project, things happen fast!

A team that collectively understands the basic principles of fiction writing will make fewer narrative fumbles and won't have to completely rely on the presence of a professional writer at all meetings or during the creation of all assets.

When I begin working with a new team on a game, I generally start off by presenting some, or all, of my full-day-long game writing tutorial. It provides a basic but solid grounding in core fiction writing theory and practice, serving a function much like the initial tuning process a symphony orchestra engages in before starting any performance. Game writer and team need to be in tune with each other if there's to be any hope of a harmonious working relationship.

Perhaps the writer you hired has a similar presentation she can offer (or create). Alternately, this book is specifically designed to provide that basic narrative grounding, as seen through the lens of game development.

Whom to Hire

It may seem that I'm asking a lot of the team leadership when it comes to game writing, and frankly, I am! But make no mistake—I also believe you should have high expectations of the game writer. And these high expectations start with deciding whom to bring on board.

Currently, the list of people who have a strong grasp of both fiction writing and game development is not a long one. The list gets even shorter if you want someone with extensive, proven experience in both areas.

So, what should you look for in potential writing candidates? Ideally, I believe you'll want to find someone with the following strengths, listed in order of importance.

Professional-Level Fiction Writing Ability

Obviously, this is the absolute minimum barrier to entry, and it's best shown in a candidate who has been published by a reputable establishment of some kind. Having studied creative writing in college is helpful, but it's hardly proof of professional-caliber writing ability. Self-published work is also questionable, and "I helped write some of the dialogue for this mobile game" is probably not going to prove much, either.

Ideally, of course, candidates will have done extensive writing *for games*.

Failing that, you want to find someone who has been *paid to be a fiction writer*—and *only* a fiction writer—by someone else. A more traditional medium might be best, such as comics, short stories, novels, TV, or movies. The latter two have the advantage of showing that the candidate has experience writing for the spoken word (assuming that applies to your game project).

By only interviewing those who have been professionally published, you let someone else vet the narrative chops of the candidate for you. And writing ability is the most basic skill needed here. After all, a newly hired writer can learn about game development from his fellow team members if absolutely necessary (though it's hardly ideal).

Familiarity with and Passion for Games

Hiring a narrative expert with at least some knowledge of and enthusiasm for games is also hugely important. Do you think a movie studio would consider hiring a writer who admitted he never watched movies? A prospective game writer must at the very least have a good working knowledge of various platforms and genres, and be able to list good and bad examples from a few. He should at a minimum be able to speak the language of games. In short, a game writer should also be a gamer. However, even better is . . .

Game Development Experience

There is a world of difference between someone who likes to play games and someone who has direct experience making them. Think of it as the capability gap between someone who has lived in houses her whole life vs. an experienced residential construction engineer. They may both have strong opinions about the kinds of homes they like, but only one of them truly understands the

reasons behind many house layouts and features. And only one has hands-on knowledge of actually designing and building the structure.

There are many elements of game development that have to be experienced to be understood. Hiring someone who has at least a few development cycles under her belt—even in a role other than that of writer—will help avoid some on-the-job mistake-making down the road.

Game Writing/Narrative Design Experience

Beyond involvement in the development of games, if the candidate has actually served as a writer and/or narrative designer before, he should be at the front of the line. Due to the interactive nature of video games, there are many elements that are unique to their narrative development. A prospect who can show familiarity with these elements will need little training or oversight to hit the ground running.

Experience in a Specific Game Genre

Finally, if a candidate has all the aforementioned strengths, *plus* development experience in the exact genre of game for which you're hiring, you may have hit the jackpot. Certainly this person, at least on paper, has the potential to be a perfect fit for your job requirements. Finding out more about that fit will, of course, require an interview.

Final Thoughts on Team Leadership

The decisions related to narrative that you make (or don't make) as a team leader can have enormous impact on your game's story quality, which in turn can significantly affect its critical and commercial success. Great video game narratives don't happen by accident, and they never happen easily. But behind every success story are insightful leaders who knew it was important, and acted accordingly.

Overall Game Design

This chapter is most relevant to those who conceptualize, develop, and approve the overarching design of a game. Titles might include *creative director*, *game director*, *lead game designer*, and *lead systems designer*.

Like you, when I am at a party or other social gathering outside the game industry, I'm often asked what I do for a living. Once someone finds out I'm a writer for games, a question I'm often asked is whether games start with a script or story concept, like movies almost always do.

This is an assumption made not only by laypeople but also professional writers from other media who are curious about writing for games. After all, in nearly every other storytelling form—movies, TV shows, plays, novels, and comics—the process starts with story as the first step.

Of course, as you most likely know, that's not how it generally works in games. In fact, whenever a writer asks me where she might shop her idea for game story, the analogy I use in my answer is that of a film score composer wondering to which movie studios he should shop the new soundtrack he just wrote. Games don't start with stories any more than movies start with scores.

A new game almost always begins with a decision on genre, followed by a concept within that genre. At this formative stage, few if any specific narrative elements are yet determined.

For example, some game concepts featuring original intellectual properties (IP) might have looked something like this in their very first days:

- A third-person sandbox game set in the Old West in which the player takes on the role of a gunslinger. (*Gun*, *Red Dead Redemption*)

- A first-person environmental puzzle game in which the player shoots "holes" in walls, floors, and ceilings that can be traveled through. (*Narbacular Drop*, *Portal*)

- A third-person co-op exploration and puzzle game that emphasizes emotion and simple beauty, and contains no dialogue. (*Journey*)

- A third-person stealth assassination game featuring climbable urban environments and large, interactive crowds. (*Assassin's Creed*)

- A third-person puzzle-action game in which the player rolls a highly adhesive sphere across the environment, collecting objects that stick to it and increase its size. (*Katamari Damacy*)

There are so many implications in these brief concept statements! Design, team size and composition, budget, schedule, engine, possible platforms, target audience . . . the list goes on and on. It's a lot to evaluate before even starting to think about more detailed questions like, *What is the story?*

Even game concepts based on existing/licensed properties, with considerably more prior baggage, might have appeared thusly:

- An isometric, four-player action-RPG "dungeon-crawler" with dozens of available playable characters from the Marvel Universe. (*X-Men Unlimited*, *Marvel: Ultimate Alliance*)

- A narrative-rich 3D adventure game that's based on *The Walking Dead* comics and TV series. (*The Walking Dead: Season One*)

- A non-open-world Spider-Man action game featuring multiple playable incarnations of the iconic Marvel web-slinger. (*Spider-Man: Shattered Dimensions*)

- A world-building casual mobile game based on a satirical prime-time animated TV sitcom. (*The Simpsons: Tapped Out*, *Family Guy: The Quest for Stuff*)

The point is, before there is a game story, there are always previously established elements such as genre, core mechanics, and context. In sequels, remakes, and licensed games you can usually add to that list established characters, abilities, and world. But unless it's a straight adaptation of an existing fictional work—remember all those inevitable and generally mediocre "movie games"?—video games generally do not start with story. Nevertheless, the impact on the final game's story starts at the very first moment of game conception.

As a creative lead on a game project, you have already at this early stage made decisions that will affect the game narrative. As covered in chapter 8 ("Team Leadership"), just by picking the game genre you begin to set expectations in your potential audience—and probably in yourself—as to how critical narrative is going to be to the gameplay experience. These drive other decisions down the line like dominoes.

How Much Focus on Narrative?

One of the first things you need to ask yourself regarding your game's narrative elements is how important and central you believe they are to the game's design, appeal, and success. Some questions that might help clarify this for you include:

- Are there existing games that are similar to the one you plan to create? If so, how prominent was each game's narrative, what methods did their developers use to integrate and convey it, and how effective were those choices?

- Can this game be successful without a strong story? Can the gameplay itself carry the experience, or is narrative crucial to its perceived quality? How much of an investment is justified?

- What do you believe your target audience's expectations will be regarding your game's narrative? What percentage of the players do you believe will be story-philes versus story-phobes?

It's important to understand and be clear with other game design leaders regarding the role that narrative elements are likely to play within the overall game design, and how those elements will be prioritized versus other aspects. This will drive smart decisions early in the process, and set the tone for the rest of the game's design development process.

Matching Player Verbs to Narrative

Core game designs and mechanics are always directly linked to what the player character can *do* . . . the verbs she is able to express within the confines of the game space. Some common verbs in video games include walk, run, jump, aim, shoot, crouch, block, climb, float, fly, swim, drive, build, and collect. Many games also have contextual verbs that are only available when the player character moves within range of a certain in-game location or object: open door, use computer, talk to NPC, pick up item, etc.

Player verbs can be expensive in terms of development effort. Just implementing a new verb will require additional code, and often also imply new art,

animation, and/or audio. Verbs also tend to open up gameplay possibilities that must be accounted for, and doing so can take a lot of time and effort. Level designers must constantly take all verbs into consideration, or disallow specific verbs at certain times (often leaving Narrative to justify a seemingly arbitrary restriction).

The lower the number of player verbs, the easier it is to control the variables and rein in scope. However, a low number of verbs can result in more and more onus being put on out-of-game narrative mechanisms to convey a story. For example, if all the player verbs in a game have to do with combat and none have to do with traversal movement, then how will you bridge from one combat context and location to another? With no option to provide the player an interactive journey from Point A to Point B, you will likely lean upon noninteractive storytelling techniques to establish a change of location and a new reason and context for the next battle. This can range from the simple, five-second panning of images in between *Angry Birds* worlds all the way up to the sumptuously rendered, ten-minute cutscenes from the *Metal Gear Solid* series. As you make the hard decisions about player verbs, keep in mind that the more narrow your focus in this area, the more you might be overburdening the noninteractive narrative tools at your disposal.

Another point to consider with regard to player verbs is that people and fictional characters are, in many ways, defined by the choices they make and what they do. In a game, a playable character ends up doing only the things the designers allow. Thus, the gameplay verbs that are available to a player character define, in a very basic way, *who that character is*. We will dive more deeply into the issue of game character development in the next chapter, but for the time being it's important to realize that player verbs and the player's character are inextricably interwoven, and should be concepted and developed concurrently.

Further, if you are using a pre-existing character as a (or the main) playable in your game, be aware that the character may come with baggage that includes a bevy of implied verbs. Spider-Man, for example, has inherent wallcrawling and web-swinging abilities that can cause waking nightmares for your level designers and camera designers/engineers. Other characters may imply other abilities.

Game Story versus Player Story

Another important decision that will have massive implications for the game narrative scope—and possibly its quality—will be how much of the story you are planning to craft beforehand versus what you allow to emerge naturally during gameplay.

Will you go for a tightly crafted, largely linear cinematic game like *Uncharted* or *Batman: Arkham Asylum*? A narrative-heavy experience with

multiple, story-impacting branch points such as *Mass Effect* or *The Walking Dead: Season One*? An open-world sandbox more loosely held together by a largely linear storyline like *Grand Theft Auto*, *Fallout 3*, or *Red Dead Redemption*? A mainly emergent story design like *FTL: Faster Than Light*? Or an almost purely systemic offering such as *The Sims* or *League of Legends*?

Most games that incorporate any kind of storytelling include, to one degree or another, two narratives running in parallel. There is the *game story*—predefined by the developers to be the same for every player who experiences it. And there is the *player story*—the narrative unique to each player based on choices she's made or things that just happened to occur via the various interactions of game systems with each other and the player's actions.

This book largely concerns the creation of game stories, but with the understanding that they almost always are accompanied by player stories.

The proportion of game story to player story can vary wildly from title to title. There are games at both extremes of the spectrum, but most are positioned more toward the middle. And, simple puzzle games aside, it is a rare game indeed that doesn't have at least a little game story or player story.

I believe when it comes to game story vs. player story, most games with any game story content at all will fall into one of four categories.

Game Story Dominant

This is a game that emphasizes rich, linear story material, potentially at the expense of player freedom.

Hallmarks

- Same linear game story for all players
 - Few if any side missions or optional quests
- Limited or no choice or customization of player character
- Opportunities for player choice and self-expression only in moment-to-moment gameplay sequences
- Moderate opportunities for expression of individual play style
- Interactions with computer-controlled characters provide potential for small-scale emergent stories

Examples

- *Uncharted* series
- *Spider-Man* (2000)

- *Batman: Arkham Asylum*

- *God of War*

Game story–dominant experiences provide for some self-expression and unique-to-each-player experiences—almost exclusively during the moment-to-moment gameplay—but still cleave closely to a linear, pre-crafted narrative that ends up being the same for all players.

For example, everyone who plays all the way through *Uncharted 2* will be playing as Nathan Drake, and every player's Nathan Drake will look exactly the same, go to identical locations, and fight the same enemies for the same in-story reasons.

However, within the gameplay sections of the missions, the player has a variety of available verbs and enough choices—of movement, of weapons, of play style—to allow for experiences that are unique to her. With various weapons and ammo scattered around an environment containing multiple cover positions and AI enemies dynamically reacting to player actions and to each other, the player is free to express herself within this context and resolve the situation in any way she can. The possibility space is still somewhat limited, but there is nevertheless opportunity for a unique player story: *How I managed to beat those ten mercenaries!*

Of course, these player stories are only of a moment-to-moment nature, and don't extend into the rest of the narrative or even change anything about the next mission. Once the combat and/or traversal climbing ends and a transitional cutscene begins, the game snaps right back to the linear game story, which is identical for all players. The player is powerless to have any effect on how things turn out. Everyone who plays *Uncharted 2* to completion will see the exact same, expertly crafted conclusion.

Working in favor of games such as this is the fact that the hand of a professional writer can be put to good use, fashioning a strong and well-paced narrative that nevertheless allows for player choice and expression within certain confined areas of the experience. However, some players want more customization, control, and influence on events than is allowed for within this type of design.

Balanced Game and Player Story

A game design intended to strike a balance between predetermined story content and player choice and expression.

Hallmarks

- Same or very similar overarching game story for all players

- Limited, often binary game story variations based on player actions or decisions

- Some choice and/or customization of player character

- Non-linear and/or optional missions

- Significant opportunities for expression of individual play style

- Interactions with computer-controlled characters provide potential for emergent stories

Examples

- *Grand Theft Auto* series

- *Red Dead Redemption*

- *Fallout 3*

- *BioShock*

- *The Walking Dead: Season One*

- *Tomb Raider* (2013)

A reasonably equitable relationship between predetermined and dynamic story elements is the compromise favored by many popular game designs. Essentially it's an attempt to "have your cake and eat it too." The goal is to provide the main components of a satisfying, resonant, and classically structured game story, while also offering the player ample opportunities to—within that framework—express stylistic preferences, personal reactions to characters and situations, and a greater sense of agency.

Some games of this type provide an open-world environment teeming with AI to provide random and sometimes unpredictable encounters and peppered with quest-givers who dole out missions ranging from purely optional to a requirement for advancing the game story. The freedom given to the player to explore, combined with the systemic AI and their potential reactions to the player and to each other, can provide an environment rich with player story possibilities.

Many games in this category also provide the player plenty of choices when it comes to his player character(s). In addition to visual customization, the player can determine his avatar's areas of skill and expertise, either via menu choices or even by performing certain actions repeatedly in the game space and watching his player character "get better" at it. This unlocks certain player character verbs while ruling out others, providing for unique player story experiences.

Perhaps the most significant and challenging feature games of this ilk sometimes attempt is to incorporate player choices that *do* affect the overarching,

pre-crafted narrative in some way. These branched structures are tricky since, with multiple levels of branching, they have the potential to set up a combinatorial explosion of possibilities, each of which may require custom content—most of which will never be experienced by a given player during a playthrough. This can mean creating a large amount of content that most players will not see, robbing precious development time and effort from the content that the player *does* end up experiencing.

One solution to this dilemma is to restrict the ramifications of player choices to settings that are quietly tracked by the game itself. Invisible to the player, these "flags" don't usually change the big-ticket aspects of the narrative—where you go, what you must do—but instead alter more minor aspects of the experience along the way. For example, if you are rude to an NPC in Mission 1, the game may silently set a flag that is referenced and reflected when you run into that character again in Mission 3. (Perhaps he's much less friendly.) This approach may still require the creation of alternate versions of assets, situations, or entire missions, but improves efficiency somewhat by allowing for significant sharing of most assets.

BioShock silently tracks some of the moral decisions you make during gameplay and uses that data to present one of two different closing cutscenes. And *The Walking Dead: Season One* provides many small-scale choices in dialogue and action that can have noticeable effects on later events and situations. However, in order to control scope, the game's developers made sure that none of these flag-based variations change where you go, what you're tasked with doing, or how the story ends.

Another solution to the threat of a combinatorial explosion of branched content is to keep the choice binary and then "pinch back" into a single, unified story thread.

This was the approach we took in *Marvel: Ultimate Alliance 2*. Once the player chose a side in the super hero Civil War, he experienced a unique series of missions from that perspective—but then we introduced a bigger threat that required both sides to put aside their differences in order to face it. This allowed us to craft a unified third act that resolved the branching and saved us from effectively developing two different games. (That said, we also included some flags that allowed us to sporadically acknowledge which side the player had chosen in the war, including the playing of two mildly differentiated closing cutscenes.)

Using a balanced approach between game story and player story creates the potential to please the widest range of players—from those who crave a well-crafted narrative to those who want a decent amount of freedom and a significant feeling of agency. The main downside of this approach is an ongoing challenge in finding the correct balance and dealing with what may be unclear priorities during development between crafted and emergent storytelling. When both are considered equally important to the design, which one wins

when a conflict emerges? And of course, another risk when one attempts to provide the "best of both worlds" is to fail at doing either particularly well.

Player Story Dominant

This type of game design emphasizes player choice and agency over rich, pre-determined story elements.

Hallmarks

- Same or similar overarching game story for all players
 - Thinner, less developed and less compelling crafted story
 - Limited, often binary game story variations based on player actions or decisions
- Significant range of choice regarding player character
- Often multiple player characters with wide variety of customization options
 - Allows for "perma-death" of multiple player characters
 - Less emphasis on the creation of engaging, memorable game characters
- Emphasis on strategy and/or tactics

Examples

- *X-COM: UFO Defense*
- *XCOM: Enemy Unknown*
- *FTL: Faster than Light*
- *Warcraft* series
- *Starcraft* series

As we move further down the spectrum toward an emphasis on the player's story over the game's predetermined narrative, we come upon titles that provide highly systemic gameplay spaces with almost limitless player story possibilities—but which are nevertheless stitched together with a unifying story that is essentially the same for all players.

Looking at the examples in this group, you'll notice they are all strategy games with the player taking on more of a "god" role, controlling a number of disposable player characters and using them as a diversified team to achieve victory in various scenarios. While there may be named NPC characters either

on the battlefield or with the player in the command bunker (or equivalent), in general the controllable characters are template-based cyphers that the player eventually grows attached to and infuses with personalities based on her experiences with them, or just her preference. In the case of the X-COM games, *FTL*, and others in this genre, certain player characters may also be very close to the player's heart due to the expertise they've gained over the course of the game up to that point.

The potential for these characters to permanently die along the way without causing automatic mission failure—otherwise known as *perma-death*— adds much to the potential of the player story and its emotional impact. There is an "anything can happen" feeling during gameplay that players don't generally experience in games of the previous categories, and it can be intoxicating. Players may never forget emergent scenarios in games like these in which one of their favorite player characters paid the ultimate price to help achieve victory, or in which everyone in the group perished except for one terrified but dogged survivor who somehow pulled off the win.

However, these games also have an overarching game story—generally focused on an enemy force that needs to be defeated. The details will vary, and the narrative elements are probably thinner and more flimsy than in the previously described categories. But games of this ilk still tie their systemic gameplay experiences together with noninteractive sequences that are as aligned with the Three-Act Structure as any Hollywood epic. By providing context, structure, fictionalized motivations, and an emotional center, predefined narrative elements prevent the game from devolving into a repetitious, endless, and potentially empty-feeling experience.

99 Percent Player Story

A game design that includes characters and a world, but almost completely eschews crafted narrative structure in favor of gameplay.

Hallmarks

- No overarching story, just a world and narrative context
 - No ending *per se*
- Often multiple player characters with wide variety of customization options
 - Allows for "perma-death" of multiple player characters
- Emphasis on strategy and/or tactics
- Sometimes multiplayer-only

Examples

- *League of Legends*
- *Titanfall*
- *Team Fortress 1* and *2*
- *SimCity* series
- *The Sims series*
- *Civilization*
- *Mortal Kombat*
- *Dead or Alive* series
- *Super Smash Brothers* series

Finally, there are games that feature characters and take place in a fictional world, but in which stories *only* emerge in a systemic fashion. They generally fall into three genres: simulation games, fighting games, and multiplayer-only battle arenas (MOBAs).

In all three types, only a touch of game story is applied at the outset—to establish the context of a fictional world, a starting situation, and possibly characters in that world—and then the player is essentially turned loose in the play space, free to take whatever actions are allowed by the rules and systems.

Simulation games, such as the aptly named *SimCity* or *The Sims*, feature dizzyingly complex and interdependent systems that create massive possibility spaces, allowing for maximum player expression. The player doesn't directly control any characters, but instead controls situations, setups, and organizational elements to influence characters and cause events to move in one direction or another. Complex interactions between the various in-game systems produce interesting and highly unpredictable results that, with the benefit of hindsight, should mesh with what the player knows of the world and the choices he's made. With no specific victory condition, the player's story can go on indefinitely.

The main strength of this setup is getting out of the player's way and freeing him to start creating her own stories within the space. However, with virtually no game story or direct control of player characters, this genre of game is aimed at a very specific type of player. Only the very best of these games can hope to capture a large audience.

Fighting games, their origins generally traced back to the venerable 1991 arcade hit *Street Fighter II*, have rarely incorporated much of a pre-crafted narrative structure to their proceedings. Their players come for one thing: to fight! And designers of these games generally focus on giving those players

what they want, allowing the stories to emerge from the endless interactions the play space allows. A recent exception to this rule was the surprising hit *Injustice: Gods Among Us* (NetherRealm, 2013), a traditional fighting game featuring the DC Comics super heroes and villains, and incorporating an epic, extended story experience.

Multiplayer-only games set up a general context and then rely heavily on players to generate emergent stories for each other. It can be an effective strategy. After all, there is nothing less predictable or controllable than other human beings, and *en masse* they will come up with all kinds of behaviors and tactics within the rulesets that a designer (or small group of designers) might never imagine or plan. Examples at the time of this writing include the very popular MOBAs *League of Legends* and *World of Tanks*.

Designers of MOBAs know that players who come to enjoy their product—even those who might otherwise appreciate a linear story in a single-player game—do not have much interest in narrative content when it comes to team-based competition in a shared space. Apart from outside-of-game lore content, the developers don't waste their time creating or integrating story material, and they don't let it get in the way of the players' shared experience.

The downside of this approach is that your game may feel less like an intellectual property and more like a gameplay facilitation space. Player loyalty and attachment will not be so much to your world or characters but to your game systems, which are difficult to transport to other media for continued expansion of the property.

So Whose Story Is It, Anyway?

When weighing the benefits of leaning toward one end of this spectrum or another, it's important to keep in mind that the bars of quality for game story vs. player story are very different.

As discussed, game stories are crafted and predefined. They can be developed slowly, tweaked and refined, tested and perfected. These are all qualities they share with the storytelling approaches of more traditional media such as movies. And because of this, game stories are often compared to the best examples from those other media.

And, for many reasons previously covered in this book, they are often found wanting.

However, player stories, emergent and personal, are judged by a different standard. It often doesn't matter if the story is objectively a good one. A player story is much better received by the participant *simply because she was there*.

If the player were to excitedly relay her personal story to someone who wasn't present and didn't take part, the tale will probably not hold up very well.

If you don't believe me, talk to a friend who plays *Dungeons & Dragons* and ask her to tell you about her latest quest in the game! As thrilling as it may have been for her to directly experience it at the time, the resulting narrative will almost surely be less than compelling to an outsider. *You had to be there.*

But for the player herself, it will be memorable.

Which is more exciting, more heart-pumping, and memorable—a movie about a baseball team making an incredible comeback to win the World Series, or watching it actually happen to your favorite team, in real time, right in front of your eyes?

Even though the movie version might be better crafted—with well-defined characters, compelling cinematography, perfectly tuned dialogue, and a rousing score backing it all up—it will probably fail to evoke the same degree of raw emotion that watching a less-polished but emergent version would. Why? Because the audience *knows* it's pre-crafted, *knows* it's not actually happening. Suspension of disbelief only goes so far when compared to something that's for real. Thus, the objective quality bar for an emergent story is much lower than for a pre-crafted game story.

This isn't to say that every emergent story is superior to every pre-crafted one. Game stories, being crafted and refined, are more likely to hit at least a certain bar of emotional impact, while player stories, by their very nature, can and will be all over the map—from incoherent and eminently forgettable to transcendent and indescribably thrilling.

The potential for the latter scenario to occur is among the reasons *League of Legends* is one of the most popular games on the planet at the time of this writing, with over 27 million people playing it on any given day.

That said, the more your design relies on emergent versus predefined stories, the more pressure it puts on your game designers—and possibly the rest of the team—to create play spaces with almost endless potential for unplanned but emotionally compelling interactions. Game stories are powerful tools to enhance the entire experience. If you decide to eschew them in favor of the player's story, your game design and its systems had better be pretty fantastic!

Final Thoughts on Overall Game Design

During the long slog of a game's dev cycle, it is frighteningly easy for "Game Design plus Narrative" to become "Game Design vs. Narrative."

In the previous chapter ("Team Leadership") much time was spent discussing the pushing and pulling that can and does occur during development of a game featuring a significant narrative element. Although various other considerations can impact your narrative plans, design tends to be the consideration that most often comes into conflict with story development.

In a story-based game, changes in design or narrative plans can wreak havoc on each other.

As a creative lead, you have the power to balance these various factors and decide, on a case-by-case basis, which is most important. Every time Design and Narrative come into a conflict that is escalated to your level, you need to do your best Solomon impression as you weigh the various benefits and costs—not only to the project, but to the enthusiasm and morale of your team members on both sides of the divide.

This should be nothing new to you. Indeed, saying yes to some ideas while saying no to others is a primary function of being a creative lead. But when Narrative is in the mix, it tends to be regarded as the ugly stepchild and can often be trumped by other considerations, almost by default.

This is not a problem if you've decided at the outset that your game's narrative quality isn't terribly important to its success (and if you're correct in that assumption!). But if you believe the story content of your game *is* central, and *is* vital to its success, then in the heat of game development, it's important at these junctures to step back for a minute and remind yourself of your priorities. The damage being done to a narrative structure in its formative stages is often only perceptible to the most experienced of writers and editors. So don't assume that the "small" change you're requesting your narrative experts make to their story design to be minor, especially if they indicate otherwise. As we covered in chapter 6, a "cool" idea may inadvertently introduce a risk to the story's believability, characterization, pacing, or even to its structural integrity.

Understanding these risks is the first step in mitigating or even eliminating them.

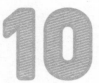

Game Character Development

Characters are a requirement for any story, and so it follows that they are also a necessity for any game that includes a narrative. The quality of a game's characters will have a direct impact on the potential strength of its storytelling.

Conceptualization, design, and implementation of every character in a game involve a number of team members, working across disciplines. The process can vary wildly depending on the target platform (e.g. smartphone versus console versus high-end gaming PC) and type of game (e.g. simple platformer versus robust RPG). It often includes team members working in the following areas of expertise, fulfilling specific functions:

- *Design*—describes the design need for the character (or character class) and defines the character's abilities, strengths, weaknesses, and overall role with regard to gameplay.

- *Narrative design*—provides the character's context, backstory, details, motivations, and dimensionality.

- *Concept art*—designs the character's look and feel, including her clothing and gear.

- *Final art/3D modeling* (depending on whether it's a 2D or 3D game)—creates the character's final in-game appearance.

- *Animation*—brings movement to the character.

- *Casting*—selects an actor to bring voice or even full performance to the character.

- *Audio/Performance*—elicits the best performance from the actor.

- *Implementation*—places the character, with all appropriate assets, attributes, and functionality, into the actual game.

Another variable that can affect the complexity and scope of this process is the prominence of the character in question. For example, a main, playable character will tend to go through many more character development steps and iterations than an NPC who appears briefly in one minor mission. And an entire class of combat enemies will have a different conceptualization process than a non-combatant NPC. But these variables aside, character development still tends to involve nearly every discipline and sub-discipline on a game dev team.

Design

Every character in a game—like every character in a story—should be there for a specific reason. The very first step in the game character development process, then, usually comes from a Design requirement, such as:

- We need a main character for the player to become.

- We need a boss for the player to fight against.

- We want to give the player a quest—someone needs to deliver and explain the challenge.

- We need several dozen "fodder"-type enemies to create an escalating challenge for the player in this mission.

And so forth.

As a potential first link in this chain, the designer must very clearly define why this character exists and, at a core level, what Design needs from it. For example, Character A needs to be able to detect, move toward, and attack the player with either melee or ranged attacks; Character B has no combat requirements but needs to be able to talk to the player to provide a quest.

It can be tempting to wander into the area of Narrative Design here, as the designer might instinctively start weaving contextual whys and wherefores into the fabric of the character definition. There's nothing inherently wrong with that, but all that is usually *needed* at this earliest of stages are the answers to some basic, Design-centric questions:

1. Why do we need this character?

2. What function(s) is he intended to serve?

3. How prominent in the game is this character likely to be? How much in-game "screen time" will he probably get?

4. Is it a single character or a class/group? If the latter . . .

 a. About how many of them will the player encounter?

 b. Is it enough that a variant-generating system of some kind may be required?

5. What ability or abilities are implied or required?

6. What strengths or advantages are implied or required?

7. What weaknesses or vulnerabilities are implied or required?

8. Does (or can) anything about the character grow and change over the course of the game?

Out of this information comes a specification sheet for the character that will support Narrative Design as well as other downstream team members such as AI designers, systems designers, combat programmers, and AI programmers.

Writing/Narrative Design

This is usually the second step in the process, though sometimes it can be first—for example, in a licensed game with an established intellectual property and pre-existing characters, or with a character essential to the narrative but not to gameplay. (Though those should be kept to a minimum.)

Using the answers to the Design-centric questions listed above as a starting point, the writer works to fashion a narrative conceit that:

- Is consistent with all Design intentions/requirements

- Fits into and enhances the overall story

Easier said than done. Often, there now begins a back-and-forth between Narrative and Design, mostly with regard to the game's major character(s), and especially the player character(s). When it comes to game characters, there are perhaps no aspects more critical to align than the game and narrative designs.

Player Character Ludonarrative Harmony

As discussed in the previous chapter, the entire game will revolve and be constructed around the player character and his verbs—what he is able to *do* within the confines of the game space. If the player character can jump, then

jumping challenges will be built into the design. If the player character can shoot, the designers will set up objectives, scenarios, and layouts conducive to shooting things. And so forth.

The entire narrative, too, is generally built outward from these mechanics, abilities, and limitations. The game writer asks herself: Is there a way to narratively explain and/or justify what this character will spend most if not all of his time actually *doing*? Who is this person who mainly does this thing?

Here's a stupid but simple (and therefore clear) example: if the only thing the player will be able to do in the game is chop things down, then doesn't it make the most narrative sense to put the player in the role of a lumberjack? Or maybe a beaver?

Now think of a real-world example: *Mirror's Edge*. At its core, it's a game about running across rooftops and making near-impossible jumps across dizzying gaps. What kind of person does this on a regular basis? A parkour expert, for one, and so that's who our playable character is in the fiction. Her name is Faith, an independent risk-taker who fights against a repressive totalitarian regime. She's even *named* in relation to the core game mechanic (as in "leap of," which is what the core mechanics often feel like). This is a good example of Design and Narrative working together to create a unified vision for the player character.

Similarly, Kratos in *God of War* is a player character featuring admirable ludonarrative harmony—a Spartan warrior out for revenge on the gods who are responsible for him inadvertently killing his own family. That's a character concept and motivation well matched to the bloody, ultraviolent nature of the player character's gameplay abilities.

One of the few criticisms leveled at the hugely popular *Uncharted* series is that the main character of Nathan Drake constitutes a less-than-ideal match between the kind of person the narrative portrays and the things you (as Nathan) actually do in the game. There is a noticeable disconnect between the likeable, happy-go-lucky, joke-cracking adventurer we know from the cutscenes, and the guy we actually control during gameplay: a heavily armed, relentless killer of hundreds if not thousands of people who stand between him and the artifacts he seeks.

Uncharted easily survives this ludonarrative dissonance, evidenced by three very successful and critically lauded titles at the time of this writing. Because it does so many other things incredibly well, *Uncharted* can afford this kind of contradiction—whereas the game on which you're working may not be in such an enviable position. And to a small degree, even *Uncharted* has been taken to task for this contradiction by some reviewers, columnists, and academics.

As Mike Bithell, developer of story-based indie hit *Thomas Was Alone* puts it:

> If you've got a character who's a pacifist, don't give them a gun. Or if you do give them a gun, talk about that relationship. But . . . don't make them enjoy killing people and don't make the act of killing people enjoyable to the player. Basically it's about avoiding contradictions. A lot of storytelling is about avoiding that break.[5]

Design/Narrative Negotiations

The character conceptualization process is not always a one-way street, with Narrative constantly scrambling and contorting to justify every item on Design's checklist. Narrative conceits often come with some of their own baggage, which may factor back into gameplay.

For example, imagine if during development of a space marine shooter, Narrative wants to include a Luddite-type enemy character group who eschews the use of high-tech plasma firearms in favor of old-style, gunpowder-based weapons. While on the surface this might seem like a harmless concept, it could have serious implications for Design. If the combat economy depends on having defeated enemies drop plasma ammo for the player's plasma gun, what will happen when the player encounters an entire mission full of these bullet-shooters (who don't drop compatible ammo)? Now the designers will have to either push back on the idea, or figure out an alternate way for the player to replenish her ammo supply during this mission.

Any negotiation process between Design and Narrative needs to begin with both sides first acknowledging the other's legitimacy and importance. Of course, you'd be hard pressed to find any professional game developer who doesn't believe a successful game design is important to a title's success. However, the same is sadly not true for Narrative. And so this is where video game storytelling experts can sometimes find themselves on the short end of the stick, especially when dealing with designers who are less enthused about the idea of narrative in games.

Character Description Documents

Once Design and Narrative have settled on the main aspects and functions of a major character as they pertain to their respective disciplines, it's time for the rest of the team to begin bringing said character to life. However, before that can happen, much more information needs to be generated and documented.

5 http://www.gamesradar.com/real-problems-video-game-storytelling-and-real-solutions/

Each discipline involved in the realization of the character will have their own set of questions before they get started. With Design's goals and Narrative's goals aligned, the narrative expert now weaves all these traits and abilities into one or more fully developed Character Description Documents (as mentioned on page 94 in chapter 7). Sometimes a single master document will house all the pertinent information anyone might need, while other narrative experts prefer to create different versions tailored more specifically for various audiences.

The amount of backstory and detail that comes out of this effort will vary depending on how prominent the character is going to be in the game and story. But it is usually a lot more information than the audience will ever be exposed to directly.

Generating overly detailed character descriptions is something most fiction writers are used to doing, as it's information they will need anyway, in order to write the character in a consistent manner (as covered in chapter 4 and chapter 7). The better and more intimately a writer knows his characters, the better those characters will be written—because they are more likely to act in a consistent manner and speak with a unique voice. This detailed information will also serve downstream team members well.

Here are some details about a main or major character that should be communicated via one or more Character Description Documents.

Basics

- Name

- Sex

- Race/species

- Age (equivalent human age as well, if applicable)

- Intelligence

- Education type and level

- Profession

- Vocabulary

- Backstory

Deeper Dive

- Character arc/change

- Desire

- Likes

- Dislikes
- Values
- Key flaw(s)
- Vices

Visual

- Physical attributes
- Clothing
- Weapons/paraphernalia

For a sample Character Description Document, see Appendix I.

Concept Art

Concept artists almost universally have fantastic ideas for characters, as well as environments and objects; but they cannot—or at least should not—work in a vacuum. Everything they design tells a story: the story of a people, of their past, their values, their priorities, their current challenges, fears, and accomplishments. The narrative expert must supply this information, or the concept artist is forced to create it herself. And if that happens, it's likely that the writer's vision and the concept artist's vision will be inconsistent, and that someone's work may have to be revised. This is neither efficient nor conducive to a positive working relationship or a harmonious result.

Ideally, the writer will provide the aforementioned detailed Character Description Document prior to a concept artist starting her work. Further, the concept artist should be encouraged to ask follow-up questions, to suggest her own ideas, and to collaborate in the truest sense of the word with the writer.

Detailed character information allows the concept artist to consider every aspect of the character while designing potential visuals. Knowing how old the character is, what his upbringing was like, his fears, goals, and prejudices—detailed, personal information such as this will fire the concept artist's imagination and help produce not only the best designs, but the ones that help tell the character's story.

What does a scar across the face tell us about someone? How about a person who only wears black? Someone armed mainly with knives in a world populated by gunslingers? A man who wears a mask? Or one who chooses not to wear a mask when everyone else around him does? These are the kinds of details that help convey important information about that character, at a single glance and with no need for tiresome explanation.

Some characters might even have arcs that result in fundamental changes to who they are and what they believe and stand for. Is a physical manifestation of these changes called for, and if so does the concept artist have a firm understanding of what the changes are and how they might be visually depicted?

Every element of the character's look should tell us something about him, and that something should be consistent with the writer's vision of that character. If you, as a concept artist, don't have the information you need regarding that vision, ask for it. Demand it!

2D Art/Modeling/Texture Work

While the 2D artist(s), modeler(s), and texture artist(s) working on a game character generally have concept art on which to base their own work, it is still important for them to understand Design and Narrative intentions with regard to that character. They need to know not just the whats but the whys. Thus, a detailed Character Description Document is just as important for them as any other member of the team helping to bring the character to life.

Animation

Animators are generally given—or generate on their own—a move list for each character or character type. They are often dry, purely functional lists based on every type of movement that character must be able to demonstrate in the game. Walk. Run. Jump. Double-jump. Take a hit. Pull out a weapon. Change weapons. Shoot. Die. And so forth.

However, a good animator doesn't just look at the rigged character model and the move list and start animating. He digs deeper into the character, trying to find out as much as possible about that character. This is where the detailed Character Description Document proves its worth once again.

The way a character holds herself and moves says a lot about who she really is. Yes, the character will need a walk cycle—but *what kind of walk is it?* Confident? Cautious? Slow? Fast? Sauntering? Striding? Revealing an old injury? That walk—and every other move she makes—reflects the character's personal history and subtly reveals character traits that would be clumsy to express otherwise.

Conversely, inappropriate animations can contribute to the creation of an inconsistent and poorly defined character. For example, a game on which I once worked featured an established badass character, a guy who had been seen to be coldly, ruthlessly efficient in everything he did—no wasted effort or movement. One of the animations required was for him to holster his pistol, and the animator chose to have the character do a fancy "spin the gun" move before shoving the pistol back in its case.

It looked undeniably cool, and the a-word ("awesome") was even heard from some team members upon first seeing it.

But that "spin the gun" move said something about the character that clashed with what had already been established as his nature. It was a flamboyant, showy display coming from a decidedly non-showy character. And ultimately, I found myself in the unfortunate position of having to argue against its inclusion. It was a "wouldn't it be cool if" situation if I've ever seen one.

So, while every animation has the potential to reinforce and enhance characterization, it also has the potential to clash with it and muddy the narrative waters. Thus, Animation and Narrative need to be tightly synchronized in order to achieve a pitch-perfect result.

Final Thoughts on Game Character Development

One thing that should have come through loud and clear in this chapter is that in order for a game to feature well-conceived, consistent, and believable characters—whether the player character, an enemy AI, or a neutral NPC—the team members working on those characters' development must all work from a unified vision. That vision—based either on an original concept or a pre-existing one—is generally described and owned by the person in charge of the game's narrative design, and thus should be clearly described to the rest of the team before they start their own work.

By the time all this information about your major characters is in circulation and has been fully discussed and digested, the team will be as familiar with these fictional people as they are with their best friends. Which is exactly as it should be!

Level and Mission Development

This chapter is most applicable to *level designers* and anyone else involved in the creation of game levels, missions, and objectives.

In nearly every video game, somewhere between the lofty goals of the overall game design and the rubber-meets-the-road reality of the moment-to-moment core game mechanics, is what most players will remember actually experiencing: *game levels*. (Note: Throughout this chapter, the terms "level," "mission," and "scenario" will be used interchangeably.)

Like paragraphs on a page or chapters in a book, game levels organize ideas and experiences into discrete, contained, and digestible chunks. They are generally designed to stand alone, providing a focused and satisfying unit of entertainment. At the same time, they also link together to form a larger experience and an overarching story—pre-crafted or emergent, but most often a mixture of both—that the player will sense and appreciate over the span of the entire game.

In a narrative-focused game, one of the closest working relationships should be between narrative experts and mission designers. After all, levels are the chapter-like expressions of the game story. Each mission should therefore move the story and characters forward. And if the game's levels don't hold up individually, as well as binding together to communicate a cohesive overarching narrative, the final result will be muddled and much less emotionally impactful.

Incidentally, much of what is covered in this chapter also applies to "instanced dungeons" in MMO titles. The structure and development process for one of these private-party quests is very similar to that of a traditional game's level-creation process, except that in an MMO the requirement to fit into a larger, crafted narrative is usually absent or greatly reduced. But an instance still must provide a discrete unit of entertainment, which, structurally, often strongly resembles a mission from a traditional video game.

Level design is a broad, complex topic that has filled numerous books much more lengthy than this one. For this chapter, then, we will briefly touch on the areas in which level design and narrative design most commonly intersect.

Shared Intent

At the very outset of conceptualizing a level, there needs to be an understanding and consensus on overall game approach and tone, and creative aspirations and functional goals for that particular mission. Why does this scenario exist at all? What do we want to get out of it—from the minimal baseline requirements all the way to loftiest hopes?

These and many other questions should be asked and answered before a level designer actually begins designing.

The *Level Design Document (LDD)*, created and owned by the each level's designer, lays out the plan for an individual mission. LDDs vary in level of detail from brief overview to meticulously documented and exhaustively mapped guide-book. Regardless of format or length, though, LDDs are also a good home for information on up-front narrative context and storytelling goals for the mission.

Before the LDD is completed and used as a blueprint for the level designer to begin crafting the actual mission, Narrative should weigh in and make sure the level designer and anyone reading the document also under-stands the following:

- Where in the overall story does this level takes place?

- What happened in the previous mission, including any interstitial narrative content bridging that mission and this one?

- What is the next mission and how is this one supposed to lead into it?

- What does this level absolutely *need* to accomplish, narratively?

 - Any main plot points or story beats that occur within the level.

- What are the main characters' current emotional states and why?

- Where are the main characters in their arcs (if applicable)?

- How is this mission supposed to make the player feel (beat by beat)?

The LDD, in addition to *containing* this narrative information, should of course be *aligned* with it as well. That is to say, the mission design documentation and all its components should reflect and support the narrative information and goals.

Further, the LDD should not be discarded once a playable version of the level has been developed and inserted into the actual game. Ideally, the LDD should stand as a living guide to the details that a rough pass on the physical space just can't communicate to other team members by itself.

For example, you'll notice that a number of the items in the list on the previous page have to do with emotion and how characters and the player are meant to feel during the mission. Ultimately, at a very core level, every aspect of a game exists to do the same thing: *make the player feel.*

Nearly every game, no matter what type, is designed to be fun. "Find the fun" is an early goal of most new game projects, especially those based on new, untested designs. But beyond the simple experience of "having fun," game developers working on titles with loftier goals often want to evoke emotions from their players as well: fear, anger, jealousy, sorrow, regret, pity, love, hatred, and many others.

The desire to make the player experience a specific emotion while playing almost always originates from either Design or Narrative. If Design wants the player to feel empowered and majestic at a certain point in the gameplay experience, all other disciplines—including Narrative—move to support this directive. If Narrative believes it's important for the player to feel alone and helpless for a specific moment in the story, the other disciplines—including Design—are in the support roles.

Since so many elements of a game are trying to make the player *feel*, it's supremely important that at any given moment they're working together to evoke the same emotion. They all need to be pulling in the same direction. However, the various game development disciplines are not Olympic rowers timing their pulls to the reliable, predictable, and rhythmic calls of a coxswain. It's not nearly that simple.

Every story and every mission will have emotional peaks and valleys. Sometimes the intended emotion on a moment-to-moment basis is obvious to everyone concerned—other times, perhaps not so much. A relatively foolproof way to make sure everyone is on the same page is to actually *put* it on a page, in the form of what some developers call an *emotion map.*

The form varies from writer to writer, but the goal is the same: lay out, in no uncertain terms, what the main emotion is supposed to be at each key point in storytelling and gameplay.

Here is a hypothetical emotion map using an Excel template with simple numbers driving a line graph.

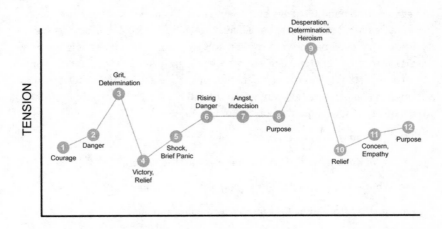

In this scenario, the player fights his way (Point 1 on the graph) into a heavily fortified bunker alongside an NPC "buddy." The twosome must take out a sniper (Point 2) blocking their path, after which the pair charges the bunker (3), dodging enemy fire and tossing a grenade into the stronghold. After fierce, close combat, the player and his buddy emerge victorious (4). But as we transition into a cutscene, the "buddy" is shot in the shoulder (5) by a sniper from outside. Suddenly the player realizes that other enemy forces are converging. They've gone from having to invade the bunker to now having to defend it (6)! Back into gameplay, the player must choose (7) between firing on the incoming forces, or pulling his friend to safety. The player chooses to save his squad mate, dragging him to cover (8), after which the player pulls out his gun and begins firing on the incoming soldiers (9). The enemies just keep coming but the player manages to cut them all down just before they breach the bunker (10). Back into cutscene, the player sees that his friend is losing blood and needs medical attention (11). The player is given a new objective: find a medical kit (12).

The emotion map helps make clear what we want the player to feel during each of these turning points. This can be used by everyone involved in crafting this experience, and is especially helpful to Audio (which we'll cover in more detail in chapter 14) team members.

Bottom line: there needs to be a guide that indicates in some way *what emotion*, and *when*.

Ludonarrative Harmony

This topic has been covered in several other chapters, but it bears revisiting at this point. Missions are generally composed of a series of tasks and challenges presented to the player. The player is asked or is required to *do* something.

And even during noninteractive story sequences such as cutscenes, the player character is often seen making decisions and taking action. As the story is told via mission happenings both pre-crafted and procedural, instances of ludonarrative dissonance can be more likely to rear their ugly (if sometimes subtle) heads.

It's important to keep in mind at all times, especially while coming up with mission objectives and events, that the following three motivations should always be as closely aligned as possible:

- What does the player want?

- What does the player character want (in the fiction)?

- What is the player/PC either doing or being asked to do?

They are further framed by several more considerations:

- Who is the player character?

- What makes sense for the story?

- What's consistent for gameplay?

An effective if oft-used example of this being done right is showing an antagonist doing something horrible—either to the player or another in-game character—and then almost immediately allowing the player to attack him. Making the player angry at an enemy is a great way to provide a strong emotional undercurrent to what would otherwise be just another combat encounter. As long as attacking the enemy makes sense for the story and the player character at that point in the experience, everything should line up and feel right to the player during the battle, and satisfying once the bad guy has been taken down.

If misalignment is going to happen, though, it will most likely happen while mission events and goals are being conceptualized, with no one keeping an eye on possible dissonance.

Potential mismatches from this group of considerations include:

- The player character does or wants to do something that the player does not want to do.

- The player character does or wants to do something that doesn't jibe with what we know about her.

- The player and player character both want to do the same thing, but the objective is to do something very different.

- The objective or action doesn't make sense from a story perspective (i.e. nonsensical, unrelated to the conflict, or in contradiction to higher-level objectives).

- The player and player character don't want to do something, but the mission objective requires that they do so.

A prime (if extreme) example of this last situation is the notorious "No Russian" mission in *Call of Duty: Modern Warfare 2*, in which the player is undercover among Russian terrorists whose goal is to ignite a war between their country and the United States.

In order to maintain his cover, the player character (and thus the player) is forced by the game to either sit idly by while the Russian terrorists gun down scores of innocent people at an airport, or actually participate in the slaughter. Those are the two choices. The player is given no option to stop the carnage; if she fires on the terrorists, the mission instantly fails because the player character's cover was blown.

This level ignited much controversy at the time, and to this day stands as a less-than-beloved memory; a risk on the developers' part that at the very least attracted a good deal of negative attention, from within the industry and from without. Players simply did not want to gun down innocents at an airport, or even stand by and watch it happen as an inactive participant.

As I said, it's an extreme example and there's no way that the developers were unaware of its potential dissonance when they created the mission or shipped the game. It was, to one degree or another, a gambit by the developers. But "No Russian" illustrates the concept in very clear terms: mission goals that the player actively does not want to accomplish can be a major problem.

Of course, every rule has its exception(s). A more successful version of this kind of dissonance can be found in the first-person puzzle game *Portal*. At the beginning of Test Chamber 17 the player is introduced to the Weighted Companion Cube. It seems identical to other cubes seen in the game up to that point, with the exception of a pink heart design featured on each of its six sides.

The Companion Cube, as a weighted object the player can carry and place on the ground, is essential to completing this mission puzzle, and it never shows any sign of life or sentience. And yet somehow—possibly due to the cheerful heart design, or the notoriously unreliable Mentor GlaDOS's repeated admonishments that the Cube is not alive—over the course of the mission the player somehow gets emotionally attached to the object.

At the end of the mission, in order to exit the test chamber and continue the game, the player is required to "euthanize" the Companion Cube by pushing a button to open an incinerator pit and then actively drop the Cube into the flames. Many players reported feeling reluctance before performing this act, and nagging guilt afterwards. Some—myself included—spent a good deal of time making futile attempts to find a way to avoid destroying the Cube.

The master storytellers at Valve, so skilled and confident, risked the purposeful inclusion of strong ludonarrative dissonance in order make a

point—that human beings can generate empathy for almost anything, even inanimate objects. However, the key word here is still "risk," which is always in play when it comes to ludonarrative dissonance.

So, when creating a mission objective—whether it's the ultimate goal for that level or a midterm means to that goal—work with your narrative expert to check it against this list:

- Will the player want to do this?

- Would the player character be properly motivated to do this? ("Want" is not necessary; it may be something the PC would rather not do but feels she must.)

- Is there something else the player and/or PC would probably rather do in this situation instead? If they are prevented from doing so, have you thought through your reasons for withholding it?

- Does this goal make the most sense for the internal logic of the story, the world, and the characters at this point in the experience?

- Does this objective—even in a small way—relate to and help to resolve the story's main conflict? If so, how?

If a mission goal creates a conflict with or between any of these areas, it will generally fall to Narrative to pick up the pieces and try to justify the objective even if it doesn't really fit. This can negatively impact storytelling, and without being able to change the quest itself, the narrative expert's hands are effectively tied.

When Narrative Impacts Design

Although mission objectives generally originate from Design, they can emerge from narrative goals as well, as can the overall structure of a mission. When generating this kind of content, it's important for the writer to avoid concepts that squander or even fight against the established core gameplay mechanics. This is one of the big reasons that narrative experts need to collaborate with the rest of the team throughout the development process, instead of following a Hollywood-like model where the writer hands off a script and expects the rest of the team to simply execute on what's been written.

An example of narrative needs frustratingly trumping established game-play mechanics can be found in several story missions in *Far Cry 3*, most notably in the one entitled "Doppelganger." By this point in the game—it's the thirtieth story quest—the player is well versed in the game mechanics and using stealth to pre-plan solo attacks on base camps occupied by multiple

hostile soldiers. In the main, open-world game, the player can use as much or as little stealth as he wishes in these systemic scenarios, and if he breaks stealth the soldiers will begin actively hunting him down and calling for reinforcements. Gameplay continues. The player can still win the battle, but it certainly gets a lot harder!

The unpredictable nature of how these scenarios unfold, the freedom of the player to act however he sees fit, and the world's believable, ongoing reactions to those choices are major factors that make the open-world sections of *Far Cry 3* so compelling.

However, in this story mission, the player is suddenly *forced* to use stealth to get past a number of guards, and there is no other option. If a guard sees the player character, the mission instantly fails. This is a violation of everything the player has been taught about stealth in *Far Cry 3* up to this point.

One can only assume the reason for this approach was so that stealth could definitely be maintained up to the next story beat, keeping the narrative on its intended track. If the enemies were aware of the player character's presence from that point on, the later parts of the mission's story would have broken. So the solution was apparently to just prevent the player from proceeding if stealth failed. But the sudden, temporary change to the gameplay mechanics is jarring—especially since it is a setup so much more restrictive than what the player has by now grown accustomed to.

The game story should never force a major change to established game mechanics unless it's absolutely unavoidable, or if the end result somehow justifies the dichotomy.

The Three-Act Mission

Levels in a game are often a lot like episodes of a TV drama, especially when it comes to narrative structure. While there are larger story and character arcs in TV shows that span multiple episodes and even seasons, each individual episode usually contains its own conflict that's introduced at or near the beginning of the show, and is resolved within that sixty-minute timeframe (minus commercials). Beginning, middle, end. Introduction, confrontation, resolution.

Similarly, each mission in a game generally starts with a conflict being introduced—possibly even at the end of the previous level or within interstitial narrative content placed between missions.

Gameplay then revolves around the Act II equivalent of confronting the conflict, by resolving a series of sub- or even micro-conflicts (for example, each individual enemy blocking your path could be considered a micro-conflict). Ideally, this series of goals creates a rising action driving toward a climactic crescendo.

And when the overall conflict for the mission is resolved, we generally get a noninteractive but satisfying Act III "outro" cutscene or other narrative

presentation that acknowledges the player's success and reveals the effects of the mission's main conflict being resolved. Even if it's often the revelation of the next conflict!

Whether you're consciously making it so or not, your mission in all likelihood sports many if not all aspects of the Three-Act Structure, and probably the Monomyth as well. So, having a good understanding of these classic story structures is important when blocking out the big beats of a game level.

Surprise, Believability . . . and Fairness

Other critical storytelling elements such as surprise and believability—covered in chapter 6—are very much applicable and important to keep in mind while mapping out the events (or potential occurrences) in a game level.

As previously discussed, there is a delicate balance between a story's need for interest-enhancing surprises and the simultaneous requirement to not shatter believability.

Ideas for big-ticket surprises often emerge during the development process for a level, mission, or quest. These "wouldn't it be cool if" concepts can have the power to invigorate the experience and create an impactful "set piece." There's no question that surprises and shocking events can be electric and exciting, but as covered in chapter 6, they can also present major roadblocks to maintaining narrative integrity and believability.

In games, the balance between surprise and believability is further complicated by another consideration: fairness.

Because when a narrative-related surprise happens while a player is engaging with gameplay, it can be good news for storytelling but bad news for the player. Often the surprise spills over into gameplay itself—indeed, this is often the very point of the surprise—creating an unexpected situation for which the player finds himself unprepared. It can be exciting, when well done.

But when poorly handled, a surprise can feel cheap and unfair. It can cause the player to fail or even "die," probably at no reasonable fault of his own. How was he to know you were going to change the rules partway through the mission? Then, when the player restarts from a checkpoint or even the beginning of the level, the surprise is now gone (the player is ready for it this time) but the feeling of annoyance might remain.

Thus, keeping fairness as well as believability in mind when preparing an unexpected turn of events for players is just one more thing a level designer and his narrative collaborator need to think about. If you're going to surprise a player, make sure he's also provided the reasonable means and opportunity to recover from and deal with it.

Enemy Placement

Believability can also be sorely tested when it comes to the final placement in a level of NPCs—especially antagonists. Enemy placement is a design task that can take a huge amount of effort and tuning in order to optimize the player experience, throttle the difficulty level, and regulate gameplay pacing.

On the narrative side, the challenge is different but can sometimes be no less obstinate. Narrative is constantly required to justify the seemingly endless waves of enemies a player encounters in a typical action title or shooter. Although an effort will probably have been made to narratively explain the enemies in general, there sometimes also arises the question regarding each individual enemy or small group.

In a visual medium like a video game, players might be apt to notice enemies just standing around, waiting for the player to get within their detection range before they charge in for the attack. The oddness of their placement might become more obvious when the player is given the opportunity to visually take it in and evaluate it. "What is that guy doing over there? Apart from just standing around waiting for me to get within his detection range?"

Beyond just odd, sometimes placements seem downright impossible. If an enemy is positioned in a tower with no discernible way he could have gotten up there (i.e. no stairs, ladder, etc.), the level designer may be thinking too much about gameplay and not quite enough about believability.

The problem here is tangentially related to one we covered in chapter 4 (see page 46). When you think about your bad guys merely as obstacles to the Hero instead of living, breathing characters with their own lives and internally rationalized motivations, you weaken the integrity of your storytelling and possibly of the entire experience. This doesn't just apply to the main Villain; it applies to every character in the game. So, when it comes to the placement of enemies in a level, we must balance gameplay needs and narrative believability, from the macro (the main Boss) down to the micro (the weakest thug in the game).

Final Thoughts on Level and Mission Development

In a narrative-rich game, much of the actual storytelling often occurs during gameplay, and particularly in game levels or missions. A level designer who understands the basics of storytelling and who is an enthusiastic collaborator with narrative experts will bring an enormous benefit to the levels and the game on which he's working: mission objectives that align with what the player and his avatar want, surprises that provide drama but not frustration or unfairness, and an emotionally impactful experience that never strains or breaks the player's suspension of disbelief, keeping him enthused and engaged every step of the way.

Environments

This chapter is most applicable to *environment artists*, *concept artists*, *level designers*, and anyone else involved in the creation of game locations.

In games featuring a strong focus on character and story, game missions and their locations must become more than just optimized play spaces. Ideally, the components, attributes, and appearance of each level and its environment will also help define and elaborate on the imaginary world of the game. This in turn can help connect the player to that world, and—when appropriate—emotionally invest her in protecting it from whatever threats may emerge in the story. A vibrantly realized fictional space will always help draw the player into the experience, contributing greatly to her immersion and that all-important suspension of disbelief.

In most games that consist of multiple missions, each level features its own unique environment, depicting a subset of the larger game world and providing for a regular change of scenery and tone. Of course, sometimes a location will pull multiple-mission duty, playing host to a number of different scenarios. In every case, though, the environment is primarily designed to be an optimal space in which some or all of the main elements of gameplay can shine. If a game's core mechanic is jumping, for example, you can bet that a well-designed level in that game will be a jumper's paradise.

But nevertheless, levels are more than just places that contain things to do. They are also places to see, explore . . . and learn from.

Taking It All In

Walk into any real-world environment inhabited by people, and you'll get the opportunity to glean information about its population just by looking around and listening. Even if that location has been mostly or completely abandoned, and if there is no one for you to talk to or otherwise interact with, you will still have access to an abundance of clues pertaining to the population's culture and history.

Video games' ability to provide that experience to the player—to allow him to really feel like he is *in* the environment, as opposed to just observing it—is one of the unique and compelling storytelling elements that separate games from other entertainment forms. From the macro of a city's layout to the subtle clues laid out in a single room, settings are characters with their own tales to tell. And as a game storyteller involved in the creation of its locations, you have enormous influence over what kinds of stories your environments will communicate.

But the creation of these environments only really succeeds when everyone concepting, designing, building, and decorating the spaces works from a common intent and framework. As with character design, it often falls to Narrative to develop and share this backstory to ensure that everyone is on the same page. And so, the best thing to do is to *put* it on a page. An Environment Description Document—the location-related version of the aforementioned Character Description Document—will include important as well as trivial details about the space, giving the team its best chance at creating a rich, thematically cohesive environment. See Appendix II on page 196 for a sample Environment Description Document.

Architecture

Architecture and urban/city/town planning are among the most basic elements of an inhabited (or formerly inhabited) environment, and in many games they have a direct impact on the player with regard to where she can and cannot explore. Beyond containing the player within a prescribed play space and restricting sight lines, though, the layout and architecture should also be designed to intentionally evoke the history, values, and culture of its fictional designers and/or denizens.

Even early computer text-adventure games like the *Zork* series from the early 1980s, with no graphics support whatsoever, used words to paint a picture of a world that seemed alive and to have a history. The description of an aqueduct in *Zork III* (1982), for example, included "mighty stone pillars, some of which are starting to crumble from age," encouraging the player to ponder a "once-proud structure and the failure of the Empire which created this and other engineering marvels."

Of course, in today's games the technology exists to create huge and nearly photorealistic 3D architectural spaces for the player to explore. Some questions that should be answered by simply looking around at the buildings and their arrangements include:

- What kind of people live here (or used to live here)?

- What are/were their lives like?

- How affluent are/were they?

- What do/did they seem to love? To hate?

- Which do/did they value more, form or function?

- Were they at peace or at war when this was built?

- How densely are/were they populated?

- Are/were they especially focused on comfort?

As the player moves from the macro to the micro, perhaps entering a building and exploring its interior, the design motif should carry through and illuminate more specifics:

- Who lives (or used to live) here? Substitute "work" if a workplace, etc.

- What was the purpose of this building?

 - What was the purpose of this particular room/space?

Obviously, the answers to these questions won't mesh into a cohesive whole unless everyone creating the space already knows (and agrees upon) them. Thus, the Environment Description Document should include all this information.

Internal Logic in Architecture

In addition to these many considerations, the internal logic of a space is just as important to keep in mind. Given the answers to all of the questions above, does the current location actually make sense? Maintaining harmony and balance between level design and narrative design in this area is a constant challenge.

For example, let's say in a realistic, modern-day FPS title we have part of a mission take place within an abandoned but fully intact apartment building. In the real world, any residence with more than four floors is going to have at least one elevator, and a taller building will have several. The problem is, level design–wise, we don't want the player to use an elevator; we want to force him to go up via the stairs or other means.

So we have a contradiction that we may decide to address. Options might include:

Simply don't include an elevator in the layout. This would take zero development effort (which is great) but the problem still exists. Playtesting might reveal whether anyone even notices the missing elevators. If not, you may be home free—but be careful. Don't assume that just because no test players explicitly mention the omission it means they haven't subconsciously noticed it or have a general sense that the building doesn't feel quite right. If the player has access to any area where one would expect to see an elevator (such as the building lobby), its absence may seem strange. So, ask the right questions—perhaps along the lines of the open-ended, "How does this space feel?" as opposed to the more direct, "Did you notice there weren't any elevators?" The larger and taller the building, the more likely the omission will be noticed by the player.

Include an elevator, but make it completely noninteractive with no explanation. Another low-effort solution, but it may feel like a cop-out. And if there are elevators elsewhere in the game that *do* work, the inconsistency will remind players that they're playing a game, not exploring a real place.

Reduce the size of the building to four floors or fewer. A very simple solution, but with the potential to clash with level design goals and narrative intentions. This is probably an extreme solution to a relatively minor issue.

Include an elevator, but block access to it. Depending on what is used to keep the player away from the visible but inaccessible elevator, this could feel frustrating, forced, and "game-y." After all, in the real world we don't expect elevators to be blocked. Also, if the player is able to access additional floors above, the level designer will have to repeatedly find ways to block the way to elevator doors on each floor.

Include an elevator, but disable it and attach an Out of Order sign. This solves the problem nicely but does imply something about the building's fiction; i.e. that at some point in the recent past this elevator went out of service and was not repaired. If it's an affluent building in all other respects, this may feel out of sync. Also, the taller and larger the building, the less believable that there would be only one elevator, or that there would be multiple lifts all simultaneously broken.

Include an elevator, but cut power to the entire building to explain why it doesn't work. This solution eliminates nagging doubts and implications about the building's past, and it also solves the problem of multiple nonfunctioning elevators. However, it establishes a reality in the present—i.e. the power is out—that the level designer will need to reflect in the rest of the design (other electrical devices, lighting, etc.).

As you can see from this simple example, every little decision when it comes to architecture has the potential to reinforce the narrative background, or clash with it and negatively impact consistency and believability.

For a level designer, then, it's important to at least try to balance creating an optimized gameplay space against creating a location that has internal logic—with all the elements one would expect to see in such a space, laid out in a manner that is as consistent with expectations as is feasible given other goals and constraints.

Environmental Storytelling

Conveying narrative backstory and exposition by embedding it in the environment itself—without using a cutscene, character dialogue, or even UI text—is a highly efficient method of storytelling, and one of the best ways to create a player-pleasing amalgam of gameplay and narrative.

Of course, using the environment to silently, visually communicate narrative information is not exclusive to games—cinema got there many decades before, and stage plays hundreds if not thousands of years prior to that. But environmental storytelling may be something games can do more effectively than any other medium. Interactivity is the key. A game player feels more involved than, say, a moviegoer when given the opportunity to actively discover and examine these environmental clues, in her chosen order and at her own pace.

As *BioShock* senior designer Dean Tate put it during a PAX East 2011 panel entitled "Setting as Character in Narrative Games":

> Good visual storytelling is almost like telling a good joke. By the end of the joke, there comes that moment where the person has to piece together everything that was said throughout the joke and there comes that "aha" moment when they realize what the punch line is. Good visual storytelling is like that. You stare at a scene, you try to piece elements of it together in your head, and then you reach that point where you go, "Oh, these things are kind of related, and now I understand what happened here" . . . and that's a really cool moment.[6]

It is also the demonstrable triumph of the "show, don't tell" axiom.

Implying a Bigger World

Environmental storytelling can prompt players to infer the existence of events, people, and places which you don't actually have to create or depict. Like the *Zork III* example on page 149, you need only provide a few words or ideas, and players will fill in the storytelling gaps; their imaginations will do a lot of the

6 http://gameshelf.jmac.org/2011/03/setting-as-character-in-narrative-games-pax-east-2011/

creative work for you. Graffiti, notes, letters, and other writings in the environment can be surprisingly effective in helping to imply a much bigger game world than actually exists.

They also provide story content to players who are interested in it, while not slowing down the pace for players who are less interested.

Foreshadowing and Planting

As covered in chapter 5 ("Exposition"), the dramatic use of planting and foreshadowing can help improve believability and bring a sense of cohesiveness and resonance to any story. However, when using these literary techniques, there is always the danger of overplaying your hand and accidentally telegraphing your intentions to the audience. Finding just the right mix of subtlety and noticeability is a constant challenge.

One of the most effective and potentially subtle means of introducing these techniques in a game is to embed your foreshadowing and planting clues in the environment.

BioShock is one of the games that most aggressively incorporates environmental storytelling, and to this day it stands as a shining example of doing it right. The game's opening sequence alone—combining a series of cutscenes and interactive sections—is rife with meaningful planting and foreshadowing, peppering the player with visual hints that only become clear as you play through the game. Replay or watch the first ten minutes of *BioShock* and, as a player who's previously finished the game, you may be amazed at how much was foreshadowed. Some of the items glimpsed during this opening include:

- The small, handwritten note on Jack's gift contains a turn of phrase that later becomes very important.

- A statue of Andrew Ryan with quotation banner and plaque all foreshadow the character and his ideology, which permeates Rapture and thus the rest of the game.

- An "Incinerate" advertisement at the beginning of Ryan's short film plants the idea of plasmids, and foreshadows the player's use of them.

- On the way toward the city, the player gets a glimpse of a Big Daddy—an enemy type the player will repeatedly battle, and a persona he will briefly take on.

- Also during the approach to the city of Rapture, glowing signs for Cohen's Fine Art, Fleet Hall, Pharaoh's Fortune, Sir Prize Games of Chance, Robertson's Tobaccoria, and Le Marquis D'Epoque can be seen—all locations the player can eventually visit during the game.

- As the bathysphere prepares to dock, it passes just below a series of neon signs which all read: "All good things of this earth flow into the city"—but the last letter of the final word sparks and winks out; one of the first hints that things may not be so rosy in Ryan's claimed utopia.

- When the player's bathysphere enters the shaft, another ad right in front of him helps plant the idea of plasmids—this one for telekinesis.

Now, admittedly, this is a huge blast of narrative information right off the bat, in a very compressed timeframe! But unlike the exposition dump of *Metal Gear Solid 2*'s opening (as covered in chapter 5 on pages 59–63), none of this is required information for the player, and none of it is communicated via dialogue. Most of it washes over the first-time player, silently and subtly priming her for what's to come.

Another example of effective, environment-based foreshadowing within the first few minutes of a gameplay experience can be found in Double Fine's mind-bending cult classic *Psychonauts*.

After completing the training level, which takes place within the mind of the drill sergeant–like Coach Oleander, the player character Razputin is left to wander into a white corridor. At the end of the hall he glimpses a blueprint of some kind on the wall, mostly obscured by a red curtain.

As Razputin reaches to pull aside the curtain, Oleander telekinetically yanks him away, barking: "Just what in the Sam Hill do you think you're doing in there?!" When Razputin answers that he was just trying to find a way out, Oleander's mood lightens and he brushes it off. But in fact the player has stumbled upon something in the back of Oleander's mind that will become very important later in the story. Ironically, this plant now exists in the back of the *player's* mind, just as intended.

Audio Clues

Harbingers that are not silent but still environmentally based include audio logs and ambient voice and sounds heard as the player moves through the space. *System Shock* and *BioShock* both make liberal use of this tool, introducing characters not yet encountered—such as mini-bosses—just before the player actually runs up against them in the game.

During development of *Marvel: Ultimate Alliance 2*, we wrote and recorded dozens of various types of audio logs that could be found hidden (and not so hidden) in the missions and hub environments. They provided backstory on characters, fleshed out story details, supported the illusion of a larger world that was reacting to the player's actions, and foreshadowed upcoming story events.

None were required to understand the story—the narrative was designed to make sense even if you never listened to a single audio log. But those who

took the time were rewarded with a richer story experience and a more complete picture of the events, characters, and world.

For example, in the first hub environment (Iron Man's Stark Tower), players can run across and listen to an audio object that plays a radio commercial for an upcoming reality TV show called *The New Warriors*. It doesn't relate to anything that's happened so far. But later in the story, the teen super heroes who star in this reality show accidentally trigger a massive explosion in a residential area, killing innocent civilians and igniting the story's main conflict. Players who took the time to listen to the radio commercial would—we hoped—feel a greater sense of world cohesiveness and continuity when they later saw the cutscene featuring the New Warriors and their fateful, explosive miscalculation.

Nobody Home

Exploring an eerily uninhabited urban or suburban environment—a place where there would normally be other people—can evoke a strong sense of mystery and intrigue. It also puts more onus on environmental storytelling to communicate narrative details. A good example of a game that takes place in an intact but uninhabited location is the critically acclaimed indie title *Gone Home*.

With no combat, health units or death, no other characters to interact with, and only simple puzzles blocking player access to new areas, *Gone Home* relies almost exclusively on environmental storytelling to allow the player to interactively explore the story of a single suburban family in transition.

Alone in a large house at night, with no time limit or imminent threat, the player can examine scores if not hundreds of items lying around; listen to audio diaries, answering machine messages, and cassette mix tapes; read journals, bills, postcards, and letters, all along the way to getting to know the four members of the family—the player's own avatar included—and ultimately unraveling a minor mystery regarding the player character's missing sister, Sam.

This all happens without the player ever directly seeing or interacting with another character.

Turn to the next page for an excellent example of an item from the game that the player can pick up: a note that was obviously passed back and forth at school, between Sam and another child.

Notice that the note actually contains its own, self-contained micro-story with a surprisingly strong emotional punch to it. And even the fact that the note has been ripped in half helps complete the story.

Is *Gone Home* truly a game? The debate raged at the time of its release and beyond, but regardless, this successful title stands as a testament that environmental storytelling *all by itself* can offer a compelling narrative experience.

Abandoned areas—like the empty house in *Gone Home*—are exceedingly common in video games, much more so than in other visual media. The

Courtesy The Fullbright Company

reasons for this are varied, but much of the pattern can be attributed to game design goals and scope limitations.

On the one hand, urban environments are popular choices for game locations because they offer the potential for fantastic gameplay layouts in a setting type that's familiar to all players. They are compact and full of spaces and angles conducive to action-oriented game mechanics such as shooting, taking cover, running, climbing, zip-lining, driving, and so forth. In-game cities are, for many level designers as well as the players themselves, virtual playgrounds for grown-ups.

However, *populated* urban environments can create a development scope explosion of additional game logic, AI design, animation, and audio, as the team labors to bring to life a city full of inhabitants who react believably to player actions and other unfolding events. This is especially true when there is a desire to include residents who are not immediately hostile to the player. When every NPC is an enemy, their reactions to the player can be boiled down to a manageable possibility set. But in an initially neutral or friendly environment, the expected range of behaviors—with potentially implied AI, animations, VO lines, etc.—can skyrocket.

While it is not unheard of for a developer to incorporate a fully populated virtual city as a traversal and gameplay backdrop—à la the *Grand Theft Auto* series—developers often choose to narrow their focus and depopulate game-play areas of most if not all NPCs that aren't enemies.

It's simpler to avoid the issue of dealing with so many living NPCs than to have them present but not reacting to players' actions the way we'd expect them to. So, players often find themselves moving through some place that used to be a populated and recognizable area, but is now largely abandoned and often also severely damaged—sometimes due to whatever ongoing conflict now dominates the location.

And the question that often hangs in the air, waiting for the player to slowly unravel as he explores the area, is: *What happened here?*

Environment as Warning

An abandoned environment is one thing—but combining it with a calamity of the past can help add a sense of foreboding and dread to a single mission's environment or even that of the entire game.

When Design wishes to de-populate an area, leaving no one (or only hostiles) behind, a narrative conceit is usually developed to explain the small number or complete lack of inhabitants. Here are a couple of the most common ones seen to date.

- A disaster has occurred, killing nearly everyone and leaving behind only twisted, hostile creatures.

- Seen in: *System Shock*, *BioShock*, *Dead Space*, *Half-Life*, *Left 4 Dead*, *Fallout 3*, *Portal*, *Singularity*, *Prototype*, *Dead Island*, *The Walking Dead: Season One*

- The location is a war zone—all civilians have died or left, and only enemy combatants remain in the area.

 - Seen in: *Call of Duty*, *Battlefield*, *Titanfall*, *Gears of War*, sections of *Uncharted 2* and *3*, *Halo*

Sometimes "what happened here" is the primary question of the entire game, or at least it's the mystery the player must solve to complete a level or section of the game. It can be directly relevant to the story, the player and the challenges he is yet to face.

In other words, a warning.

Some of the most powerful warnings in stories are established in Act I or early Act II, by implying or even clearly showing what happened to very similar protagonists who were previously undone by a threat the Hero will soon face.

In the movies, think of *Alien*, *Aliens*, or John Carpenter's *The Thing*. On TV, there are a number of classic *Star Trek* episodes that open with the *Enterprise* answering the distress call of a sister ship or starbase, only to find it crewless, nearly destroyed, or both. In all of the above examples, the main characters almost immediately begin asking and investigating "what happened here"—and by the time they find the answer, the same threat is now upon *them*.

The pattern may be somewhat predictable, but its effectiveness remains potent. It can be a powerful form of foreshadowing and building up the threat to clearly, visually demonstrate that whatever dark forces are in play, they have already proven their ability to take down would-be Heroes.

For a game example, we can look to the opening cutscene of side-scrolling beat-'em-up *Castle Crashers*. In this introduction, the Dark Wizard is seen attacking the castle, stealing the giant mystical gem from the throne room, and making off with it the way he came. Once the players get control of their avatars, they head after the Wizard, and it's here—in the background art while the players fight their way through enemy soldiers—that they see the flaming and bloody remnants of the battle which must have just taken place.

This is simple window-dressing, perhaps, and too lighthearted to really cause any sense of worry in the players, but it's still effective and efficient. The backdrop elements have no bearing on gameplay, but they silently reinforce the unseen story of the invasion by the Wizard and his many minions. The visuals make it clear that the threat the players are about to face is a deadly one.

On a darker note, *BioShock*, *Dead Space*, *Portal*, and others use the environment to foreshadow and warn the player about upcoming challenges and threats that have the potential to evoke a real sense of dread.

In *Portal*, barely coherent graffiti scribbled on the wall in a hidden, uncharacteristically dirty section of Test Chamber 16 famously warns the player, "The Cake is a Lie." This of course references GlaDOS's repeated reassurances to the player character Chell that, once she finishes all the test chambers, there will be cake. In another secret "backstage" area there is a menacing drawing of GlaDOS—whom up to this point has been revealed through her voiceovers as being slightly odd but certainly not a villainous threat—with a disturbing caption: "She's Watching You."

Since GlaDOS is the only character in the game besides the player—the only "person" to keep you company, as it were—the idea that she is secretly malevolent is quite a chilling one. And just a few test chambers after having the opportunity to see these scrawled warnings, the player learns they were quite true. GlaDOS attempts to incinerate the player.

Internal Logic and Placement

Another question to ask oneself when setting up an environment to tell a story is, are you crafting it in such a way that it that makes sense and is easily comprehensible?

For example, imagine a mission scenario in which the player begins listening to the contents of a voice recorder he found in a burnt-out, apparently abandoned building. The recording—a woman's audio journal—continues to be heard as the player interactively explores the environment. On the tape, the woman is heard moving through the same location, and is eventually attacked and apparently killed by something that clearly terrifies her. The recording culminates with the sounds of her violent death just as the player happens upon a woman's gruesomely mutilated corpse, which has only been decomposing for a matter of hours. An I.D. badge confirms that she was the woman on the tape.

This hypothetical setup certainly seems like it would have the potential to effectively establish a mood and an imminent threat, perhaps even raise the hackles on the player's neck—and all with minimal interruption to gameplay. But if the player takes just an extra moment to think about it, he might wonder how the voice recorder got so far away from the woman's body if she died while recording it. Wouldn't it have been found on or near her?

A small point, perhaps, but you might be surprised how perceptive your players are and what kind of inconsistent detail might "bounce them out" of the fiction—especially if you give them some time to think about it.

I always liken this kind of situation to a scene from one of my favorite movies, *Monty Python and the Holy Grail*. Brother Maynard is translating a mysterious cave's ancient carving, which King Arthur and his knights hope will lead them to the Holy Grail. When the carving ends with the phrase "the Castle of . . . aaaaaaugh," Maynard hazards a guess that the author must have died while carving it. Arthur and the knights immediately see the logical

flaw in this theory; if he was dying, he wouldn't bother carving "aaaaaugh," he would just say it.

Like Arthur, players may notice inconsistencies in the backstory implied by what they've found. So, whenever possible, try to make sure everything about the "what happened here" story jibes not only with what's found in the environment, but also with *where* these items are discovered.

Preventing the player from experiencing head-scratching moments while trying to parse incoherent environmental storytelling is mainly a matter of thinking things through, then documenting and sharing your findings and intentions.

Here's an example from my own experience. Once, as part of an unpublished title on which I was working, the team decided to include an extended player-after-enemy chase through an industrial meat factory. We felt the potential for visual interest was high, and tonally it was a good fit for the overall game and particularly for that part of the narrative. However, we also wanted to add an interesting side story that would further establish the seedy nature of the area, which was a new location to the player.

We came up with the idea that the meat-packing plant was actually a front for a gunrunning operation. This concept did not directly relate to the main plot, but was intended to help imply a larger world with many more people and moving parts than we could afford—or wanted—to show. In order to contain the possibility space, we depopulated the building of anything but automated defense systems. Our narrative explanation was that due to the chaotic chase, the workers had quickly abandoned the facility, leaving their workstations as they were, in mid-process. At various points throughout the chase, we would plant environmental clues regarding the secret operation.

In order for these visual hints to make sense and tell the story of the factory's dark secret, we first needed a common understanding among everyone developing content for the level as to how the facility normally worked and how the gunrunning operation functioned within it. I generated a short but informative addendum to the LDD, which laid out in some detail how the gunrunning operation actually worked. It went something like this

Plastic-bag-sealed gun parts would be hidden within some of the large, incoming slabs of meat, which were subtly marked. Workers would separate these contraband-laden slabs from the rest as they came in, so they could be cut open and the gun parts removed. There was a cleaning and drying area to prepare the gun parts for assembly, while the meat was sent along the line to be processed and packed with the rest. Another area would provide the space for the gun parts to be assembled into full weapons, which were in turn packed into crates for shipping, presumably to some pretty shady characters.

Adding to the challenge of showing this story as the player moved through the factory was that he would be moving *backward* through the chain, seeing the packed guns first and the innocent-looking slabs of meat last.

During the process of various team members weaving background clues into the level environment, there were a number of interesting developments.

1. Even with the benefit of detailed documentation, it turned out to be very easy for elements of this side story to be misunderstood and misinterpreted. For example, instead of gun parts being embedded in the meat as originally described, at some point during implementation they morphed into fully assembled assault weapons. To me this seemed less believable and negated a number of the gun assembly work areas we had planned. Interestingly, it also raised a game design issue: the designers felt strongly that if you leave a weapon lying around in the game, the player would expect—and rightly so—to be able to pick up said weapon and use it (which we didn't want the player to do in this location). Communication between the level designer, artists, and myself was important throughout the entire process to ensure the integrity of the concept.

2. Being creative people, the designers and artists would sometimes take liberties with specifics of the storytelling, some (but not all) of which worked very well. For example, the level artist added an area where the slabs of meat were run through an X-ray, so the workers could confirm the presence of internal contraband before proceeding. A bit far-fetched, perhaps—a hidden mark on the meat would be a lot simpler and cheaper— but the visual was powerful and was able to speak volumes about the operation with just a single glance from the player as he ran past it. Ideally, these new ideas would be discussed as a group before the artist proceeded to take the time to actually build and place the assets. However, to be honest, that wasn't always the case; sometimes I didn't know anything about these modifications until I saw them in the build.

3. At times, some team members seemed to be more concerned about the gunrunning subplot than about the main conceit of the factory chase. While it was heartening to see how seriously some folks were taking this instance of environmental storytelling, I occasionally had to remind team members that ultimately, the gunrunning story was not on the critical path and should not take precedence over—or distract from—anything else we were trying to do with that location in terms of gameplay or the main story.

By the time we were done, the background elements definitely helped tell a small but interesting side story about the secret goings-on in the meat-packing

plant. Each step of the process made visual and logical sense and, had the title shipped, would have provided players who paid attention with a little more of a sense of a larger world full of people going about their (sometimes questionable) business.

Final Thoughts on Environments

Developers who design, construct, and decorate a game's environments have the power to take on a huge part of the storytelling effort. Close collaboration with other team members, especially with those driving the narrative effort, can yield results that help make players feel they are not just observing the story world, but are in it.

Engineering the Story

This chapter is most relevant to *programmers* of various special-
ties, including those focused on AI, physics, systems, and develop-
ment tools. Throughout, we will use the terms "programmer" and
"engineer" interchangeably.

When one thinks about storytelling in games and the people who make it hap-
pen, it's rare that programmers spring to mind.

However, throughout this book we have emphasized that everyone on the
team ends up helping to implement the narrative and therefore becomes a
storyteller. Engineers are no different in this regard, even if their contributions
may not be as glaringly obvious as those of some other team members.

After all, engineers make the game—and all its clever design concepts—
actually happen. And the story is told through the game. Thus, to at least some
degree, engineers make the story happen.

Like every other team member, then, programmers should strive to have
a core understanding of narrative intent, and to understand the important ways
they can help support those aspirations on the most practical—and technical—
of levels.

Artificial Intelligence

One of the engineering-related features most likely to be assumed by the Design
and Narrative plans is that of AI—specifically, what the computer-controlled

characters in the game will be capable of *doing*. This covers not only enemies but also ally characters and neutral NPCs.

At its core, AI development primarily serves Design and its goals for computer-controlled characters. In order for the game design to work, these characters need to be able to do what Design has requested. But as we covered in chapter 10 ("Game Character Development"), Narrative also plays a strong role in defining these characters, and by this point in development—with any luck—a good deal of attention has already been placed on the all-important aspect of ludonarrative harmony between Design and Narrative. Now, as an AI engineer, it's your turn to either contribute to—or clash with—those intentions.

Design has weighed in with its requirements for an NPC. Narrative has added context and framed that character, including his desires. The question now is, will the character actually express those qualities via observable in-game behaviors? Ideally, all three—design intent, narrative context, and AI functionality—will perfectly align to form a fully realized and believable in-game entity.

From a functionality perspective, an NPC's observed behaviors should simultaneously express several factors.

1. What the character wants (base, long-term, short-term, and immediate desires), and how badly

2. What the character currently believes is the best way to get what he wants

3. What the character is actually capable of doing.

Let's look at each in more detail.

What the Character Wants

This can be stratified into base, long-term, short-term, and immediate desires. Taking a *Star Wars* Stormtrooper as an example, we can assume that his base desires—like those of almost any living being—will include staying alive and unharmed, and seeing to his basic needs such as food, shelter, etc. His long-term desires might include being a good Stormtrooper, following orders, and getting promoted. His short-term desire, building on the previous, could be to capture or kill those darn Rebels currently skulking around the Death Star. And his immediate desire might be to shoot the Rebel who's hiding behind cover just across the hangar bay.

Base and long-term desires remain constant for most characters through-out a story (or game), but short-term and immediate goals can shift rapidly based on changing circumstances. In a game, the situation can evolve based on any number of predetermined or dynamic events, as well as in response to unpredictable player actions. "Acting is reacting," as the old Hollywood saying goes, and this most definitely applies to in-game AI-controlled characters.

How badly the character wants that thing should also be reflected in his behavior. What is he willing to risk? With regard to video game characters, this generally boils down to, is the character willing to pay the ultimate price in pursuit of her desires? From an AI design perspective, the easy answer is always "she's willing to die to get what he wants." This makes programming an enemy character a lot simpler, to be sure; she attacks until either she or her target is defeated.

But a more nuanced and realistic AI model might incorporate the concept of self-preservation and morale, with NPC characters who might retreat or even surrender if things get too hairy. A more subtle version of this concept might simply see the NPC becoming less aggressive when things are going poorly—staying in cover, hunkering down, etc.—and more aggressive when she perceives she has the upper hand.

What the Character Believes He Should Do

This does not necessarily align with the very best thing the character *could* do! But having a good understanding of who this character really is should help an AI programmer know at all times what that character would think is the best course of action given any circumstances that might emerge during gameplay.

For example, a "Common Infected" zombie in *Left 4 Dead* has very little brain power, but is clearly always thinking about one thing: how to reach, kill, and eat the player characters. These zombies' simple pathfinding and suicidal attacks make it very clear what they want, what they're willing to do to get it, and, on a moment-to-moment basis, what their rudimentary intelligence tells them they should be doing to accomplish their goal.

A more complex adversary such as an enemy soldier in a *Call of Duty* game will take cover, switch weapons depending on player location, and even try to flush a hunkered-down player out of cover with a well-tossed grenade. The goal might be similar to that of a *Left 4 Dead* Infected (i.e. kill the player) but the tactics and intelligence on display are quite un-zombie-like.

What the Character Is Capable of Doing

The range of an NPC character's in-game capabilities must be well matched to everything else that's been established about him. Programming the AI so its desires and intentions are aligned with its character design is pointless if we then fail to follow through with giving her the ability to *act* on those desires and plans, in what at least appears to be an effective manner.

An NPC that's been framed as superintelligent in the narrative must be able to carry that aspect out in actual gameplay, or we'll once again bump up against the problem of ludonarrative dissonance. The same holds true for a character who's been built up in the fiction as a powerful threat.

All disciplines should be involved to create an NPC that's fully realized and consistent in terms of appearance, behavior, and abilities. Team members must work together from soup to nuts, eventually "bringing it home" so that everything about that character (or character class) clicks in the final game. Here is a highly simplified example for a "badass" character:

- Narrative: She talks and acts like a badass.

- Design and Engineering: She is very difficult to defeat in gameplay.

- Art: She looks very tough.

- Animation: She moves in a confident and threatening manner.

- Audio: She sounds dangerous.

Sometimes, however, the requirements of one discipline create an over-reach; a gap that may not be able to be filled without breaking something else or expanding scope beyond what is tenable for the project.

Enemy Illusions

One common example has to do with enemy characters. Narrative sometimes establishes a degree of tactical competence and coordination in an enemy group that Design and Engineering are hard-pressed to fulfill in actual game-play. Rather than watching AI programmers beat their collective heads against the wall of humanlike enemy AI behavior—or twisting the fiction so that the enemies are painted as less organized—Narrative and Audio will often step in and help create the illusion of coordinated intent and action.

Simple systemic VO trigger lines such as "Flank him!" and "I've got you covered!" and "Defensive position Tango!"—even when they are accompanied by *no change in enemy behavior whatsoever*—can go a surprisingly long way to convince the player that the enemy is smarter than they really are. In the heat of battle, it can be difficult to determine which VO lines really do indicate enemy actions and which don't.

Physics

Back in chapter 6 we discussed the need for a storyteller to take world consistency into account in order to maintain believability. The rules of a fictional world must be defined and adhered to so that the audience isn't overtly reminded that it's a contrivance, and get "bounced out" of the fantasy. This doesn't mean that the rules need to perfectly match those of the real world in which we live; they just need to be clear and internally consistent.

If the rules are different than what the audience would normally expect, that needs to be established early and clearly. If those rules change

over the course of the experience, there needs to be a believable reason they've done so.

For an interactive space such as the world of a video game, consistency is even more important, since the player counts on it to succeed. For example, knowing how far an avatar can jump is critical and must be predictable by the player, if he's to avoid falling into death pits!

So, for a physics programmer, it's especially vital to remember that the narrative and its believability rely on many factors, and one of them is the successful creation of an alternate world that holds together in all respects. Look at the physics of the *Halo* series vs. those of the *Call of Duty* games. They're both first-person shooters, and yet they feel very different thanks to wildly divergent physics models. Would the relatively "floaty" feel of the sci-fi *Halo* games, based on far-flung alien worlds, feel equally appropriate for a modern-day, Earth-based military shooter? Or, switching it around, what would change about the narrative tone of the *Halo* games if the physics were more mundane, less fantastical—like those of the real world?

What about the *Uncharted* series? While certain aspects of the physics seem quite realistic, anyone who's watched Nathan Drake scale the side of a dizzyingly high stone building has seen that character defy physics as we know them (particularly gravity). But the rules are bent a bit; just enough to make the game more fun without completely shattering the illusion that Nate lives and has adventures in the same world that you and I inhabit.

Deciding how the physics of the game world will work and what (if any) rules will be bent or broken should not be done lightly, and not without including whoever is driving the narrative effort. Additionally, if the game is to feature cutscenes, physics consistency between those scenes and the in-game experience is also a subtle but important point to keep in mind.

Tools and Pipelines

The successful realization of the great narrative ideas and plans for a game usually ends up heavily reliant on how easy—or frustrating—it is for team members to implement narrative content into the actual game, and to update it. Narrative development tools and pipelines are as varied as game genres and even games themselves, but in the end, every game featuring story content ends up with some form of them. The question is, do they help or hinder?

The amount of thought, planning and energy that is brought to bear on these technical tools of the trade can have an enormous impact on the story content—how much there is, how slick its presentation, and how well it flows. Here are some questions to consider if you are involved in the design, implementation, and/or maintenance of tools and pipelines that will be used to inject narrative content into a game.

How Technical Does the Developer Need to Be to Use Them?

It might sometimes be easy for a programmer to forget that not everyone on the team is as tech-savvy as he. Of course, engineers who are developing tools for use by others always need to take into account what those users know and are capable of. Often, game writers originally come from other media, and even if they've been in games for a while, they can still tend to be among the least technical of game development team members.

So, evaluate your team members and make sure the tools you're developing feel sufficiently friendly to all. What can you do to make these team members more comfortable with the tools and thus more productive?

How Difficult Is It to Update the In-Game Narrative Content?

As all developers know, iteration is critical to successful game development. It's key to game story development as well. If the tools and pipelines make the revision process onerous, narrative content developers might shy away from using it as often as they should, or they might just spend more time doing it than necessary—reducing iteration cycles and potentially impacting the narrative quality.

If you're able to streamline and simplify the process of updating narrative-related assets, you will have played an important role in giving the game a better shot at including a high-quality story.

How Representative Are Placeholders?

Narrative presentation can be expensive and time consuming, especially on high-profile game projects that will include systemic VO systems, scripted in-game scenes, and/or fully animated, pre-rendered cutscenes. During the iteration process, it's important that placeholders be integrated and evaluated in the context of the evolving game, well before final creative decisions are made regarding the narrative content. If not, by the time awkwardness is discovered (at an implementation phase) it may be too late or very expensive to fix the problem.

Placeholders temporarily take the place of robust assets to follow—thus living up to the term—but some provide no real sense of what the final assets will be like. These are unreliable placeholders and are often not particularly helpful.

A console game on which I once worked included a plan for a robust systemic VO system. During development, well before we cast actors and recorded the thousands of lines of dialogue required for such a system, technical work on the system itself proceeded apace. In order to "prove" that it was working— i.e. firing off voice lines when appropriate trigger conditions had been met—the audio engineers used a single placeholder VO file (a man saying "One") combined with caption text featuring the actual, correct VO line.

Once the system was integrated, the first thing most team members did was to adjust their audio options so they didn't have to hear the word "one" constantly being spoken as they played the build—understandable, but hardly ideal.

Worse, using a single placeholder audio file to stand in for the thousands that were to eventually follow ended up concealing some major bugs in the system. Once the final audio files began to be dropped in toward the end of the Production phase, hundreds of strange errors started showing up, such as female characters speaking with male voices and vice versa.

And because these numerous issues were discovered so late in the cycle, many of them remained unfixed and shipped in the final game. Game reviewers (and players, it can be assumed) did not miss these odd bugs. So yes, we had placeholders, but they proved quite unreliable.

We will dig deeper into the subjects of audio systems design, audio engineering, and support in the next chapter.

On-Site versus Off-Site

Narrative experts aren't always incorporated as full-time, on-site members of a development team. While the aforementioned BioWare and a few other studios have invested heavily in this area, bringing full-time writers, narrative designers, and even editors on staff, it's still more common for narrative team members to be contractors, often doing some or all of their work from off-site. From an organizational point of view this can, of course, pose a number of challenges. From an engineering perspective, it has the potential to complicate the process by which these writers will integrate their content into the game.

Understanding this reality going into the project will give you time to allow for off-site writers—some of whom, as mentioned on the previous page, might not be the most technically savvy of developers—to be granted remote access to your development tools and some subset of your build environment.

Discussing the process early is key. Is there a person on the team who has been identified as the main point of contact for the off-site writers? (Hint: if not, there should be.) If so, is this person a narrative expert as well—enough so that she can speak on behalf of their concerns in the team environment? Enough so that she can anticipate and articulate problems they might encounter as off-site writers working within your system?

I have seen this situation handled a number of ways, and my perspective on it includes stints on both sides of the fence. Without prior planning, the default process seems to be that once narrative content starts coming in from the writers, an on-staff team member—sometimes with narrative expertise, sometimes without—is eventually made responsible for hand-copying that content into the tool that allows it to be integrated into the build. It's one way to solve the problem, though inefficient, time-consuming, and error-prone.

Rather than failing to plan and ending up resorting to this default setup, find out early whether it's believed there will be off-site writers contributing narrative content that will need to be integrated into the game. With enough lead time, you may be able to create a system and pipeline that are much more efficient, freeing up one or more of your fellow team members to focus on more important things.

Final Thoughts on Engineering the Story

Engineering implications emerge not only from game design concepting but also from the Narrative side, especially on a project which has a strong narrative vision at or shortly after its inception. However, with all the various technical elements that need to be considered in these initial stages—design implications, target platforms, game engine, middleware, and so many more—it's not surprising that sometimes ramifications coming from the story side get lost in the shuffle.

Don't let that happen!

If story-planning discussions are occurring and they include assumed tech, then the person or people responsible for that tech should be consulted. If you are that person, make it your business to know what's being planned and assumed. You might help head off disaster down the line when it comes to light that the storytelling tech needed to convey the narrative was never accounted for. Artificial intelligence, physics, tools, or anything else that might ultimately be related to storytelling—you have the power, especially early in development, to help move things in the right direction.

It may feel at times like you're sticking your nose where it doesn't belong, but if you've read up to this point you know that *everyone* on the team should be aware of and involved in the story you're all trying to tell. And if the folks who are leading the narrative charge on your project don't see it that way, maybe hand them your copy of this book!

Audio

This chapter is most relevant to audio-related developers, including *audio designers*, *voiceover directors*, and *composers*, as well as *audio engineers* and *programmers*.

In my experience, there is a good deal of camaraderie between game narrative specialists and audio experts. This isn't just because their work is so often closely related and tightly interdependent. I think specialists in both these disciplines can relate to each other partly because they tend to run into the same kinds of challenges and frustrations.

Both Narrative and Audio are heavily slanted toward *enhancing* the core gameplay experience, making the player more likely to feel the way we want her to. Like a video game's story, good audio is rarely noticed, but bad audio always is.

Sometimes Audio needs are neglected until late in the cycle, just like Narrative needs. They both tend to be glossed over early in development, and are then expected to work magic on the game late in the cycle—often too late.

As I hope I've made clear throughout this book, close and effective collaboration between story experts and most other team members is essential to a positive narrative outcome—but some collaborations are more key than others. Narrative and Audio harmony can be absolutely crucial.

Voiceover (VO)

The most obvious intersection between Narrative and Audio is their shared responsibility for the creation and integration of voice actor lines into a game that will feature VO. So tightly interwoven is this process that it can sometimes be difficult to clearly define where one side's role ends and the other's begins.

In my experience, it's best to try to define boundaries and responsibilities as much as possible up front, but to not get overly hung up on areas of overlap that will inevitably be revealed during development. It's very likely that at one point or another, you will step on each other's toes. And when that happens, it will be a lot easier to handle if a good working relationship has already been established.

From the Page to the Stage

Once a VO line has been written and approved, there are generally five distinct phases of getting that line recorded, finalized, and integrated into the game:

1. Casting

2. Performance/recording

3. Takes selection

4. Post-production

5. Implementation

The first three steps merit a closer look from the perspective of Narrative/Audio cooperation.

Casting

The process of casting major characters in a voiced game should start with, of course, a detailed Character Description Document (see Appendix I). Those of you who've faithfully been reading up to this point should by now recall this document as an old friend! A special version of the document, customized for the Audio team, can be slanted toward how the character should sound, with fields potentially including information such as:

- Voice age (how old does she sound?)

- Actors who might be a good reference (and in what prior roles?)

- Accent

- Sample, defining dialogue lines

Of course, there might be additional audio clues you want to call out. Is she confident, arrogant, nervous, inexperienced, grizzled, relaxed, etc.?

Does she have an accent, or maybe an accent she's trying to hide? Is her use of language current or dated? Does it betray her economic or social background? Does she/did she smoke? Is she a woman of few words or a babbler?

Please note this information would be *in addition to* the standard, basic data on the character (described on page 134 in chapter 10) of which all team members are made aware:

- Name

- Sex

- Race/Species

- Age (equivalent human age as well, if applicable)

- Intelligence

- Education type and level

- Profession

- Vocabulary

- Backstory

Of course, for minor voiced characters all that may be needed are essential stats such as the character's sex, age, profession/role, and accent. But for main and supporting characters, much more information is helpful.

Once the auditions come back for evaluation, the Character Description Document continues to be of use, as whoever is involved in making the casting decisions will also rely on having an understanding of who each character is really supposed to be.

Performance/Recording

During the actor's performance, the director (or voice director if audio-only) will want to have a good understanding not only of the character's background, attitudes, and personality traits, but also of the overall game story and the character's arc (if applicable) and where the current scene or lines fit into both.

This always holds true; ideally, the voice director should have a good handle on the game and its characters. But when it comes to getting the lines read in a way that is *fully* in sync with the writer's intent and with game context, there is no replacement for also having a knowledgeable narrative expert present at the shoot/recording session.

It does not necessarily have to be the person who wrote each line, but unless your team is blessed with an on-staff narrative expert leading the entire charge on story—say, a lead writer or a lead narrative designer—then getting the writer involved when her lines are recorded is vital. Please note—this

optimally applies to a writer who is intimately familiar with the game and the details of its development, not just the lines she wrote.

The narrative representative—whether on-team or off-site—is not there to take the place of a talented director. She is there to advise, to support, and ultimately to make sure that for each line there is at least one take that is correct with regard to narrative intent and gameplay context.

Contextual questions likely to only be known by the narrative expert for a given line include:

- How far away is this person from his listener(s)?

- Is the line likely to be read under duress (e.g. combat)?

- Is the local area quiet, average, or loud?

- At what point(s) in the game story is this line likely to play?

- What is the current emotional state of the speaker, and attitude toward his listener(s)?

- What does this character want right now?

Someone included in the recording session needs to know the answers to each of these questions.

Another very important reason to have a narrative expert on-hand during recording is to handle on-the-spot rewrites. While an experienced game writer who's scripting for the spoken word may be good at what she does, no one is perfect. And sometimes there's a turn of phrase that looked fine on the page, but that sounds terrible when read aloud.

Perhaps a case of alliteration was overlooked, or maybe a tongue twister was lurking in the mix. Sometimes the line, when spoken, just sounds corny, false, or off-tone. Whatever the reason, if a line needs to be reworked on the spot, you want a professional dialogue writer to handle it, or to at least vet whatever other options might be improvised or suggested by the actor or director.

In the not-too-distant past, this kind of involvement often meant flying extra people around the country for recording sessions—an expensive and logistically challenging proposition. But with today's high-speed Internet connections, there are now excellent options for patching off-site personnel into the recording session without sacrificing audio fidelity (which is vital for real-time evaluation of each line reading).

One thing I'll caution against is trying this approach over a conventional phone line or, heaven forbid, a cell phone. I've had experience with both, and the unfortunate reality was this: line readings that seemed just fine over the phone sounded completely different—and often not acceptable—when the high-fidelity versions of the files were eventually delivered. Phones just can't be relied on to accurately deliver a trustworthy reproduction.

Takes Selection

So you took my advice in the previous sections, and included a narrative expert in the recording sessions to make sure high-quality, usable, and context-correct lines were captured. Nice job!

The next step, of course, is selecting a single, ideal "take" for each line: the one you actually want to hear in the game. Sometimes this selection process happens on the spot, during the recording session, as the favorite is marked for delivery—and the developer only receives one audio file per line. Other times, though, *all* the takes are delivered to the developer, for someone there to sift through and ultimately make selections.

The "someone" saddled with this daunting task is usually a member of the Audio team, and often a junior team member at that. In my experience, it's a person with audio expertise but no way to know which take was preferred by the narrative expert—who may very well have stepped in to ensure that take actually got recorded. In other words, even if the perfect take was captured, it might get lost on the cutting room floor because the person making the selections has limited insight and context.

It's a waste of time and effort to involve your narrative expert in the recording process if you're not also going to include her in the takes selection process.

Does this mean that every instance of dialogue in a twenty thousand-line console game needs to be hand-selected by the lead narrative designer? Probably not. But for the most prominent lines spoken by named characters—probably so. The more important the line, the more important it is to get the best version of it into the game.

As a fallback, keep all the outtakes handy and give the narrative expert access to them, in order to go digging for a better take if she hears something amiss in the build.

Scripted (Mission) VO

Mostly applicable to console games with campaign/story modes, scripted mission VO is one of the primary areas where Mission Design, Narrative, and Audio come together. VO lines that play at very specific, pre-determined moments during a mission can be critical to fulfilling important functions, such as:

- Communicating design-related information to the player, such as objectives and hints
- Narratively contextualizing in-mission scripted events
- Moving the story forward
- Contributing to character development

- Creating interesting/entertaining incidental background dialogue/
 conversations

Game missions are sometimes crafted almost to a moment-to-moment level of detail, while others are more "loose" and systemic in style. But most missions in games that feature VO rely in some way on scripted VO to help clarify and contextualize gameplay, especially with regard to events that will definitely happen every time a player experiences that mission.

The process I've seen work best looks something like this (your mileage may vary depending on your tools and pipelines). It involves three key team members: the *mission designer*, a *narrative designer*, and an *audio designer*.

1. Mission Design and Narrative come to agreement on gameplay and story content and objectives for the mission up front, in the mission's early documentation phase. All is detailed in a Level Design Document (LDD).

2. Once there is a fully playable version of the level, the mission designer, narrative designer, and audio designer sit down and play through it together, making notes as to where scripted VO might be needed or desired and what the function of each line or conversation should be. This process can be referred to as "blocking."

3. The narrative designer creates a document (probably a spreadsheet) that lists all the planned scripted dialogue, their trigger events, and a rough pass placeholder line (or something more final) for each one.

4. At this stage, the mission designer is commonly tasked with inserting "hooks" into the mission that programmatically call the blocked-out VO lines to play at the right moments, based on the designated trigger events.

5. Someone—depending on the specifics of the pipeline—imports the lines into the build via a process that also auto-generates placeholder VO files; possibly robotic-sounding text-to-speech versions for the time being. Combined with the mission designer's "hooks," the lines should now be playing in the mission when they're supposed to.

6. The mission designer, narrative designer, and audio designer evaluate the current state of the mission and agree on any changes with regard to content, timing, etc. Lines are added, deleted, and/or changed—new versions are implemented and evaluated.

7. An iterative cycle continues here, as the mission inevitably changes and evolves. Portions of steps 3 through 6 are repeated as necessary, keeping consistent with the current state of the mission—until the level is close to being considered "locked."

8. Finally, Audio and Narrative work closely together to record the final versions of the VO lines and select the best takes. From there, Audio can implement any processing or other post-production effects, and the final VO files can be dropped into the build, replacing the placeholder files via a (hopefully) simple and quick method.

Although Audio's involvement in the process might seem somewhat tangential to the bread-and-butter decisions being made by Mission Design and Narrative, the audio designer's inclusion throughout this cycle is the only way to ensure good follow-through with all intentions for scripted mission VO. Each member of this triumvirate will bring a vital perspective to every scripted line in the mission:

- *Mission designer*: Does this line help involve the player and make him aware of what's going on, what he's supposed to be doing, and how? Does it avoid "stepping" on the gameplay?

- *Narrative designer*: Does this line provide context, motivation, and emotional impact? Does it move plot, arc(s), and/or characterization forward?

- *Audio designer*: Does this line sound right? Is it clearly audible, comprehensible, and does it generate the intended effect on the listener?

If you're an audio designer and you're not being brought into this process until it's time to record final VO, your team processes may be in need of re-evaluation.

Systemic VO ("Barks")

Planning and executing a system by which certain categories of VO lines may play based on various real-time conditions and statistics—colloquially referred to as a "barks system"—can be one of the most scope-heavy and time-consuming aspects of a video game's Narrative and Audio efforts. It's also often a major challenge for audio programmers and tools developers. In terms of sheer line count and technological infrastructure, nothing else in the shared realm of Narrative and Audio generally comes close.

The most obvious games with a need for systemic VO are big, open-world console games along the lines of the *Grand Theft Auto* series, and massive open-world MMOs such as *Star Wars: The Old Republic* (currently the world record holder for the most amount of VO in any entertainment product, featuring a staggering two hundred thousand-plus lines). And while it's true that

these types of games may feature the largest amount of systemic VO—and thus the most VO, since systemic line counts usually dwarf every other type within a game—other genres also call for "barks," "quips," or whatever each studio's own culture has decided to refer to systemically triggered VO lines.

Nearly every VO-inclusive game featuring any type of combat, for example—whether it's a shooter, a fighting game, or a multiplayer online battle arena—will be improved by players hearing barks that offer clues to character status and intentions while simultaneously providing entertainment and character development. They also just make the AI feel more alive and real—as long as the system is working well.

Even games in which you might not expect to hear systemic VO are starting to include it. For example, Blizzard's *Hearthstone* digital collectible card game features in-game enemy characters quipping and commenting in reaction to attacks, being hit, things going well, things going poorly, and many other trigger conditions—*in a card game*.

In the future, as cellular bandwidth continues to increase and mobile and social game platforms allow for more and more robust gaming experiences, we will almost surely hear more VO in the city-building, bird-flinging, and color-matching distractions occupying us on our phones and tablets.

So, understanding the importance of close, early collaboration when designing a systemic dialogue system is becoming an increasingly common requirement within the industry. The actual design will vary wildly depending on the type of game you're making as well as many other factors, but regardless of these details there are a number of constants I believe apply to all these situations.

System Planning

The first step in the development of any system, of course, is to define what it needs to be able to do. As part of this specification and planning process, up-front collaboration between Design, Narrative Design, Audio, Engineering, and Tools Development is essential.

While defining the goals and functionality of the barks system, it can be helpful to evaluate games that might have a similar system running "under the hood." Meticulously documented playthroughs of games featuring aspirational VO functionality will help yield a shared understanding of what's really desired from your own system.

As these systems can be complex to develop, the technical members of this sub-team might want to investigate the repurposing of existing tools and tech already present at the studio. And if that's not feasible, they'll definitely want to account for plenty of development time.

One of the most illuminating parts of this phase can be generating an initial list of trigger events that it's hoped can potentially cause certain kinds of VO lines to play. A solid understanding of the current game design will be

important here, as will research into other titles on the market, to see what works well and what doesn't. The trigger list not only helps define the scope of the barks system, but the systems designers can also use it to begin putting "hooks" into the code that will later be used to actually fire the appropriate VO lines when these predefined conditions are met.

This process will also start to reveal scope: of writing, recording, and implementation. All three are related, though not exactly the same. (For example, a certain line might be written just once but recorded by five different actors to allow for audio variety.) It's never too early to start getting a handle on the size of the job.

Placeholders

Voiceover lines generally aren't recorded until fairly late in the development process, since actor and booth time can be expensive, and most lines end up being rewritten as the game evolves through production. However, for a multitude of reasons, it's essential to hear at least rough versions of the game's VO lines pretty early on—thus the importance of placeholder lines and your system's ability to integrate them quickly and easily.

Ideally, your tools and pipeline allow for narrative designers to drop new VO into the game without the need to rely on any other team members, such as programmers or audio experts. In most systems, these files will be digitally generated, text-to-speech files (à la Stephen Hawking's artificial voice).

Not all text-to-speech is created equal, however. Low-quality, excessively robotic-sounding text-to-speech does a poor job of standing in for human VO. It won't reveal important issues and will tend to be ignored by nearly everyone on the team due to its grating, barely comprehensible nature. Cheap-sounding text-to-speech will make any well-written line sound bad and prevent accurate evaluation prior to recording. Worse, by making every line sound clunky, it can unfairly hurt the credibility of the game writing.

High-quality text-to-speech, however, can be a boon to the team's many storytellers, and help them more accurately test the quality of the dialogue writing and event-triggering decisions. If you're considering cutting corners by not springing for the best digital voices available, think again. It's probably more than worth the extra few dollars.

Repetition and Tuning

The noticeable repetition of a video game VO line can cause a barks system to suddenly go from making the world feel real and alive to blatantly revealing that same world to be artificial and contrived. There are few occurrences that can so immediately, decisively shatter a player's suspension of disbelief, reminding him that he's playing a game.

Game writers and audio designers with experience in this area know how important it is to write a sufficient number of variants of each type of line so that repetition is reduced or eliminated. The key fact that can be difficult to know early in the development cycle is: *How often is this trigger event likely to happen?* The more often it occurs, the more variants for the associated VO line will be needed.

However, the brute force method of simply writing more and more variants for triggers that keep calling a certain line is not a very efficient way of dealing with the issue. Also, there is a point of diminishing returns in terms of writing quality when trying to generate more than, say, twenty ways to say the exact same thing. Integrating tools that allow for monitoring of how often each line is being played in the game, and for tuning these numbers up or down, can be immensely effective and much more efficient.

For example, the tool could potentially detect and prevent repetition of a line within X minutes of its previous playback. There could even be lines that can only play once during a single play session, or even just once during a player's entire playthrough of the game, spread out over a week or more!

Why go to such extremes? Because some lines bear repetition better than others do. The more generic a line, the more it can probably stand to be repeated. Something more specific, however, should be tuned down. And anything that is supposed to be funny should be tuned *way* down if possible. Very few jokes are funny the second time, let alone the third, the fourth, the fifth—at which point the player wants to strangle whoever wrote that joke, even though the blame should probably be on the system that insists on repeatedly playing it!

Testing and Bug-Proofing

It's very important to be in a position to begin properly testing the systemic VO performance as early in the dev cycle as possible. Good placeholders are crucial in these stages to identify bugs early enough to begin debugging the system. Waiting until final VO files are being dropped into the game to unearth major structural problems will most definitely be too late.

Make no mistake: barks systems are, by their very nature, huge generators of bugs. However, these issues often tend to take the form of "C" or lower bugs—the kind that don't always get prioritized over progression blockers, inventory issues, UI problems or even visual glitches. A VO line that breaks immersion by playing three times in a row may never get fixed due to more pressing bugs, so designing the system to prevent these kinds of issues from occurring in the first place is advisable.

My personal take on this issue is that I'd rather hear no VO line than hear a bad one—one that repeats a joke, or seems incongruous to current

circumstances, or otherwise breaks immersion. In my opinion, when it comes to systemic VO, silence beats a mistake every time.

Environmental VO

Environmental sounds that vary from location to location in a game can play a huge part in bringing the fantasy alive and making the player feel even more immersed in the experience. This can include ambient VO (including sound effects and general soundscapes that sit right on the edge of conscious perception) along with other VO such as you might hear in an audio log.

Let's stick with the VO aspect for now and move on to other elements after.

Ambient VO is similar to systemic VO and may even work from the same base of technology within a game, but whereas systemic lines are generally in reaction to player-initiated game events or resulting conditions, ambient lines are the ones that play just as a matter of course, assuming and requiring no player-related triggering.

Walking down the street in a *Grand Theft Auto* game, you will notice that if you just stand in place and listen for a while, you will hear a multitude of different virtual people with different things to say. Muttering to themselves, asking each other what the time is, commenting on the weather, pushing as they tell each other to get out of the way . . . this is the kind of VO that can help give the player the feeling that this world would continue to do its thing whether or not the player were there (even if that's not true, apart from persistent worlds such as those seen in MMOs).

Other ambient sounds in addition to VO can do much to fill out an environmental game space: a rumbling growl from across a dank, swampy landscape; the sound of birds chirping as you approach an open window; the groan of giant titanium beams reverberating through the hull of a long-abandoned space freighter. These *diegetic* (in-world) sounds can imply things that the player will never see—thus saving the time needed to build them and allowing the player's imagination to fill in the blanks. Ambient sounds can be used to trick the player into feeling safe when he's not—or vice versa. They can prepare the player for what he's about to face—either physically or emotionally.

But ambients only work well when they're fully aligned with the shared vision for that environment. As has been repeated throughout this book, a given team member's ability to enhance storytelling often relies heavily on how well Narrative has communicated their full intent to related team members. It's also true here that an audio designer tasked with creating ambient VO and other sounds for a given game environment needs a lot of up-front information about that place beforehand. An Environmental Description Document, coupled with concept art, can go a long way to creating a unified vision and ultimately a unified presentation of each game location.

If you don't have the information you need to confidently move forward with ambient sound, your best bet is to ask for it!

Another type of environmental VO is the *audio log*. Some are automatically triggered to play when the player wanders near, while others may require manual activation. Fictionally, they may be represented by conceits such as:

- A TV in an electronics store or apartment
- A radio in a car
- A digital or tape voice recorder
- A security system
- A computer
- A two-way radio

And the content of their messages might consist of:

- A personal audio diary
- An audio recording of a scientific experiment or other event
- A recorded phone call or voicemail message
- A news report
- A commercial
- A public service announcement (PSA)
- A talk show
- An urgent warning or call for help (but with no way for player to reply)

The player can generally keep playing and exploring while listening to the contents of these logs, making them "ambient" after a fashion.

Audio logs usually don't contain narrative content that's crucial to understanding the overall story or even the current objectives, but they can be a powerful delivery mechanism for background and character-developing story material. They're also relatively affordable to produce, considering they can provide almost as much bang for your buck as a cutscene! In fact, I have worked on games in which certain scenes that were intended to be fully-animated-and-rendered cutscenes were ultimately downgraded to audio logs. While these sequences needed to be rewritten to be more like "radio plays," incorporating elaborate foley and sound FX work to take into account the complete lack of visuals, they still did a serviceable job of telling part of the story in a dramatic and engaging fashion.

These systems may not be as bug generating or worrisome as a barks system, but they may still require a large amount of writing and recording, and can take up a lot of audio-related memory. As with systemic VO, an early shared understanding between Design, Narrative, and Audio of the goals of the game's environmental VO is crucial.

Music

The close connection between Narrative and Audio is very obvious when we look at game VO. Narrative writes lines, Audio gets lines recorded, edited, processed, and playing in the game—simple, if not easy. But through game VO a very clear and close relationship between Audio and Narrative is easy to perceive.

What might not be as apparent is the connection between these two disciplines when it comes to music. Ultimately, at a very core level, the story and the music are trying to do the same thing: *make the player feel*.

As covered in chapter 11 ("Level and Mission Development"), the desire to make the player feel something almost always originates from either Design or Narrative. If Design wants the player to feel empowered and majestic at a certain point in the gameplay, Narrative and Audio move to support this directive. If Narrative wants the player to feel alone and helpless for a moment, Design and Audio are in the support roles.

Audio doesn't initiate the intentions—it is always in the support role. But it has incredible potency in generating these emotions in the audience, especially through the power of music. Think of the minor-key, unresolved musical themes in survival horror games such as *Silent Hill* or *Resident Evil*, or, at the other end of the spectrum, the inviting, cheerful accompaniment to any and all Mario games from Nintendo.

Sometimes the intended emotion on a moment-to-moment basis is obvious to everyone concerned—other times, perhaps not so much. As referenced on page 140, a good way to make sure everyone is on the same page is for the narrative expert to provide an emotion map. Its purpose: to lay out, in no uncertain terms, what the main emotion is supposed to be—and how intense it should be—at every moment of storytelling and gameplay.

Emotion maps can be scaled down to describe not only moment-to-moment emotional intent, but also scaled up to cover the sweep of the entire game story. Understanding these intentions will help the composer create a musical arc across the entirety of the game that aligns the story and gameplay arcs—with the most dramatic music being saved for the most dramatic moments in the entire game.

Final Thoughts on Audio

Narrative and Audio are hard to beat when it comes to eliciting emotion from players, and when they work together true magic can be the result. However, this holds true only if experts in both these disciplines spend the majority of their time in fruitful collaboration—rather than fighting over which of this "dynamic duo" is Batman and which is Robin. (Because, let's face it, you're both Batman!)

Quality Assurance (QA)

It's with a pang of guilt that I leave a short discussion regarding Quality Assurance and its relationship with storytelling for the last chapter of this book.

Of course, QA testers are used to finding themselves last in the chain, working under extremely tight deadlines and trying circumstances—so often crushed between unforeseen development delays on one side and an immovable shipping date on the other.

The most serious bugs that testers find and report have to do with crashes, freezes, progression blockers, performance issues, missing art assets, holes in level geometry, and so on. Less serious but nevertheless important-to-report issues can include menu errors, animation glitches, localization problems, spelling errors, and art oddities.

However, testers sometimes also weigh in on less "bug-like" issues such as game balancing, difficulty curve, presentation details, and even potential legal concerns. Categories such as these can meander away from simple bug reporting and into the realm of subjective feedback.

Which opens the door to a brief discussion of QA and video game storytelling.

As a QA tester who—having read this book—better understands the foundations of narrative development, you now have more skills you can bring to the table. Your ability to perceive correct vs. questionable story elements can help improve the narrative quality of the games you help to test.

For example, you may find yourself in a position where you're a "cold" audience member—you haven't been exposed to the development process or what was intended for any given narrative sequence. As such, your reaction to said sequence upon seeing it for the first time might be invaluable feedback to those who created it, hopefully at a point in the process where it's still possible to adjust course.

More important, because you have some distance from the material, you may have a better chance of noticing narrative problems than those who actually created the story content. These "bugs" might relate to any of the topics we've discussed in this book, such as structure, characterization, exposition, consistency, believability, dialogue . . . you name it.

What if a game level and its narrative unintentionally feel less intense than the ones before them?

What if a character's mission objectives conflict with something she indicated about her beliefs in the previous cutscene?

What if something happens in a cutscene that you know violates the physics that have been established in the rest of the game?

What if there's a VO line that is playing incessantly?

What if you simply don't "buy" the surprise that just exploded into the story and game from out of left field? Or worse, what if you felt it was unfair?

Of course, it can be a delicate matter providing feedback to developers on their work—especially on a topic as subjective as storytelling. You may want to first ask the relevant team members whether they're interested in receiving feedback on the story elements. Any narrative professional worth her salt will welcome your perspective, even if she doesn't always end up acting on it—either due to time or scope constraints, or a simple difference of opinion.

So, if you are a QA tester and your reading of this book has expanded your understanding of game narrative—or if you already had a good, solid understanding of story development—you should consider yourself another line of defense against sub-par fictional content making its way into the games you test.

In fact, you're the last line of defense.

AFTERWORD
Return with the Elixir

In the Hero's Journey, the story usually ends with the grown, changed Hero returning to his Ordinary World and improving it with the boon he fought so hard to win.

With your journey through this book now nearly complete, my hope is that in some way it's changed your thinking about storytelling in games, and rewarded you with at least one benefit you can bring back to your day-to-day game development experience. My goal with the many game narrative lectures and tutorials I've presented over the years—and now with this book—has always been to communicate to game developers of every stripe that they are all storytellers, and to therefore provide some basic principles and tools to help them become better at it . . . *as a team.*

It's something of a selfish quest I'm on, really, because I love experiencing good game stories. Every quest starts with a conflict and a Hero's hope that he can somehow resolve it. When it comes to storytelling in games, here are some of my own hopes.

I hope *team leaders* will treat narrative experts and their concerns with the same consideration, respect and professionalism they do members of every other game development discipline. I hope these decision-makers will perceive and value the huge contributions a game writing professional can bring to nearly any project, and understand that they hold an expertise not possessed by "just anyone." I hope team leaders will realize that game narrative isn't an afterthought to be tacked onto an existing Alpha, but a critical game component to be included in the creative process from the very first days of development. And I hope that leaders will instill in their entire teams a shared sense of ownership over the quality of the game's story.

I hope *designers* will remember the importance of ludonarrative harmony as they develop their overall design and their missions, and work to echo that harmony in their dealings with narrative experts throughout the process. I hope they'll recognize when a design decision may impact the story, and immediately raise a red flag. I hope they'll always work hard to find the appropriate balance between crafted and emergent storytelling in the specific game on which they're working, and continuously seek new, innovative ways to express story through gameplay. And I hope they will take the time to go beyond this book with their investigation of the principles of fiction, an understanding of which has the power to improve a designer's effectiveness in countless ways.

I hope *artists* and *animators* will never forget that everything about the visualization of a character, item, or place conveys narrative information. I hope as they're developing every visual—every concept painting, every environment, every item of clothing, every facial feature, every movement, no matter how subtle—they always remember that each one has the potential to either improve or negate the effectiveness of the game's storytelling. I hope they'll collaborate with narrative experts in an open and productive way, with creativity encouraged to freely flow in both directions.

I hope *engineers* will keep in mind that they have an important part to play in the successful expression of a game's story. Whether they're tasked with developing tools, world physics, audio systems, or any other technical component of a game, I hope they'll take an active role in discovering what the narrative intent is and how they can help bring it to life.

I hope *audio experts* will see in narrative experts kindred spirits and potentially staunch allies in enhancing players' emotional engagement. I hope they'll work to break down barriers and treat the Narrative/Audio connection as the crucial, hand-in-glove relationship that it is. I hope audio developers will take personal responsibility for getting as much knowledge of the game story, characters, and world as possible in order to support that vision as only they can. And I hope that they'll treat narrative experts as partners, inviting them into the audio development process from the earliest possible stages.

I hope *QA testers*, those unsung heroes of game development, take the principles and lessons from this book and apply them to the critical eye with which they evaluate every nuance of an in-development game. I hope they'll notice when characterization and mission objectives seem misaligned, or when a line of dialogue doesn't make sense. I hope the principles expressed in this book help them improve every game they test in at least some small way.

And finally, I hope *game writers* and *narrative designers* will realize that educating the rest of their teams in the core principles of storytelling is a crucial step to productively working together over the long haul of a game project. I hope they'll show initiative in providing ample, vivid descriptions of characters and environments to give the rest of the team the ingredients for narrative

consistency and success. And I hope narrative experts will acknowledge and demonstrate that storytelling isn't a responsibility to be compartmentalized or territorially guarded by a single developer, but an experience to be collaborated on and shared across an entire team.

There's that word again: "storytelling." It's right there in this book's title, and I've used it liberally throughout. Why? Because it's a term that's familiar to everyone, even if—as we've discussed a number of times by now—"telling" a story is almost always the weakest way to convey it. As video game developers, we have the potential to offer so much more to our audience when it comes to story.

Our players aren't just *told* about a Hero—they *are* the Hero.

And they aren't just *shown* how a conflict was resolved. They're challenged to *do* it themselves.

This is why more players spend more money every year on games, with no end in sight. They're out there, by the millions. Ready to take part in a new story. Eager to see what we'll challenge them to play—to *do*—next.

APPENDIX I
Sample Character Description Document

Character Description Documents, usually generated by the narrative expert(s) on a game project, provide different team members with the information they need to bring a character to life in a way that's consistent with a unified vision of that character. It is possible to create a large, singular document that covers all aspects of the character, or to generate a baseline document with additional versions customized for different disciplines within the development team. This example—describing a "classic comics" version of Peter Parker/Spider-Man— uses the latter approach.

Peter Parker/Spider-Man

Basic Description

(All team members involved in character creation and/or execution would receive this section.)

Name: Peter Parker (secretly Spider-Man)

Sex: Male

Race/Species: Caucasian

Age: 17

Intelligence: Gifted, "book smart" but not necessarily "street smart"

Education Type and Level: High school junior, top of his class, augmented by his own studies

Economic Background: Peter has grown up in a modest home in Queens, New York. While he doesn't want for any of the basics, his life is far from extravagant and in order to get anything fancy he has to find ways to earn the extra money himself.

Profession: Full-time high school student, part-time photojournalist

Vocabulary: Exceptionally diverse

General Attitude: Peter is a conscientious, considerate, and well-intentioned young man. He tries to see the best in people and generally believes that they can change for the better. That said, he has very little patience for those he believes are bullying or preying on the weak or helpless.

Backstory: Peter Parker was a highly intelligent but socially awkward orphan teenager growing up with his beloved Aunt May and Uncle Ben in Queens, New York when he was bitten by a radioactive spider during a lab experiment gone wrong. Peter found he now possessed superhuman, spider-like powers such as massive strength and agility, increased durability, wall-crawling, and a "spider-sense" that alerted him to immediate danger to himself. Employing his extraordinary scientific skills, he invented wrist-mounted "web shooters" that allowed him to fire web-like projections at the press of a button on either hand. He also fashioned a costume for himself and, calling himself "Spider-Man," decided to capitalize on his good fortune by entering the world of professional wrestling. He became an overnight sensation and novelty TV star, and basked in the fame and fortune that were beginning to come his way. However, when he blithely refused to help stop a fleeing thief running through the halls of the TV studio, Peter was later horrified to learn that the same criminal soon thereafter robbed and killed his Uncle Ben. Suddenly, painfully realizing that with great power must also come great responsibility, Peter committed from that

time forward to use his powers—as Spider-Man—to do everything he could to help protect innocents from criminals such as the one who murdered his uncle.

Deeper Dive

(This section is most geared toward writers and designers who will determine what the character can, might, and/or will do within the framework of the story and game.)

Desire: Peter is driven by a deep-rooted sense of guilt over his Uncle Ben's murder, which provides his burning motivation to protect innocents from being victimized or otherwise harmed by evildoers. At a very fundamental level, Peter constantly desires to atone for his past mistake. In his personal life, he would like to be more popular, or at least more included, in social activities, but despite his superhuman abilities he remains awkward and shy, often opting for individual, scientific pursuits over getting involved in typical teenage extracurricular activities such as sports, parties, or dating.

Likes: Peter likes challenging his mind, especially in the arena of scientific research. He loves his Aunt May, and would like to be more social and accepted but doesn't know how.

Dislikes: Peter hates bullies, criminals, and anyone who preys on those weaker than they. He also hates "fake" people who put on a front (despite the irony of his own dual identity).

Values: Peter values honesty and fairness, and believes that good people deserve to have good lives. The thought of good-hearted people like his late Uncle Ben being threatened by thugs and criminals disgusts him and drives him to risk his own life on a regular basis to help prevent it whenever possible.

Key flaw(s): Peter is an intelligent young man with amazing powers, but he is still a teenager and despite his upbringing in New York City, he is not particularly street smart. His naïveté regarding the crime-infested world in which he now spends so much time sometimes puts himself and others in danger. Also, as a nerdy and

socially awkward teen, Peter doesn't always know how to act around his peers and tends to retreat from social interactions, oftentimes playing the part of a self-pitying loner.

Vices: Peter doesn't indulge in many vices, even those some of his teenage peers might be trying, such as alcohol or recreational drugs. He might be said to be mildly addicted to the "rush" he gets when hiding behind his Spider-Man mask and swinging, leaping, and crawling around the city to the amazement of those around him.

Character Arc/Change: When we first meet Peter he is a typical high school science nerd; intelligent, awkward, and bullied. When he gets his spider-powers, he initially revels in them and becomes a self-absorbed celebrity—essentially, a selfish jerk. And finally, after the death of his Uncle Ben, for which he blames himself, Peter grows into a more mature and responsible person, and ultimately into a hero.

Visuals

(This section is customized for concept artists, character artists, modelers, riggers, and animators.)

Physical attributes: As Peter Parker, he appears to be of average height and slight of build. As Spider-Man, his skintight costume emphasizes a wiry physique, which he's able to bend in almost inhuman ways.

Movement: When in costume, Spider-Man crawls and crouches like a giant arachnid, striking strangely insect-like poses. He hangs upside down from his webbing, much like a spider does, and generally will not be seen just standing or strolling along, instead moving in ways that are more "spider-like." In combat, speed and agility are his most notable talents, as he jumps, flips, dodges, and strikes beyond what any human acrobat could hope to achieve. His super-strength and resilience also come into play, as he is deceptively powerful and can take much more punishment than a regular person could.

Clothing: As Peter Parker, he wears fashion-oblivious, conservative clothing most likely picked out by his Aunt May. Oversized glasses emphasize his nerdish appearance. As Spider-Man, his fully enveloping costume masks the fact that he's just a teenager.

Weapons/Paraphernalia: Spider-Man's web-shooters can fire their "webs" in a number of ways to form lines for swinging; snares for trapping enemies; and even thicker, stickier webbing to be used as an adhesive (for mounting his camera when shooting pictures of himself as Spider-Man). Spare "web cartridges" are stored in his belt, the buckle of which also houses a special Spider-Man-themed flashlight/signal. And he also carries several "spider tracers" that he can fire onto moving objects or people, to track the target down via his spider-sense.

Casting/Audio

(This section is fashioned with casting agents, audio experts, and cutscene directors in mind.)

Voice age: 17

Reference actor(s): Tobey Maguire at age 20

Accent: No accent, or a very slight Queens, New York accent

Other Notes: As Spider-Man, Peter often covers for his nervousness during a fight by "quipping" at his enemies. With a sharp sense of humor and dry wit, Spider-Man sometimes infuriates his opponents with these jokes, even to the point of goading them into making a critical mistake during battle.

Sample, defining dialogue lines:

As Peter:

"Well, it does sound like fun, but there's that chemistry test tomorrow . . . "

"C'mon, Flash, get out of the way. I need to get into my locker."

"That was delicious, Aunt May. Is there any more left?"

As Spider-Man:

"'*Doctor* Octopus' . . . is that a real title, or did you just get one of those fake honorary degrees?"

"For the last time, it's 'arachnid', not 'insect'! If you're going to insult me, at least get it right."

"Here, let me show you my take on gun control."

"What's that? The webbing tastes bad? Aw man, and here I was thinking I'd get rich selling it as a dessert topping."

APPENDIX II
Sample Environment Description Document

For this sample, we will use an interior location with which every reader should be familiar: the Mos Eisley Cantina in *Star Wars*.

The Cantina is a dark and cool-feeling contrast to the glaring and hot environment of Tatooine and its furnace-like landscapes. The only light sources are some artificial lights illuminating the central bar area, and a few small, adobe-like windows along the cantina's rock-hewn perimeter. The relatively unlit nature of the single-story building suits its clientele well, since many appear to be characters who operate mainly in the shadows.

The bar itself, oval in shape, is central to the establishment. It houses a multitude of mysterious-looking metallic pipes (running from the center of the bar up to the ceiling and toward the back of the building), and glass flasks and spigots, used in distilling and serving various alcoholic beverages. Off to one side, an alien band plays an inappropriately bouncy tune as shady characters of every species and race quietly drink, socialize, and conduct questionable business at the bar and in eight dimly lit side booths. As in many bars, there is a sense that many of these characters spend much of their lives in here.

There is a notable lack of droids in the cantina, as they are not allowed inside per the owner's orders.

Like most things and places on Tatooine, everything here looks worn and not particularly well-maintained. Very little technology is on show here; most everything looks old and mechanical as opposed to new and electronic. There is an inevitable layer of desert sand and dust on the stone floors. You would not want to see the kitchen, let alone eat the food.

Acknowledgements

This book would not exist if not for the tutorial on which it's based; and that tutorial would not have happened nor endured for close to a decade now without the support, encouragement, and participation of many fine people. Therefore I'd like to first thank the management and advisory board members of the Game Developers Conference (GDC) who have welcomed me to their show, year after year, to share my insights on video game narrative with game developers from around the world and in every discipline. It has been, and continues to be, an incredible experience. Just as important, my thanks to those who have attended these tutorials over the years, as an attendee or a Conference Associate. Thank you for your enthusiasm as well as your honest feedback. I can say without reservation that I learned at least as much from you as you may have learned from me.

Thanks also to my brothers- and sisters-in-arms from the International Game Developers Association Game Writers Special Interest Group and from the front lines of game writing everywhere. There are too many to mention here, but special thanks to Richard Dansky, Wendy Despain, Andy Walsh, Mary DeMarle, Bob Bates, Haris Orkin, Toiya Finley, Jeff Spock, Maurice Suckling, Lee Sheldon, Chris Avellone, Tom Abernathy, Chris Keeling, Lev Chapelsky, James Waugh, Susan O'Connor, Steve Jaros, Sande Chen, Soraya Een Hajji, Steve Williams, Matt Forbeck, Wynne McLaughlin, Blake Rebouche, Christy Marx, Drew McGee, Alex Freed, Joelle Sellner, Jeremy Bernstein, Anne Toole, Jonathon Myers, Warren Schultz, Tracy Seamster, William Harms, Stephen Dinehart, Daniel Erickson, Brian Shurtleff, Rhianna Pratchett, and many other colleagues and friends who've shared more than one narrative "war story" with me over frosty beverages in Austin or San Francisco. (If I advertently left you off the above list, I apologize and blame it on the frosty beverages!) When I see people as talented as these also struggling mightily with the challenge of integrating great stories with great games, and hear about their triumphs as

well as their occasional setbacks, I don't feel so alone in my own little corner of the game development world. And that means a lot.

Thanks as well to the team members I've been lucky enough to work with at various game development studios over the years—at Hyperspace Cowgirls, Vicarious Visions, 2K Marin, Kabam, LucasArts, Disney, TinyCo and others. Thank you for being such incredible collaborators as we worked together to create and integrate high-quality narrative content into our games.

Finally and most importantly, thanks to my beautiful wife Lynn, who supported and encouraged me as I worked—and sometimes struggled—to balance the writing of this book with my many other responsibilities, both professional and personal. And to my sons Jacob and Bennett, who regularly remind me why I work in video games in the first place: to make people happy.

Index